The Sacred Whore

SHEELA, GODDESS OF THE CELTS

Maureen Concannon, MA, Dip. Psych, PhD, an historian
and psychologist, has made the Sheela na gigs
a twenty-year study. She lives in Dublin
where she is in private practice,
working with individuals and groups.

e1

409334

The Sacred Whore

SHEELA, GODDESS OF THE CELTS

MAUREEN CONCANNON

The Collins Press

Published in 2004 by
The Collins Press
West Link Park
Doughcloyne
Wilton
Cork

This publication has received support from the
Heritage Council under the
2004 Publications Grant Scheme.

Maureen Concannon has asserted the moral right to be identified as author of this work.

Concannon, Maureen
 The sacred whore: Sheela Goddess of the Celts
 1. Sheela na gigs 2. Celtic antiquities 3. Sculpture, Celtic
 4. Christian art and symbolism 5. Mother goddesses in art
 6. Civilisation, Celtic 7. Celts – Ireland – Religion 8. Celts
 – Great Britain Religion 9. Great Britain – Antiquities, Celtic
 10. Ireland – Antiquities, Celtic
 I. Title
 940'.04916
 ISBN 1903464528

Typesetting The Collins Press
AGaramond, 11 point

This book is printed on uncoated paper manufactured with the greatest possible care for the environment.

Printed in Ireland by Woodprintcraft

Cover image: Sheela-na-gig from Ballylarkin, County Kilkenny, courtesy National Museum of Ireland

Contents

List of Illustrations

Photographs by the author unless otherwise stated.
Line drawings and sketches by Jakki Moore.
NMI = National Museum of Ireland in Dublin.
Department of the Environment, Heritage and Local
Government – Con Brogan photographer.

Acknowledgments

I wish to acknowledge with gratitude the help and assistance of so many people over the twenty years or so during which I have been researching Sheela na gigs. My thanks to Gemma Barry of Dubray Books who recommended The Collins Press so very highly. My deepest thanks and praise to the editor, Maria O'Donovan, for her skills, insight and enthusiasm. The Goddess was with me when Maria came into the picture. Thanks to Con Brogan, photographer of the National Heritage Service for his encouragement and sensitive photographs of the ancient Sheela carvings, so masterfully executed. Without the visual, the words would have little significance. Thanks also to my agent and friend, Marianne Gunn O'Connor.

My thanks to Jakki Moore for the artwork; Jakki, an anthropologist, artist and friend of many years, shared the Sheela vision. Her enthusiasm, interest and encouragement never flagged from the beginning. The lighter side of the Sheelas came to the fore when we went 'gigging' over the countryside in search of Sheelas in out-of-the way places where they are still 'on guard' despite 400 to 500 years of being rooted out of conscious memory. Thanks to the others who have come gigging with me: artist Carmel Benson, who recently held an exhibition of her beautiful Sheela paintings, to Jean Fitzgerald, Elinor Detiger, members of the Millionth Circle at Glastonbury and Iona, all my spiritual friends in Margaret O'Sullivan's group at Monkstown, and for the support of Sheila O'Hagan, poet and friend, and poet Maureen Charlton, who helped me choose the book's title and remains one of my dearest friends.

My thanks to Siamh Moddell, artist at the National

Museum of Ireland in 1985 from whom I learned about those 'carvings of naked female figures' stored away in the vaults of the museum. I am deeply appreciative for the advice and comments of Seán Ó Duinn, for his reading of the chapters on the Goddess and on Celtic Christianity, for his great depth of knowledge about Irish myth, history and the Irish language. He saved me from several 'gaffs' – any that remain are my own! To Muriel McCarthy, Head Librarian at Marsh's Library, my gratitude for the bibliography of Archbishop William Palliser of Cashel. Thank you to those who read the whole text: Sylvia Brinton Perera, Mary Molony Lynch, Sally Ann O'Reilly, Eileen Stephens, and to Tom McNally for his help with the computer.

My thanks to the head antiquarians of all the museums that house Sheelas, particularly to the National Museum of Ireland (where the largest collection is held) and the Keeper of Antiquities, Eamonn Kelly, author of a monograph entitled *Sheela-na-gigs.* Thanks to the curators of the museums at Bolton Library, Cashel, Kilkenny, the Hunt, Limerick, Cork Public Museum, Athlone Castle Museum, Ulster Museum, Belfast, Kendall Museum, Cumbria, and the British Museum London.

To all the guardians of the Sheelas whether on public or private grounds – you are the keepers of a symbol that can help humanity restore balance to the earth. Thank you for protecting and preserving the one you are charged with. Too many of these carvings have been destroyed or stolen.

The author and publisher are grateful for permission to use the following photographs: *Our Lady of the Fruits of the Earth* by Frank Cadogan Cowper from Christies, London; *Aurora Consurgens* from Bibliothek National, Zürich, Switzerland; for the use of the photographs in the National Museum of Ireland collection; and for permission to use the photos from the collection of the Department of the Environment, Heritage and Local Government. With appreciation to Seamus Heaney for the use of his poem *The Sheela na Gig of Kilpeck* and A.P. Watt Ltd. on behalf of Michael B. Yeats for permission to include his poem *Red Hanrahan's Song about Ireland.*

The Hero and the Hag

Once upon a time the five sons of the High King of Ireland went hunting together. At twilight they set up camp and one of them went off to find water. He returned without any, saying, 'There was a monstrous black hag guarding the well. She wouldn't let me have any water because I refused to kiss her.'

One by one the other brothers went and came back with the same account – without water, except Fiachra who gave her 'a bare touch of a kiss', for which she promised him 'a mere contact with Tara'.[1]

Finally, the youngest prince, Niall by name, went and returned with an abundant supply. Not only had he kissed the hag, he lay with her.[2] With that, she turned into the most beautiful woman in the world. 'Who are you?' asked the hero. 'I am Sovereignty [the goddess of the land] 'and because you honour me, you will be High King over the whole of Ireland and your seed shall be over every clan.' And so it came to pass.

Those who face their greatest fears win sovereignty over life ... and death!

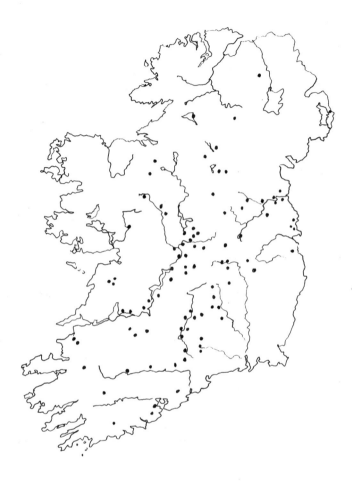

Locations of Sheela na gigs in Ireland.

Introduction

This is the stone
Poor and of little price,
Spurned by the fool
But honoured by the wise.*[1]*

Within the past quarter century public attention has been drawn to a series of carved stone images of naked female figures, hands emphasising the exposed genitals. These images have extraordinary effects on viewers, frequently eliciting a strong emotional response.

Although more of these carvings have been recorded in Ireland than in any other country (over 110) they have, until recently, been a carefully guarded secret, when they have not been overlooked entirely. Thirty-two similar carvings have been noted in England, nine in Scotland and eleven in France. Further discoveries are being made every year. My own research has uncovered five additional carvings (two in County Meath and three in Scotland) that have not yet been cited in official listings.

Since the eighteenth century, these carvings have been called 'Sheela na gigs', a combination of Irish and other languages, that has mystified interpreters. Despite their presence on ancient churches and castles, these carvings were overlooked by historians and antiquarians for hundreds of years. The Annals of Ireland made no mention of

them. What are these carvings? Who carved them? Why? What was their purpose? Why are they coming back so forcefully to our attention at this particular time, many hundreds of years after they had completely disappeared from human awareness? Why were they preserved so long, and then, why hidden away? What function can they possibly serve today?

The Sheela na gig represented an aspect of the goddess of the land, worshipped by the indigenous people of Ireland and adopted by the Celts when they settled on this island.[2] The Sheela is a hybrid of the pre Indo-European goddess religion and the Celtic heroic tradition. She became an integral part of the concept of the sovereignty of Irish kings, who entered into a symbolic marriage with the goddess of the land. But she was not called Sheela then.

This is the story of how an ancient symbol of the goddess survived over many centuries in Ireland even though every other symbol of the goddess was erased from the consciousness of the western world. A synthesis is undertaken from antiquarians, archaeologists and anthropologists from mythology, history and psychology, to bring a fuller understanding of this religious symbol and its relevance in modern times.[3]

Sheela, the Divine Hag of the Celts as she was called, was incorporated into early Celtic Christianity which retained a considerable amount of the indigenous nature religion combining it with a form of Christian monasticism that came from Egypt through France. One of the main principles of the monastic/hermetic way of life was 'Peregrinatio' – the duty to travel to bring the Christian message to others. Irish missionaries (in particular Colum Cille and his followers) brought the imagery of the Divine Hag with them during the fifth and sixth centuries and

Sheelas are still found at some of those isolated places on the islands and the mainland of Scotland, Wales, England and France where they introduced Christianity.

The Celtic Church enjoyed a 'golden age' from the fifth to the eighth century when Irish monasteries became the repositories of all the ancient learning while the rest of the continent was engulfed in the Dark Ages. The Irish in effect, saved European civilisation.[4]

The establishment of Celtic foundations in Northumbria alarmed the kings in southern England, who feared the whole country would be taken over by the Scotti from Argyle (originally a clan from Ulster). In order to stop the advance of the Celts, an alliance was set up with the Roman Church and from the mid-seventh century a series of synods gradually established the dominance of the Roman Church over the Celtic monastic system.[5] Like many other branches of early Christianity, the Celtic Church was threatened with expulsion from the Christian Church as heretical.

The symbolism of the Sheela, so central to the first Irish founder missionaries, stood in direct contradiction to Papal Supremacy, which the Roman Church began to claim for itself. As spiritual head of the Holy Roman Empire and successor of St Peter, the Pope claimed to be God's earthly representative and to have the right to appoint all kings. The Divine Hag of the Celts, a symbol of the bestower of sovereignty on the rightful king, had to be eliminated. Many other beliefs, customs, traditions and ancient systems of knowledge of the early Irish church were also eliminated gradually over a period of 600 years.[6]

Although weakened through these compromises, Celtic Christianity managed to survive and even prosper side by side with Roman Christianity. Even during the

Roman reforms of the twelfth century, Sheelas were insert-
ed on newly-erected churches at early Celtic foundations
in England, Scotland and Ireland. They have been found
at some of the great early foundation of Glendalough,
Clonmacnoise, Kells, Sierkieran and Cashel in Ireland and
at Whithorn, St Vigean's and St Andrew's in Scotland,
which further attests to their powerful hold on the con-
sciousness of the clergy as well as the populace.

By the thirteenth century, however, the full effects of
Roman reforms succeeded in eliminating the Divine Hag
even from Irish churches. They were removed and dis-
carded. At the same time England and the Papacy were
united in seeking the conquest of Ireland with the Norman
Invasion (1177 AD). Henry II of England was declared
sovereign of Ireland.

Fortunately for the Irish this was not a complete con-
quest of the country. Irish chieftains regained some of
their lands and castles. They reinstated native Irish cul-
ture, language, traditions and laws, and maintained them
for over 200 years, down to the sixteenth century. As part
of that Gaelic Revival, when Sheela carvings were
removed from the ancient churches, the Irish chieftains
retrieved them and placed them on their newly-built cas-
tles as a symbol of their right to sovereignty over their
own lands. Only in Ireland did the Sheela survive during
the Middle Ages when every other symbol of God in fem-
inine form had been eliminated from Europe and the
western world.

The Normans integrated into Irish society and mar-
ried into the families of the Irish aristocracy. They adopt-
ed the convention of the Castle Hag, placing newly-carved
Sheelas on the corner quoins of their castles. In this way
'the hag' on the castle wall became an architectural con-

vention in Ireland. By the seventeenth century, the symbol lost both its religious and its political significance, becoming merely 'a luck stone' for the owner and a hex on enemies. The individual name each Gaelic lord had for the sovereignty goddess has been lost in most cases.

The reappearance of the Sheela in modern times is an interesting and significant phenomenon. It is a synchronous event – marking the return of the feminine archetype of the Creator, Destroyer and Regenerator of Life just when this archetype is so desperately needed. Sheela is a gift to modern people from the ancient past. She functions as a psychopomp: a symbol capable of assisting in psychological and spiritual development. She is the gateway to the transformation of consciousness.[8] As the Prince who succeeded his initiation was rewarded with kingship, and the hag was transformed into the beautiful woman, the individual who contemplates this symbol becomes sovereign over self.

History explains how this archetype of the goddess of sovereignty over the land was lost to collective consciousness, and the effects of that loss on humanity. Psychology and present-day world events explain why it has reappeared: to wake us up during this age of chaos, of the Kali Yuga. It is time to end the five thousand year 'nightmare' of interminable warfare that until recently was thought to be the permanent condition of the human race. Not so! Archaeology,[9] mythology and modern scientific technology all reassure us that for thousands of years there really was 'an actual age of harmony and peace in accord with the creative energies of nature'.[10] This long-repressed aspect of collective consciousness has returned to redress imbalance because perhaps humanity is now ready to reintegrate the feminine principle.

Chapter 1

WHAT IS A SHEELA NA GIG?

The first official recordings of Sheela na gigs were made by nineteenth-century antiquarians. Normally dispassionate and scientifically objective people, they reported their discoveries in highly emotive terms, describing the carvings as 'ugly', 'repellent', 'immoral' and 'horrifying'. John O'Donovan, working for the first Ordnance Survey of Ireland in 1840, described the Sheela on the Kiltinan Church in Fethard, Tipperary as:

> ... a shockingly crude, naked female with splayed legs and fingers holding open a gaping vulva. Two odd breasts, one with two nipples, a triangular Celtic head and a pipe-stem neck ... whose attitude and expression conspire to impress the grossest idea of immorality and licentiousness.[1]

O'Donovan hypothesised a pagan origin. He thought that if it had been carved during Christian times 'it would owe its origin to the wantonness of some loose mind'.

Jørgen Andersen (1977), described the Sheela carvings as consistently ugly, '... as if lean ribs were not repellent enough, the Irish carver might add a tattooed pattern, incised or moulded[2] ... A streaking of the breasts down-

wards, an extremely horrifying form of pattern, or tattoo-
ing, presumably undertaken to produce a repellent
image.'[3] They shocked the sensibilities of the men who
described them.

> The distinct traits of emaciation shown by lean ribs,
> the ugly rows of teeth, or those shrunken limbs of the
> Sheela are all characteristics showing medieval carvers
> moving beyond naturalism into caricature, with the
> apparent aim of producing warped and witch-like
> looks. There is no reason to doubt the medieval origin
> of a sheela like the Fethard figure set against that
> authentic fragment of the fourteenth-century town
> walls.[4]

ORIGINS OF THE SHEELA

Some experts opt for a pagan origin, others for a conti-
nental Celtic origin. Over 70 years ago Professor
Macalister compared the Sheela at Tara to the god
Cernunnos, the Lord of the Animals.

> It does not look like a Christian figure at all. Rather
> does it resemble one of those strange fertility and luck-
> bringing figures, which occasionally grin at us even
> out of the sacred walls of a church to remind us that
> paganisms were scotched rather than slain when the
> new teaching spread through Europe ...[5]

However, Macalister himself pointed to the deficiency
of this interpretation, observing the Tara Sheela's legs 'are
not flexed in the Buddha attitude as in the representations
of Cernunnos which we possess'.[6] Much more likely the
pose is the age-old birthing position, with hands ready to

catch the emerging newborn.

Etienne Rynne also saw a likeness to Cernunnos[7], as does Dr Anne Ross in her description of the Sheela-like figure on the north pillar of the medieval high cross at Clonmacnoise Abbey:

> Several pieces of iconography in Ireland, late though they indubitably are, seemingly stem from this fundamental concept and emphasise the original presence of the cult of a horned god of the Cernunnos type in Ireland.[8]

PAGAN FEATURES

Like the Tara Sheela, the figures on Boa Island and on some High Crosses, pagan features turn up on what is otherwise identifiable as carvings of a much later date. For example the Sheela from Sierkieran, a fifth-century monastic foundation in County Offaly, has holes in the head that may have held antlers or some other headdress. The Sierkieran figure is unique in many ways: it has a number of holes deliberately made by the carver on the body. The carving is executed in red sandstone as are a number of other examples (red is the colour of

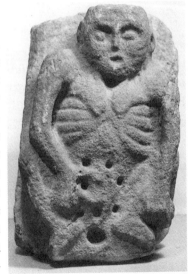

SHEELA NA GIG, SIERKIERAN, COUNTY OFFALY.

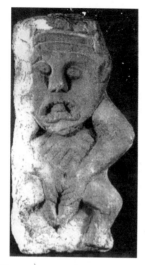 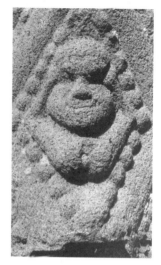

SHEELA FROM COUNTY CAVAN, with striped chevrons across her breast.

SHEELA FROM THE NUNS' CHAPEL, CLONMACNOISE, COUNTY OFFALY, who is positioned within the diamond shape symbol.

the goddess). Symbols used on megalithic carvings are also featured on the Sheela carvings, some featuring chevrons like that on the wall at Fethard, County Tipperary or the Sheela from County Cavan.

A MEDIEVAL ORIGIN?

Despite the fact that over two-thirds of all Sheela-type figures are found in Ireland, the majority of scholars and antiquarians have opted for a continental origin. Stella Cherry, in her monograph for the National Museum, states:

> Several types of exhibitionist figures were popular and were frequently carved on the churches along the pilgrim routes in France and Spain in the Middle Ages,

some as early as the eleventh century. It is thought that Sheela-na-gigs ultimately derived from these.[9]

The National Museum of Ireland classifies them as medieval, dating from the Norman conquest of Ireland, because they are mostly found on medieval castles and churches. But we must ask, if the Sheela was either Celtic or continental in origin, why are there so few examples from Celtic areas on the continent? Why did they have such a short-lived popularity on the continent and everywhere but in Ireland? Undoubtedly this symbol had greater significance in Ireland than in Britain or on the continent – a meaning that must stem from Irish religious and cultural beliefs.

WHERE SHEELAS ARE FOUND
Some of the best recent work in identifying Sheelas has been conducted by Jack Roberts and John McMahon in *Sheela na Gigs of Britain and Ireland.* Jack Roberts has also produced a very useful map, showing the locations with drawings of many of these carvings. Sheelas have been found at or near early Celtic monastic settlements in Ireland, Scotland, England, Wales and France. The greatest concentration is in the Irish midlands – an area that housed the largest number of early Christian monasteries. Many are found on twelfth- and thirteenth-century churches at these early foundations and one was discovered in a round tower (at Rattoo, County Kerry). A few are placed over church entrances, some are found inserted sideways on church walls – in what is known as the occulted position, and many are placed on the outer walls of medieval castles. A few, such as the Sheela at Tara, County Meath and at Stepaside, Dublin are carved on menhirs, or

standing stones, placed directly in the earth. Others are found in medieval town walls, on bridges or in outhouses close to castles.

In England, Sheelas have been found on 29 churches in Yorkshire, Shropshire and on the Welsh border, areas that were originally Christianised by Irish monks. They do not appear on churches built after the thirteenth century, however. Only one has been found on an English castle and one in a cave. Two are on bishops' tombs – one in Kildare, Ireland and the other in St Andrew's, Scotland.

THE ETYMOLOGY OF THE TERM, 'SHEELA NA GIG'

The name itself is as mysterious as the origin and meaning of these carvings. There appears to be no reference to the name Sheela/Síle/or Sheila in Old Irish texts down to the arrival of the Normans in the twelfth century, when many of the French Christian names were translated into Irish as Síle or English Sheila. Neither does the name appear in the oral tradition or in mythology.

The name has been spelled with many variations. Three variations of the name – Síle Ní Ghig, Sheela ní Ghig and Sheela Ny Gigg – were given by John O'Donovan in 1840. Sheela-na-gig was the form used by the Royal Irish Academy in its Proceedings (1840-44). This is now the commonly accepted spelling, although the hyphens are often omitted, according to James O'Connor.[10] Jørgen Andersen in his thorough work, *The Witch on the Wall*, spelled the word 'sheela' without a capital 'S'. The name will be referred to here as Sheela – the phonetic spelling of the Irish word Síle.

Sheela has as many names as she has transformations. 'Sheila na Guira' was the name given to the one at Cullahill Castle, County Laois, said to belong to Gillian

O'Dwyer, head of the O'Gara clan.[11] *Sighile Ni Ghadharadh* is the name of a poem by Tadhg Ó Súilleabháin, where Shighile is an allegory for Eire, once beautiful, but now despoiled, awaiting her salvation and transformation when the handsome prince arrives.

'Cathleen Owen' was the name given to the Sheela on Moycarky Castle by the local people of Thurles, County Tipperary, after the nearby river Owen. W.B. Yeats uses the name 'Cathleen ní Houlihan', the hag, the old woman of the roads, in his play *The Countess Cathleen*, as a symbol of Ireland itself.

Yeats captured the imagery of the goddess of the land, whose sovereignty has been taken from her and her people, wandering alone seeking the young men of Ireland to follow her, giving their blood to fight to free her land.

O'Connor lists various alternative names in the *Evil Eye Stone*: the 'Idol' (used in England in the eighteenth century), and the 'Castle Hag' was used by O'Donovan to describe the Sheela on the Rock of Cashel. Again, Síle na gCíoch is an Irish form of the name, meaning Julia or Celia of the breasts (paps).[12] The breasts refer to the fertility, the life-giving, pregnant qualities of the goddess (though the breasts are not emphasised in most carvings).

A derivation from Old Irish is proposed by Peter Berresford Ellis:

> ... *sileadh* (which is almost an approximation of the phonetics of sheela) which means 'generates', 'multiplies', 'propagates', 'spreads' – in other words ... a word connected with fertility which would well suit the concept of the image and its associations with the goddess of fertility, Brigid and hence the take-over of the pagan traditions by the saint.[13]

This derivation of the name as a goddess of fertility may seem to be inappropriate and contradictory since most of the carvings appear unattractive, ugly and forbidding and all emphasise the exaggerated pudenda. These carvings express the death and transformative aspects of the great goddess, which includes, but does not accentuate, the creative aspects. Herein lies the anomaly – through death comes new life. This is the Goddess of the earth in anthropomorphic form, changing and transforming with the seasons.

Linguistically, the first syllable of Sheela has the same sound as Sídh – the name of the sacred hill in which the Tuatha Dé Danann lived. The Tuatha Dé Danann are named Aos Sídhe, that is, the people of the sacred hill. In Irish folklore these people became fairies and dwelt in the Sídh – the fairy rings and forts. According to Sean Ó Duinn, Sídh may be cognate with the Latin *situs* meaning site or place.[14] Some Irish scholars connect the root *sí* with *suídh* or *suí* which means 'the place or habitation of the gods'. There would seem to be a linguistic connection between the root sound, 'sí', and the fairy people, as the goddesses of the older religion were called.

A final observation, and one that may be most relevant, is that the name Sheela (with the same spelling) is a very common name for girls in parts of India – and an ancient one also.

THE ETYMOLOGY OF THE WORDS 'NA GIG'
'Na' is the genitive case in Irish meaning 'of the'. 'Gig' is not readily identified – it is not an Irish word. Some scholars attribute the word to the medieval period, to a dance originating in Shakespearean England. 'Gig' or 'jig' would certainly describe the jigging Sheela on Kiltinan Church in Fethard, County Tipperary and the one of Ballaghmore

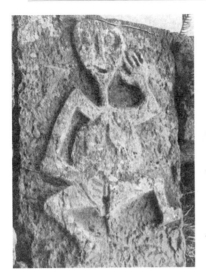

SHEELA ON KILTINAN CHURCH IN FETHARD, COUNTY TIPPERARY. Note the stove pipe neck, triangular pagan head, staring eyes, upraised arm, supernumary nipple on the left breast and the emphasised pudenda – all symbolic of the goddess.

Castle, Laois. The Kiltinan carving, stolen a few years ago, had one arm raised above her head, one leg lifted high in the air as if she were dancing. The Ballaghmore Sheela appears to have her hands on her hips, one leg raised as if dancing.

A CONNECTION WITH SANSKRIT?

Linguists have noted that Old Irish retains more of the original Indo-European root words than any other Celtic language, and in a purer form.[15] Scholars have noted a similarity between Old Irish and classical Sanskrit.[16] This common origin in the languages linked Ireland to India, and a culture that stretched back over 4,000 years, before the advent of the Indo-Europeans (a misnomer). Could there also be a connection with the gods of India, so many of whose names ring with similar phonology to the goddesses of Ireland?[17] One of the earliest references to the name appears on a British naval vessel: the *Sheila nagig* registered some time before 1780. This was the period of the Raj and of great prosperity of the East India Company. A

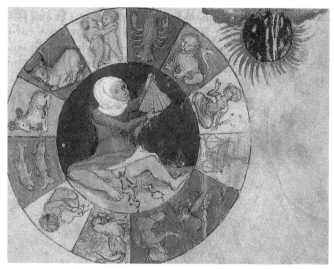

A MEDIEVAL SYMBOL OF EARTH surrounded by the twelve signs of the zodiac. Note the earth mother 'ghee' flowing from her vagina – symbol of her creativity.

glossary of Anglo-Indian colloquial words and phrases does not mention Sheila nagig but does list the name 'Naga', a clan in the southern mountains of Assam partly taken over by the British. 'They have light brown complexions, are well built, but treacherous. They go about naked like beasts.' Also, 'the etymology of 'Naga' is still disputed; some identify it with the Snake Aboriginals in the legends and sculptures of the Buddhists'.[17]

A SANSKRIT SOURCE

Another explanation of the word 'gig' fits in with the emphasis on the generative organs and gives a Sanskrit origin to the word. Sanskrit 'ghee' refers to butter, a precious fat, a substance vital to life and also used in Hindu and Buddhist religious rituals. In southern India, at the Temple of Meenakshi in Madurai, newly-married women

still rub ghee on the statue of a Yakshi, praying to conceive and be fruitful, in rituals that have remained the same for over 3,500 years.[18]

The image of medieval alchemy encapsulates the connection between the great earth mother and the generative organs. As illustrated here, several Sheela carvings display ghee flowing from the goddess' vagina. Ghee represents the feminine life force and the ability to generate. There does not seem to be a word in English for this lubricating substance, other than crude slang.

In Ireland, from earliest times down to and including the early Christian period (c. seventh to eighth century), the holy women, nuns and midwives, always had a sacred white cow whose milk was used to heal and to baptise newborns, and whose butter was used for healing. This fat may also have been used in keeping the eternal flame lit in St Brigid's of Kildare (a custom that relates back to the goddess rituals).[19]

Archaeological materials are not mute – they speak their own language and their symbols can be deciphered, according to Marija Gimbutas, one of the outstanding archaeologists of our time and an expert on matrifocal civilisations.[20] Tracing the Sheela may unravel the spirituality of those of our ancestors who predate the Indo-European by many thousands of years.

Study reveals that the origins of the Sheela symbol lie not in France, England or Scotland, but in ancient pre-Celtic Ireland, and have been incorporated into subsequent cultures and religions on this island. The source of these carvings can be traced back to a goddess religion practised before patriarchal religions surfaced. Sheela carvings are symbols of the Divine Hag of the Celts, the source of life, death and regeneration.

Chapter 2

SHEELA – SYMBOL OF THE GODDESS

L ike all the earliest known cultures around the world, the people of Ireland worshipped God as the Great Mother,[1] the source of all creation. From the Palaeolithic through the Neolithic and Megalithic eras (40,000 to 2,800 BC) God was symbolised as the Great Goddess of life, death and regeneration. The earth was the body of the goddess and the female body was worshipped in an embodied religion, in which the body of the goddess, the earth and the female body were all revered and celebrated.

The Great Goddess, a unified deity, represented divine energy and power – the *neart* (in the Irish language) that permeates all life. There were many aspects to her nature, reflecting the ever-changing circumstances of life itself: at times she appeared as the fertility goddess; sometimes she was pregnant or in the act of giving birth. In other instances she took the form of the goddess of sex, death, transformation and rebirth. Different Sheela carvings portray various aspects of the goddess.

IRELAND'S MATRIFOCAL CIVILISATION
Although a great deal of the surface evidence of goddess civilisation has long since disappeared, six sources still proclaim her presence in Ireland: 1) megalithic archaeology

and symbols; 2) topographical features of the land and the elements of water, earth, fire, air; 3) place names; 4) mythology; 5) folklore; and 6) language/linguistics.

1. Megalithic Archaeology and Symbols

Numerous archaeological and anthropological discoveries point to an ancient worldwide worship of God in female imagery. Evidence comes from shelters and caves of the Cro-Magnon people of Palaeolithic Europe (40,000 BC) from the near east to the northwest, 'the same goddess religion [extended] to all these regions as a cohesive and persistent ideological system'.[3]

In Old Europe, anthropomorphic carvings and rock paintings of the Great Mother have been discovered dating back to 25,000 BC, when the first sculptures of bone, ivory and stone appeared.[4] These carvings depict a naked goddess, often pregnant. Over thirteen per cent of the carvings were found in caves and on ledges of rock in the French valleys of the Dordogne, the Vezere and the Ariege. They have been found in the earliest Neolithic village sites of Europe (c. 7000-3000 BC).

Excavations at Catal Huyuk, Central Anatolia (c. 6400–5600 BC) reveal a highly developed goddess civili-

SYMBOLS OF THE GODDESS: chevrons, symbols of protection, and the diamond, symbol of the yoni. On the underside of this stone at Fourknocks, County Meath, is a carving of the spiral with head and legs – symbols of the goddess.

19

sation and at Achilleron, Thessaly, some of the earliest European temples are found (6000 BC). At Malta (4000-2000), in Ireland (*c.* fourth millennium BC) and the Orkneys and on the Shetland islands of Scotland (*c.* third millennium BC), the continuation of advanced and sophisticated civilisations have been uncovered, based on a goddess culture and religion, long before the development of religions based on God the Father. The signs, symbols and themes indicate '… a religion in veneration both of the universe as a living body of a Goddess-Mother-Creator and of all the living things within it as partaking of her divinity'.[5]

From around 30,000 to 3000 BC (the period lasted longer in Wales, Scotland and Ireland), the evidence points to an ancient worldwide social system organised around the life-giving qualities of fertility of the land and people in mother-centred communities that functioned in harmony with the rhythm of the changing seasons of the year.

People lived in fixed settlements across Europe during the Neolithic period (after 7000 BC), tilling the land and keeping domestic animals. They were concerned with physical survival, food production, fertility, the family and tribe. The Great Mother – the source of all life was also the reaper. Society was organised around the worship of the Great Goddess, guided by a queen, assisted by a council of women.

In Europe, Anatolia, Minoa, Greece, Etrurea, Rome, the Basque country and the islands of the north west there was a balanced social system, neither patriarchal nor matriarchal, in which women as heads of clans or queen priestesses played a central part. Mythologies, folklore and religion during this long period show (according to Marija Gimbutas and other archaeologists), European cultures

continued a peaceful existence, reaching its zenith in art and architectural development in the fifth millennium BC.[7] Matrifocal societies were preserved longer in Ireland and the Orkneys than in Central Europe.

When communities became more settled they built grandiose megalithic temples to the goddess on the earth, using large stones forming the shape of her body. Examples are found at a number of sites in Ireland, such as those in Sligo at Creevykeel and Newgrange in Meath (fourth millennium BC). Gimbutas gives these and other examples as evidence.

2.) Topographical Features of the Land and the Elements of Water, Earth, Fire, Air
THE GODDESS AND HER ASSOCIATION WITH WATER
The most ancient words in the Irish language describe water features such as rivers, lakes, wells and seas. Throughout Europe the names given to waters are feminine in gender: they symbolise the waters of life – the goddess' watery womb, the milk that flows from her breasts, and the ghee – a symbol of her fecundity.

The rivers of Ireland, like rivers across the continent[8] bear the names of the Great Goddess in her different guises – the Shannon – longest river in the country – is named after Sinann, 'yellow-haired goddess of the Tuatha Dé Danann, yearned for and sought after, the secrets of magic wisdom';[9] the Erne, 'a maiden from Rathcroghan [the royal seat of Connacht] who was synonymous with the river Erne';[10] the Boyne, named for the goddess Boann – a reference to the cow goddess.

Holy wells are associated with the goddesses, mainly with Brigid[11] and some with Sheela[12]:

For the pagan Celt, the essence of the universe and all its creativity was female. The mother goddess, and all her personifications of fertility, sovranty [*sic*] love and healing, was an essential basis of their very role in the world.[13]

According to the mythic genealogies of Ireland, the goddess Cessair led the first people to inhabit Ireland. She symbolised water – arriving as she did out of the seas with her small group of 50 women and three men.

Symbols of water are found at the earliest archaeological sites: symbols of water expanses, streams and rain such as zig-zags, meanders, wavy or serpentine forms, chevrons, net checkerboard and water fowl – all refer to the generative forces of nature, just as water flows through the land, providing life and growth.

THE EARTH IS HER BODY
The shape of mountains and hills evoked feminine names: the Paps of Anu, near Killarney, where the mountains are shaped like her breasts and her pregnant belly, attesting the beauty and power of 'the Great Mother of the gods'. The

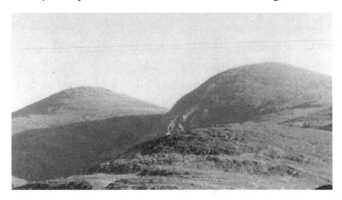

THA PAPS MOUNTAINS, NEAR KILLARNEY, COUNTY KERRY.

Hill of Allen in County Kildare was named after the goddess Almu; KnockAine or Knockanny (the Hill of Áine) in County Limerick and Knocknarea 'the Hill of the Queen' in Sligo are two further examples. A cairn on top of the latter is said to be the tomb of the goddess Maeve (Medb) (not to be confused with the Queen of Connacht whose army fought Cúchulainn and the men of Ulster). Slieve na Cailli, another name for Loughcrew,[14] in County Meath means 'the mountain of the Hag or Nun' (hag is derived

COURT CAIRNS, MEGALITHIC TOMBS. *Large stones were used in western European grave architecture to construct the entire body of the goddess. Ireland abounds with cairns or earthen mounds under which lie Neolithic passage graves. These drawings of the plans of Carrowkeel, County Sligo, illustrate the placement of the large stones in the shape of a body (c. 3500-3000 BC).*

from Greek *hagia* meaning 'holy'). Slieve na mBan in County Tipperary means 'the mountain of the women'.

These mountains are visible symbols that can represent the Great Mother's breasts, and the rolling hills represent her fruitful belly. The 'Cat Stone' on Uisne hill outside Mullingar, County Westmeath represents her umbilicus at the centre of her body and the symbolic centre of the country.

The natural cave evoked connotations of the womb of the goddess. Man-made grave architecture as found in Ireland and north-western Europe depicts, in stone, the body of the goddess. Caves together with bodies of water such as Lough Gur in County Limerick and Lough Derg in Donegal symbolise the moist womb where all life begins. Crags such as the Shannon Pot in County Leitrim (where the River Shannon rises) represent her vulva. At death all life returns to the womb (the tomb), to be transformed and renewed in a never-ending cycle. To be aligned with nature was to be in touch with the goddess who ruled over life and death.

THE GODDESS OF FIRE (LIFE FORCE – SEXUALITY)
Celtic peoples across Europe worshipped Brigid as the goddess of fire. The Irish name Brighid means 'fiery arrow', coming from Sanskrit *brihati* meaning 'the exalted one'. In her cosmic role Brigid was the goddess of the sun, the moon, of fire, divination and the laws of nature. She was the goddess of knowledge – of medicine, herbs, mid-

BRIGID CROSS: DIAMOND SHAPE. This was a symbol of the sun and of solar cults. The sun was a symbol of the goddess. Diamond shapes are also symbols of the yoni and 'the eye of the goddess'.

wifery and healing wells.[15] She was goddess of arts and crafts: smithing, spinning, music, poetry, and also of animal husbandry, dairying and food production. Finally she was the goddess of the art of war, but a different sort of war: she was able to change the course of war by using her magic skills of compromise and negotiation.[16] Brigid is in fact, more than a goddess of fire, she is an amalgam of all the ancient goddesses, like the great Hindu goddess Parashakti, who encapsulates all the attributes of all the lesser goddesses. All is one.

SEXUAL FIRE

The goddess Maeve (Medb) is another manifestation of the fire energy of the female deity. By her energy she empowered the king. Early records describe the rituals of inauguration of the high king as the *bainis rí*, the ceremony at which the rightful king had first to mate symbolically with the goddess Maeve – the titular goddess of Tara. The king, as husband of the goddess of the land, was her mortal consort. The ritual of inauguration required that the woman representing the goddess offer a goblet 'of mead'[17] (the same word as Medb or Maeve – meaning 'intoxication' or 'frenzy') water, or blood to the king. By accepting it and drinking it, he promised to look after the land and all the people. The second part of the ritual (which has associations with rituals from Mesopotamia of the third millennium BC) was mating with the goddess. This sacred contract earned him the title to his position or 'seat' (the *rígh-shuidh* or king-seat), as the guarantor of peace, prosperity and fertility to her land and her people:

Underlying the multiple functions of the Irish goddess is one phenomenon: her superhuman sexuality. By

having intercourse with the hero, the goddess of war/sovereignty transmits to him, in an active manner, her energies of kingship and war. Far from being a negative manifestation of lust, the Sheela – just as the Irish goddess – is sacred. She both energises and protects the people who occupy her land. In the bestowal of energies through her huge sexual prowess, she manifests her complementarily huge sacrality.[18]

According to ancient tradition, if the king did not live up to his promise to protect and provide for the land and people the goddess divorced him and famine and pestilence followed. Any king who gave a false judgement had to resign so that the land might be saved from the retribution of nature.[19]

THE GODDESS OF SOVEREIGNTY
Tara was the sacred spiritual centre of the goddess long before it was taken over by the political sovereigns (in the first century AD). The goddess Maeve was served by an order of priestesses at Tara. Among the duties of the priestesses were the performance of rituals to ensure peace and prosperity, somewhat similar to the Vestal Virgins of Rome. Though much has been recorded about the historical period of the High Kings of Tara, very little survives about Tara as a centre of the Council of Women that existed there before it was taken over by the Milesian kings.

BRIGID CROSS: THE BOGHA BRÍDE.
An unusual type, made in the south west
of Ireland. It is a circle surrounding
an equal-armed cross, and is a symbol of
the sun wheel. This shape is known
as the Celtic Cross.

Tara was a spiritual centre, like the other great spiritual centres that were all taken over by the Milesians as the seats of their political power.

THE ELEMENT OF AIR

Air signifies the breath of life, the power of the spoken word, the quality of intellect that puts human thinking and communication at a higher level than that of any other living being. Air signifies the human qualities of intelligence, communication and knowledge. It completes the four elements. The goddess, with her intellect and intuition, sees through both illusion and deception. They are recognised and attacked. Bird goddesses represent this element: the crow and raven are destructive, the eagle is far seeing and the dove is the messenger of peace from heaven to earth. Brigid brought the light of the sun – representing clarity and reality. Down to the present day, Brigid crosses are placed inside the front door of Irish houses as a blessing on the house.

3) Place Names and 4) Mythology

The conservative nature of the Irish in retaining place names over millennia has ensured the survival of folk memory and this has greatly assisted in the maintenance of the association of historical and mythological events within their geographical contexts.[20] The places described in the saga *Táin Bó Cuailnge* (The Battle Raid of Cooley) have facilitated a complete reconstruction of the events. Archaeological digs have verified that chariots and other equipment, thought to be poetical inventions, were indeed used by the warriors of the time.

Inevitably, some ancient place names were lost due to successive colonizations of the country by Christianity, the

Vikings and the Normans. The village of Holy Cross, in County Tipperary, for example, was originally known as *Baile na gCailleach*, 'the settlement (convent) of the veiled ones, or nuns, near KnockAnny (the hill of the goddess Áine) in County Limerick'.[21] The name was changed to Holy Cross in the eleventh or twelfth century when a continental order of priests set up a monastery there. Some local signs still proclaim the ancient name, though the nuns have long since vanished. Another instance is Éire, derived from the goddess Ériu, who represented the sovereignty of the country. According to the myths, she extracted a promise from the Celtic conquerors that her name would remain the name of this island forever, and so it has. Éire is the name of Ireland in the Irish language.

5. *AND* 6.) *LANGUAGE AND LINGUISTICS*

Linguistic connections to the Goddess are discussed in Chapter 1 as well as the present Chapter, and where mythology leaves off, folklore takes over in the stories, traditions and superstitions of the ordinary people.

Recent excavations in Counties Mayo and Wicklow uncovered evidence of communities living on this island as long ago as 9,000 years ago.[22] Carbon dating of bones and other artefacts at Carrowmore, County Sligo (the most extensive megalithic complex in Europe) has established that it was a thriving centre as long ago as 5400 BC.[23]

CARROWMORE, COUNTY SLIGO – A BIRTHING CIRCLE?

There are reputedly no carvings at stone circles found throughout Ireland. However, there is an interesting stone in one of the circles at Carrowmore 'one of the largest complexes in Europe'. Although Carrowmore is termed a 'cemetery' it was used 7,000 years ago as a ceremonial and

ritual centre. The various circles probably had different purposes. The stone circle in the photographs below is positioned with an uninterrupted view of Knocknarea in the distance. One of the stones has a feature that looks like

CARROWMORE, COUNTY SLIGO AND KNOCKNAREA
with the goddess Medb's cairn (tomb) on top.

This stone circle has an uninterrupted view of Knocknarea. It has an inner circle or small chamber, perhaps one of the earliest examples of the maternity ward. Birthing took place in the open under the supervision of the 'wise women' midwives, and no woman died in childbirth during the reign of the rightful king, according to ancient texts.

an incised carving of a pregnant woman. Perhaps it is an accidental rock formation. If so, it may have been the reason for our ancestors to include that stone in the circle, which may have been used in the birthing ritual. Interestingly, recent excavations found only one burial within this circle – and the bones were those of a premature baby.

According to myth and folklore, women in Ireland gave birth in the open – in sacred places designated for that specific function. In the descriptions of the reign of a good king, childbirth was not painful, nor did women die in giving birth. The knowledge of midwifery (of which Brigid was patron) may have included the use of herbal sedatives, such as the psilosylin mushroom, which often grew around the birthing areas. A ritual fire was built surrounding the newborn and its mother, and the child was baptised with milk from the holy woman's sacred white cow. Many of these rituals are associated with St Brigid, who was invoked by all birthing mothers in Ireland. It was the custom to put a Brigid's cross under the pillow of a woman giving birth. Interestingly, the Brigid crosses contain the lozenge – symbol of the goddess – a sign of fertility found all over Old Europe – in the Aegean area (c. 6300 BC). The same lozenge symbol appears at Newgrange, and at Four Knocks, both in County Meath.

NEOLITHIC TEMPLES TO THE GODDESS IN IRELAND
Tombs shaped to resemble the generative organs of the goddess have been dated as far back as Palaeolithic times in parts of the world: there is evidence of narrow passages, oval-shaped areas and clefts and small cavities of caves were sometimes painted red – the colour of the regenerative powers of the goddess.[24] Like the seed buried in the soil,

the bones of the dead were placed in the womb of the goddess. When the sun penetrated the inner chamber it was believed life would be regenerated.

NEWGRANGE

Newgrange has recently been classed as one of the treasures of the world. It was built around 3200 BC (700 years before the Great Pyramid of Egypt) by master astronomers/architects with such precision that the sun to this day penetrates the inner chamber through a long passage and hits the carvings on the rear wall at the winter solstice – just as the builders planned over 5,000 years ago.[25] Newgrange is built on an earth energy line that links up with Stonehenge in England, Carnac in France and the Great Pyramid in Egypt. From Newgrange that line continues to Croagh Patrick in Westport, County Mayo – anciently known as *Cruachán Aigle* – a place once sacred to the goddess.[26]

The interior of Newgrange is anthropomorphic –

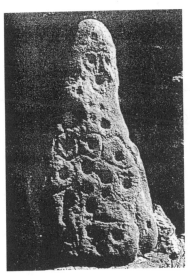

CUPMARKS AND WELLS - the eyes of the goddess. These are found on large rocks throughout Europe, particularly in the west and north, on anthropomorphic stones. The holes are metaphors for the eyes of the goddess which see all, and water collects in them, symbolising her provision of the water of life.

TRIPLE SPIRAL AT NEWGRANGE, COUNTY MEATH. The number three is very significant in the symbology of the goddess. The imagery of constant change and movement, inwards and outwards; of the constant change of life – birth, maturity, old age, death, transformation, rebirth.

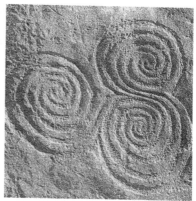

shaped like the female generative organs: a long narrow passage resembles the birth canal, leading into the main chamber, like the womb with the two side chambers to resemble the ovaries. Newgrange was constructed to resemble both tomb and womb. The corbelled roof, made of great boulders, ensures that no rain or dampness ever reaches the chamber.

There are many myths connected with Newgrange and many theories regarding its purpose. No doubt its use changed with the successive cultures and religions but the purpose of the structure was both spiritual and cosmological.

SYMBOLS OF THE GODDESS

Symbols associated with the goddess – spirals, vulvas, triangles, breasts, chevrons, zig-zags, meanders and cupmarks – are found at Megalithic sites in Ireland and around the world as early as Palaeolithic times.[27] Mesolithic and Neolithic gravesites and living quarters reveal her presence. Prehistorians have found her images and symbols – in Europe, Africa, Australia, New Zealand, Siberia and the North American Arctic, as well as in Eurasia.

Gimbutas observed that symbols are tied to nature and

therefore must be studied in context and with their associations in order 'to decipher the mythical thought which is the raison d'etre of this art and the basis of its form'.[28]

Newgrange is rich with carvings that are associated with goddess cultures throughout the world. Spirals and cup marks are found carved on megaliths, both inside the chamber and around the outside. One of the most famous of these is the triple spiral snake coils at the entrance stone. Spirals denote the changing energies of life and the three may indicate a triple life source. They may symbolise the triple goddess – Maiden, Mother and Crone; or birth,

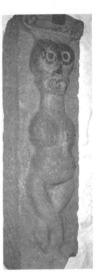

THE CAT GODDESS AT THE ROCK OF CASHEL, COUNTY TIPPERARY This is not a Sheela, but she is a symbol of generativity and abundance.

maturity, and death/regeneration.

Archaeologists, anthropologists and researchers of goddess civilisations all observe the threefold aspect of the goddess. She symbolises A) the generative force of nature, B) the destructive force and C) the regenerative force. Within the one is the potential for the others. All these divisions, categories, functions and symbols were united in the one deity that symbolises all of nature.[29]

A) SOME EXAMPLES OF SHEELA REPRESENTING THE GENERATIVE FORCE OF NATURE
This aspect of the goddess is often depicted as pregnant, propagating, birth giving. She is symbolised by the lozenge, the circle, water, the cow, milk, fires, healing, smithing and

weaving. The Irish goddesses that fulfil these functions are Anu, Brigid, Cessair and Gobnait (Gob = mouth; -ait = the feminine suffix). Carvings such as the Iona Sheela and the carving of the pregnant, full-breasted Cat Goddess at the Hill of Cashel, County Tipperary, are strongly evocative of the goddess of fertility. They represent the life-giving aspects of the goddess.[30]

THE GODDESS AND HER DIVINE SON

A later development of the generative function of the goddess was the portrayal of the mother goddess with her divine son. During the age when the religion of Egypt worshipped the goddess Isis and her brother-consort Osiris, she is often depicted holding her son Horus, in much the same manner as Mary holds Jesus in medieval and modern carvings. There are many similarities between the cults of Isis and that of Mary – both gave birth to the divine child, both are linked with the moon and Mary is often depicted standing on the moon, a primordial symbol of the goddess. Isis was a star goddess, and one of Mary's titles is 'Stella Maris', Star of the Sea. Both are seen with

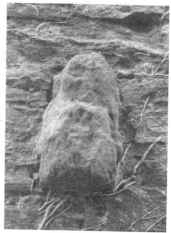

ANCIENT SHEELA ON THE THIRTEENTH-CENTURY CISTERCIAN ABBEY IN ABBEYLARA, COUNTY LONGFORD, the only Sheela that is displaying a baby at her womb. The Cistercians replaced the earlier Celtic church but kept the symbol of the Great Mother because of the devotion of the people.

34

serpents – Isis with her headdress in the form of a cobra's head and Mary standing on the orb of the earth with her foot on the head of the serpent. The serpent was a symbol of the power of the goddess to regenerate.

THE SHEELA AT ABBEYLARA, LONGFORD

An excellent example of a Sheela with child is on the ruins of the thirteenth-century Cistercian Abbey at Abbeylara. The carving, though deeply incised, is very old and most probably predates the twelfth-century church. It may have come from nearby Kilbride (the cell or church of Brigid). The carving displays a baby in the womb of the Great Mother – it is more like a homunculus than a newborn. The place is known as St Mary's Abbey – an example of the custom that set out to replace the cult of Brigid with the cult of Mary in the Middle Ages. Brigid had become known as 'Mary of the Gael' and 'the midwife of the Blessed Mother'.

The goddess not only preserves, she protects and delivers from harm – opposing those who dishonour her, inspiring fear in those who have not made their peace with her. As the deliverer, she liberates, guarantees victory over enemies and ensures peace. The Lord's Prayer, translated from

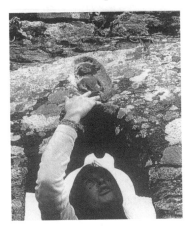

THE RITUAL OF TOUCHING THE PUDENDA OF THE SHEELA at St Gobnait's, Ballyvourney, County Cork, on 11 February, which is supposed to bring fertility.

the original Aramaic, begins: 'Our parent, father-mother god, creative force of the Universe ...'[31] Roman Christianity rejected all credence in the feminine as divine, although the symbols of Mary were the same symbols as those of the goddess of generativity.

THE SHEELA AT BALLYVOURNEY, COUNTY CORK [32]

A further symbol of the Generative Mother is the carving over the window of the medieval church at St Gobnait's Abbey in Ballyvourney. Gobnait's feast day is on 11 February, linking her to Brigid and the festival of Imbolc. An object of great veneration, this carving is not crouching, but standing. Every year thousands of people flock to Ballyvourney to pray for cures. Women who are unable to conceive rub the genital area of the carving, taking rubbings of the stone in their handkerchiefs and drink them in water.

The historical Gobnait, like St Brigid, was an abbess who lived during the sixth century. Gobnait was trained by St Enda on the island of Inis Oírr (on the Aran Islands) and her first establishment was at Séipéal Kilgobnait. The first convents of the Celtic Christians were run by abbesses, but even at that early date it was recorded that the nuns at Ballyvourney lost their autonomy when a priest was assigned to be chaplain and Gobnait was made subordinate to him.

A wooden carving of the Madonna, badly worn and probably dating from the twelfth century, is in the safekeeping of the local Catholic Church. The statue used to be paraded through the village on the feast day of Gobnait, but is now venerated at a mass on her feast day. The carving is similar to the Black Madonnas brought back from the East by Crusaders. It may have been brought to

Ballyvourney by the Knights Templar whose duty it was to guard the pilgrimage routes. A Templar cross is carved on the side of the same medieval church that has the carvings of the Sheela and the Hag or Crone.[33]

Today's pilgrim touches the statue with a ribbon which is taken home to be used to heal family and livestock. This ritual is reminiscent of one practised at Imbolc, when a cloth or a cloak is spread on the branch of a tree or on the ground on the eve of Brigid's Day. The dew that collects on the material is supposedly endowed with special healing properties – and that cloth is used as a protection and healing for the family and its possessions during the year.

THE HAG AT BALLYVOURNEY

A third feature at Ballyvourney that makes it unique amongst the sites where Sheelas are found is a carved head of the Hag over the arch leading to the high altar inside the medieval church. Local superstition says this is a man who tried to invade the abbey and who was turned to stone. However, comparison of this carving with the Hag at Clanaphilip Church in County Cavan demonstrates the same strongly marked ridging across the face, in the form of chevrons, a symbol of the goddess.

The presence of all three aspects of the goddess at Ballyvourney – Sheela, Madonna and Hag – makes it the only centre in Ireland and perhaps of all the places where the Sheela now remains, to have preserved the tripartite aspects of the goddess – maiden, mother and crone.

Ballyvourney has other symbols of the goddess. A modern statue of St Gobnait includes carvings of bees and deer on the plinth. Bees are the symbol of prosperity, fertility of the land, and of honey – the fruit of a good summer, flowers and herbs and the co-operation between bees

and beekeepers. The bee is the symbol of regeneration and 'an epiphany of the Goddess of Regeneration'.[34] The deer or doe is a symbol of love, of the primeval mother – a transformation of the birth giving mother'.[35]

The hagiography[36] of the saint explains she had been instructed from on high to establish her convent only at the place where she would find nine white deer. After extensive journeying around the country she discovered these deer at Ballyvourney. According to Druidic terminology this could imply that women set up a group at Ballyvourney who were Druidesses capable of shape shifting, that is, changing their appearance. One of the hagiographies of St Patrick reports that he could turn himself into a white deer.[37] Similarities cannot be overlooked to the Greek and Roman goddess Artemis (Diana), and the Scottish deer goddesses who could turn into women having the power to shape shift. (In the tradition of the goddess – white, not black, is the colour of death.)

B) SYMBOLS OF DESTRUCTION – SHEELA THE CRONE

Animals such as the boar, and birds like the owl, raven and crow were symbols of the destructive, war-like, death dealing side of the goddess. The owl goddess, with radiant eyes of the deity, sees all. Owls are seen on pottery at tombs (Dowth, County Meath 3200 BC) and on megalithic tomb carvings – at Sess Kilgreen, in County Tyrone (3000 BC).[38] Similar carvings are found in Spain about the same period.

The destructive force of the Great Goddess represents the chaotic and annihilating urge of nature, with a twin appetite for sexual gratification and for causing violent death. The triple goddesses were known collectively as the Morrigna. They functioned as goddesses of war and destruction, appearing as a raven or crow. Morrígan

(whose name means Great Queen or Great Phantom) was the first, and the second, Badhbh (whose name means rage, fury, and violence), was also called Scald Crow, the devouring bird that eats carrion. The third goddess was called Macha. These three hags followed the armies into battle, screeching and spurting fire, confusing the warriors and putting spells upon them, causing them to lose their battle-strength. The Morrigna follow Cúchulainn as a Raven – promising him great triumphs and also an early death. They shape-shifted to become the vulture, the raven and the crow – symbols of the devouring, eliminating aspect of the goddess.[39]

The destructive goddesses are found in the earlier myths concerning the Tuatha Dé Danann, but in those myths they are not warriors. They adopted shape shifting and worked directly on the emotions using magic, as in the First Battle of Moytura, where they repelled the Fír Bolg through their use of magic.[40]

Since the dark aspect of the goddess was removed from religions, western people have difficulty understanding the psychological function she represented.

> The goddess may appear in wrathful or challenging forms, but these should not be considered as hostile. She is the kernel of truth at the heart of everything ... The old outworn, dualistic concept of the goddess as cruel and capricious must be viewed for what it is: a reflection of the shadow side, a terrible polarisation of social responsibility with which women have been burdened as a sex.[41]

Sheela inspires the fear of destruction, but she brings change, transformation and renewal. With the archetype of the Sheela present to his consciousness, the Celtic warrior had learned not to fear death, where he would sim-

ply sleep in the womb of the Great Mother until such time as he would be regenerated. It is only through the disintegration of the old that re-integration at a higher level can take place. Sheela was the gateway to that transformation.

Like her counterpart Black Kali[42] (the central deity of the ten Hindu goddesses) Sheela is outwardly fearsome, but underneath she is pure ecstasy, beyond all ideas of positive and negative. Kali, her face with three eyes and contorted with a hideous laugh, stands on the funeral pyre in which the 'world' is reduced to ashes, but she is herself pregnant with the potential of re-creation.

THE WITCH ON THE WALL

At times, particularly during the later Middle Ages, the Sheela appeared to symbolise old age, starvation, hopelessness and fear. The 'witch' on the wall of Fethard town in Tipperary is a good example. Like Dhumavati 'the smoky one', she is thin, grim and slovenly. Her body and eyes are crooked. Like Dhumavati this Sheela looks as if she is tor-

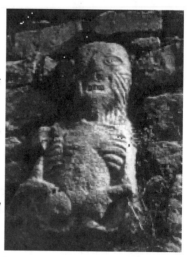

THE SHEELA AS HAG AT FETHARD, COUNTY TIPPERARY, showing symbols of the goddess: chevrons on her left cheek, the staring eyes, the striping of the chest, the open mouth with teeth exposed in a grimace. Though representing a fearsome old hag, at the same time her distended belly and umbilicus speak of the potential for regeneration.

40

mented by hunger and thirst and existing at the lowest possible level:

> ... it is she who generates that stage of being where individuals forget their origin, lose contact with their source, and suffer continually the agonies of unsatisfied appetite and defeated hope.[43]

The Sheela on the fourteenth-century town wall of Fethard, County Tipperary, may have come from an earlier period, like the one at Fethard Abbey, nearby. This carving has chevron symbols on her face, and the big staring eyes of the owl goddess. There appears to be a gash on her right cheek. The skinny arms and protruding ribs indicate poverty and old age – they too are symbols of the goddess of death. However, her belly is pregnant, the umbilicus prominent (another symbol of the goddess). This Sheela is one of the best examples of the symbolism of the goddess – death in life and life in death.

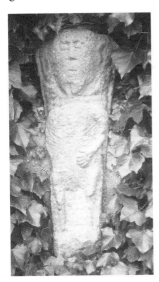

SHEELA AT THE AUGUSTINIAN ABBEY, FETHARD, COUNTY TIPPERARY. Note the striping on the ribs, the large triangular face and big ears of the pagan examples. This Sheela was inserted in the wall of the Abbey and may previously have been a standing stone.

The end of a year, or of a life cycle, is not literally 'the end'. Kali, the crone and the Sheela symbolise the ability to devour the old and to transform – to be pregnant with the potential for re-creation. This concept is borne out in the rituals for the first day of November – Samhain [*sauahn*], the Celtic New Year, to ensure the fruitfulness of life during the coming year:

> ... the ritual fire of Tlachtga [the Hill of Ward in County Meath] was lit on the eve of Samhain, when the Druids of the four provinces of Ireland gather there to offer sacrifice to all the gods. It was at that time that they used to burn their victims.[44]

The victims were usually the prisoners of war taken in battles during the year and saved for this occasion. The offering of human sacrifice as a propitiation to the gods was performed all over Europe and in Mayan and other civilisations in the Americas.[45]

C) THE REGENERATIVE FORCE

The final stage in the growth process is enacted by the goddess: she regenerates, providing integration and sovereignty over self-wholeness. Irish mythology is replete with regenerating goddesses: Ériu, Banba, Fotla, Medb, Macha, and Brigid are a few. This is the stage of empowerment, arising from the experience of having gone through all the earlier transformations. Our Lady, Seat of Wisdom (Sophia) performs this function in the western world; Kamala the lotus lady and Shakti are goddesses of integration and wisdom in the Hindu tradition.

The Great Goddess – the exalted one, was the Creatrix of all life – her realm included the entire cosmos. All the

functions of the goddess represent aspects of the total qualities of that deity. She was a reflection of the cultural and spiritual life of the peoples who worshipped her, the source of perpetual renewal, supplying all their needs and hopes, inspiring their value system.

The psyches of men as well as women mediate all the aspects of the goddess. They describe the psychological energy systems within human nature and are neither good nor evil – some are 'dark', some 'light'. On some occasions the 'dark' side needs to be expressed as a protector or a challenger, destroyer of the old and outworn, or as the empowerer, in order to elicit further development and enrichment of the personality.

For tens of thousands of years feminine symbols represented the universal life force known as God. For the past 3,500 to 4,000 years, masculine imagery has represented God. All thinking people know that the source of all creation is neither male nor female, but the choice of imagery has had the effect of unbalancing the psyches of individuals and of civilisation. A balance in the symbolism of the archetypal force that represents God needs to be brought into the consciousness of every man, woman and child so that humanity will not destroy our Earth Mother. The goddess and the laws of nature embodied in her worship need to be brought back into consciousness so that a balanced order can prevail on this planet and on all the life forms living on it.

Sheela – the goddess of transformation – can assist humanity in this process of change, which is particularly crucial at present. That is why, with perfect serendipity, Sheela, she who can bring peace to earth, is re-entering collective consciousness.

Chapter 3

THE SHEELA OF THE IRISH CELTS –
MYTH AND THE HERO

The Celts originally came from the Lower Volga basin of Russia. They were a branch of the 'Indo European'[1] warrior tribes who dominated Central Europe by 2800 BC, but they did not arrive to Ireland until over 2,000 years later, around 600 BC. Thus matrifocal society continued to develop for two millennia longer in Ireland, with the result that when the patriarchal/warrior society did arrive there appears to have been a more balanced blending with the indigenous matrifocal social structures.

Scholars of Old Irish classify the earliest group of myths as the Mythological Cycle which extols the Tuatha Dé Danann. The Historical Cycle covers a later period and elevates the cult of the warrior/hero, devaluing the feminine qualities of the goddess. In the Historical Cycle goddesses were demoted into human beings who were raped and murdered by the warriors. However, the principles for which the Great Goddess stood were not entirely eliminated as they had been in Europe and in the Middle East. Irish mythology retained many traditions of the earlier peoples – including the concept of the Goddess of Sovereignty to whom the king was symbolically mated. This is an important point to remember as it explains the

44

survival of the Sheela later in Irish history.

A MATRIFOCAL SOCIETY

The most important function of early society was the maintenance of the fertility of the land and of the people. Women, as the givers of life, 'were the central elements in the social fabric'.[2] They enjoyed power over their own bodies, over birthing and creativity of all kinds, including the skills of medicine and midwifery, smithing, dyeing, and weaving. By the first millennium BC, the skills of fine metalworking had been developed[3] and animals were herded on the lands that belonged to small settled communities of people. The culture of Ireland was similar to early matrifocal cultures of old Europe – in Turkey, and in Mesopotamia, as far back as 30,000 years ago.[4] Everyone had his/her place.

In Ireland, as in other early cultures, life was centred around the mother and the mother's family, the entire blood group related to the mother, though descent was sometimes through the male line. In pre-Celtic times, when a man married he went to live with his wife and her people, except in the case of the ruling families. Even then, the paternity of a child was often not known, nor did it matter, because every child belonged to his or her mother's family. No child was considered 'illegitimate' or a 'bastard' in this country until medieval times under Christian and patriarchal cultures.[5]

THE ARRIVAL OF THE CELTS – THE CULT OF THE WARRIOR

The Celts arrived in several stages between 600 and 200 BC (the exact dates are unknown). The Picts were Celts who came from Eastern Europe and spoke P-Celtic. Many settled in Northern Ireland and Scotland, and some in the

west of Ireland. The group that ruled Ireland for over 1500 years came from the Iberian Peninsula and spoke Q-Celtic. They were called Milesians because their leaders were 'The Sons of Mil', the King of Iberia. They were a branch of the Celto-Scythian peoples,[6] who originated in territories around the Euxine Sea, including parts of Europe and Asia Minor. Other branches of the Celts dominated central and western Europe around 500 BC, sacking Rome in 390 BC.

Those who were conquered by the Celts were the Tuatha Dé Danaan – the people of the goddess Dana or Anu (the Great Mother). Some say they were not human but the gods of the earlier people. They were reputed to be tall and graceful, with dark hair, white skin and blue eyes. They were very knowledgeable with regard to the laws of nature and the changing seasons of the year; they were astronomers and they also used magical techniques such as shape shifting – a technique that successfully repelled invaders. Nonetheless, the Milesians were eventually victorious against the Tuatha. Years later the Milesians returned and were victorious on the second occasion.[7]

A truce was concluded between the two peoples and to seal the agreement, the king of the Milesians married the queen of the Tuatha. By the terms of their peace treaty the victors were to have all the land above ground and the Tuatha Dé Danaan would inhabit all that was underground. The Tuatha became known as the *sí* or *sídhe*. The sidhe were called 'the fairies' or 'little people', and many superstitions surrounded these people, who were sometimes benevolent and sometimes malevolent.

THE HEROIC PERIOD

The Heroic Age was characterised by the supreme value put on the skills and arts of warfare, conquest, exploitation

and the acquisition of wealth, land and power. Society had shifted from the nomadic horse-riding, hunting/gathering type, to living in settled pastoral communities. Fixed boundaries became important as livestock was no longer hunted but herded. The Celts, unlike the Tuatha Dé Danann, were skilled in the techniques of working iron into effective weapons and that was the source of their military and technical superiority over the Tuatha.

The ethic of the warrior society was, first and foremost, loyalty and service to the king. Sons had to leave their mothers' clans to fight for the king. They were repaid for their loyalty with land, wealth and status as warriors. The ability to kill and pillage became paramount; human life was no longer sacred. Power, through the ability to bring death and destruction, became the primary value system. Classical Greek and Roman writers described the Celts as ferocious fighters: 'the individual weapons, the boastfulness and courage of the warriors, the practices of cattle raiding, chariot fighting and beheading ...'[8]

The feminine power to give life was usurped by the warrior culture of taking it. Neurotic, sadistic rituals developed amongst the king's warriors, such as sleeping with the severed heads of their victims between their legs, as if giving birth.[9]

ASPECTS OF THE GODDESS RELIGION RETAINED

Despite the brutality and the cheapness of life under the warrior culture the incorporation of many aspects of the earlier nature religion tempered and balanced the violence of the warrior kings in Ireland, if not on the continent. The Druids, who were philosopher-poets and lawmakers, provided a balance between the laws of nature and the will of the kings. Even the sovereign was bound to obey the

laws of the Druids.

THE VALUE SYSTEM OF THE HEROIC AGE

Táin Bó Cuailnge, 'The Battle Raid of Cooley', is the oldest heroic saga in Europe after the *Iliad* and the *Odyssey*. It describes a kind of culture similar to that of Homer's warriors, and even to the Indian *Mahabharata* written several centuries previously. All these sagas portray chariot-driving warriors, their legends and conquests.[10]

These are the qualities expected of a hero in a description from the *Táin* of the young Cúchulainn:

> In his fifth year he went in quest of arms to the boy-troop in Emain Macha. In his seventh year he went to study the arts and crafts of war with Scathach [a fierce female warrior] and courted Emer. In his eighth year he took up arms. At present he is in his seventeenth year ... You'll find no harder warrior against you – no point more sharp, more swift, more slashing, no raven more flesh-ravenous, no hand more deft, no fighter more fierce, no one of his own age one-third as good, no lion more ferocious; ... You will find no one there to measure against him – for youth or vigour, for apparel, horror or eloquence; for splendour, fame or fashion, for voice or strength or sternness, for cleverness, courage or blows in battle; for fire or fury, victory, doom or turmoil; for stalking, scheming or slaughter in the hunt, for swiftness, alertness or wildness; and no one with the battle-feat 'nine men on each point' – none like Cúchulainn.[11]

The craft of the warrior was the opposite of life giving. The warrior achieved spiritual transcendence by either

defying death or giving his life on the battlefield, encouraged by his Druids to go bravely into death, in a kind of mad frenzy of destruction:

> ... In this great carnage of Murtheimne Plain Cúchulainn slew one hundred and thirty kings, as well as an uncountable hoard of dogs and horses, women and boys and children and rabble of all kinds. Not one man in three escaped without his thighbone or his head or his eye being smashed, or without some blemish for the rest of his life. And when the battle was over Cúchulainn left without a scratch or a stain on himself, his helper or either of his horses.[12]

In spite of all the repetitive braggadocio of the *Táin,* the personalities of the women come out strong and varied. Medb, Derdriu, Macha, Nes, Aoife seem more like goddesses than ordinary women to the translator: '... it is certainly they, under all the violence, who remain most real in the memory.'[13]

In order to copper-fasten the new ethics that required the primary relationship to be with the King rather than the mother, women had to be firmly restricted. Their bodies had to be restricted, their standing in the social order had to be diminished, their reproductive capacity held under tight control. The goddess had to be taken down, shamed and demonised in order to substitute the new order, based on military might and male reproductive consciousness.

DISEMPOWERING THE GODDESS AND THE SCAPEGOATING OF WOMEN

Ancient Ireland was divided into five provinces: Munster

(south), Leinster (east), Ulster (north), Connacht (west) and Meath (centre). All five provincial capitals were originally sacred sanctuaries to the goddesses and they were all built on hilltops associated with their founders. At the centre was the titular goddess Ériu of Uisnech (outside Mullingar, County Westmeath); in the east Tea was goddess at Tara and Tailtiu, goddess of the corn, was worshipped at Teltown; the sorceress Tlachtga at Athboy (all three in County Meath); and in the north Macha at Emain Macha (Armagh) – capital of Ulster. On the west, Cruacha, the handmaiden who accompanied Etain when she eloped with Midir of the Tuatha Dé Danann, gave her name to Cruachan, ancient seat of the Kings of Connacht. Festivals were held at different times of the year at these centres to celebrate the changing season to keep the land fertile and people healthy and prosperous.

All of these places were originally spiritual sanctuaries where the goddesses were buried. They were taken over by the Celtic conquerors and became their political centres, just as Christian basilicas were placed on the ancient temples of Rome. '... most of the Irish centres were "notre dames", like so many of the great ecclesiastical centres of latter-day Gaul.'[14]

THE RAPE OF THE GODDESS

The myths that originally extolled the many life-giving qualities of the goddess were turned into satires. All of the places that had been sacred centres were associated by the Celtic conquerors with gang rape, death, or the overthrow of the goddesses. Cessair, the leader of the first settlers in Ireland, died of a broken heart when she thought her husband Fintan had perished. Tailtiu also died of a broken heart as she strained to clear the plain that bears her name.

Tlaghtga was gang raped by the three sons of Simon Magus, a Milesian leader, and died giving birth to triplets at the place that bears her name.

> Tlachtga's status as a goddess ended when men violated her control over her own fertility by means of a gang rape. But even more significantly, her death took place in the act of giving birth to three famous warriors. Clearly the warrior culture had triumphed over her, and thereafter the warrior assemblies were held on the eve of Samhain, the November Celtic festival at Tlachtga. Traces of the goddess are usually to be found only in stories describing their overthrow or subjecting them to ridicule.[15]

The myth of the goddess Macha (whose name was bestowed on Armagh, the capital of Ulster) is one of the most shocking of the stories. Macha was living with a rich farmer, a widower, pregnant with his child. She was forced by the king of Ulster, who threatened to take her husband's life, to run a race against the king's horses and chariot, in spite of the fact that she was due to deliver at any moment. She appealed to the king and the crowd: 'You who were born of a woman, for your own mother's sake, pity me, and let me deliver my child before I run the race.' They refused. Macha won the race, delivered twins at the finishing line in full view of the men of Ulster, thus rendering what had been a sacred and secret ritual into a public display. She died on the field, after cursing every man born in Ulster for nine generations: that when they had to go to battle they would be unable to stand, feeling birth pangs for five days and four nights, incapable of fighting.[16]

Macha has been called a warrior goddess, and perhaps

she has some connection to the horse goddess Epona, which would make sense of her racing against the king's champion horses. But the way in which she has been historicised casts shame on her and on the sacred rite of birthing. Her curse on the men of Ulster was given not only because of the insult to her but to women in general. Macha was begging for the dignity and the rights of motherhood.

THE DIMINISHMENT OF THE FEMININE

Once the goddesses were historicised and disempowered, their status destroyed by the symbolism of rape – ordinary, mortal women were then subjected to similar abuse. The warrior society triumphed over the culture of the wise woman. The women of Ireland were no longer free to make their own choice of a man but were forced to marry to extend the lands and the relationships of the warriors and the kings. Myths like 'Diarmuid and Gráinne' and 'Deirdre of the Sorrows' tell of the destruction of the men these heroines loved, due to the treachery of the king and his warriors, and of their own deaths because they dared to have the man of their choice. Women are blamed and scapegoated. On the day she was born, the Druid Cathbad predicted that beautiful Deirdre of the Sorrows would bring a curse upon the men of Ulster – because of her beauty! No justification is thought necessary for the king, whose behaviour was the real cause of the conflicts between himself and his warriors and the loss of Deirdre's and Naoise's lives.

THE INTEGRATION OF THE NATURE RELIGION WITH THE WARRIOR ETHIC

Despite the many changes in society, some aspects of the goddess civilisation survived, particularly in the seasonal

festivals and the life-cycle celebrations at cross quarter days such as Imbolc (1 February or 11 February in the old calendar). Imbolc was the celebration of the new life of nature and honoured the young Brigid (*Breege Óg*). Bealtaine (1 May) celebrated the fertility of the goddess; Lughnasa (1 August) the harvest festival; and Samhain (1 November) the end of the Celtic year. This was the festival of the dead, transmuted to Halloween, All Saints and All Souls by the Christian religion.

Attention to the festivals celebrating the varying seasons of nature and the ordered growth of crops and livestock was fundamental in the older religion and continued to be important under the governance of the Druids. The following description of the festival of Teltown at Lughnasa (1 August) marked the beginning of the harvest season. Tailtiu, corn goddess, symbolically gave her life under the sickle, having first cleared the forest to create the fields.

> About the Calends of August she died, on a Monday, on the Lugnasad of Lug; round her grave from that Monday forth is held the chief fair of noble Erin. White-sided Tailtiu uttered in her land a true prophecy, that so long as every prince should accept her, Erin should not be without perfect song. A fair, with gold, with silver, with games, with music of chariots, with adornment of body and soul, by means of knowledge and eloquence. A fair without wounding or robbing of any man, without trouble, without dispute.[17]

The *Metrical Dindshenchas* quote St Patrick as having said about this feast: 'Victorious was the proud law of nature; though it was not made in obedience to God, the

Lord was magnifying it.'[18] The 'law of nature' refers to the natural laws incorporated into Irish Brehon law.

THE PRINCE AND THE HAG

Although the Celts replaced the gods and goddesses of the Tuatha Dé Danann with their own gods, they did preserve some of the ancient myths. The goddess of the land and of sovereignty – Éiru or Medb – was also the old Cailleach – the Crone or Hag – who guards the well. In the tale of Niall of the Nine Hostages and the old Hag recounted at the start of this book, the hero has been historicised in the person of the High King of Ireland – Niall – but it presumably predates his time.

The myth describes an initiation ritual that appears in many cultures. It is the test of the hero for his suitability to be king. He is presented with the wizened hag. Can he see beyond the illusion? By kissing her and laying with her he is facing all his deepest fears – disgust at what is not attractive, fear of impotence in the sexual act, especially with what is repugnant, and even greater – the fear of death and dying (sex has been called 'the little death' or *le petit mort*). Niall is quoted *Laigfead pat la taeb póici do thabairt* meaning 'Besides giving thee a kiss, I will lie with thee'.[19] She is transformed into a beautiful maiden and he is rewarded with the sovereignty of Ireland!

SHEELA – BESTOWER OF SOVEREIGNTY

The king was in a special relationship – symbolically married to the goddess who was a symbol of the land itself. 'The purpose of the marriage was to produce a child, and the child, of course, was the harvest, the *ith agus blicht* of ancient Irish tradition, the corn and the milk.'[20]

By lying with the goddess, the hero succeeds in his ini-

tiation, attaining victory over his fears and the wisdom that allows him to generate that quality of peace over all he rules. This tale is reminiscent of the spiritual test found in many cultures in the journey towards enlightenment. It necessitates breaking through all taboos and social restrictions, and by humbling the ego to find wisdom and personal empowerment. '... and the goddess herself, having met her rightful spouse, is transformed from hag to young woman, from winter to summer, from barrenness to fertility.'[21]

The ethics encapsulated in this myth, involving the necessity to honour the Great Goddess, became the foundation of the philosophy relating to the rights of kingship in Ireland and Scotland.

The symbolic marriage of the goddess of the land to the rightful sovereign was a fundamental tenet in the political and religious philosophy of the people of Ireland. That is why the myth, though much older, was historicised to relate to Niall of the Nine Hostages, High King of Ireland from 378 to 405 AD. Niall's progeny were kings of territories in Ireland, Scotland and England. He was a Christian, according to some authors,[22] and his kin were the founding 'saints' of many of the first Irish monastic foundations.

The Sheela was a fundamental symbol to these founding saints who were members of the dynastic families. The Sheela archetype was brought forward from the vast wisdom incorporated from the goddess religion and integrated by the Druids, initially into the Heroic period and later into Celtic Christianity.

Chapter 4

CELTIC CHRISTIANITY:
SHEELA'S GOLDEN AGE (350-800 AD)

Celtic Christianity was a form of monasticism devel-
oped in the deserts of North Africa.[1] By the second
century it appeared in the trading towns of Gaul and the
Atlantic seaboard,[2] and from there it spread to Britain and
Ireland.[3] By the time of St Patrick's arrival (432 AD), there
must have been dozens of monasteries in Ireland, as he is
reputed to have consecrated 450 bishops.[4]

The archetypal symbolism of the Great Goddess was
retained by the Druid-priests, who fused together the two
traditions into what became Celtic Christianity. The laws
of nature do not change, no matter what the religion, and
to the Irish Sheela was an expression of an eternal verity
that requires balance between masculine and feminine.
Moreover, her function as goddess of the land was of
prime importance to the sovereign whose right to rule
came through a symbolic marriage to this deity.

Many Sheelas extant today have been found at the ear-
liest monasteries established on the British Isles and on the
continent by Irish missionaries. Sheelas are found in
northern France, along the Atlantic coast, and on the pil-
grimage route to Santiago in Campostella, Spain. That
they are not found at all Irish foundations indicates a

divergence in the attitudes and beliefs of the different strands of Christianity in Ireland even from the fifth century: Brigid represents the nature religion, Patrick – Roman Christianity, and Colum Cille the fusion of the two. Colum Cille and Columban Christianity preserved the symbolism of the Divine Hag and transmogrified it to blend into the new religions.

THE ARRIVAL OF CHRISTIANITY

Because they were skilled sailors in frequent contact with Europe and North Africa, the Irish had learned about Christianity as early as the second century. Sailing around the shores of the Atlantic and the Mediterranean for commerce and warfare, slave taking and piracy was an integral part of the lifestyle of Irish chieftains – a major source of their prosperity.[6] Parts of what are now England, Wales and Scotland were conquered by Irish clans who exacted tribute and hostages from those kingdoms.

The new religion suited the leading strata of Irish society – both kings and Druids. A prolonged power struggle had been waging between these two classes. The Druids objected to the constant warfare, violence, and wanton loss of life and property that was destroying the fabric of Irish society. The kings resented the Druids' claim to supremacy in matters of law and morality, and they resented having to pay the Druids with excessive grants of land to avoid being lampooned in poetry and disgraced forever. The kings hoped the new religion would remove their power, and the majority of Druids were pleased because they were expecting a new form of spiritual life to appear that would bring stability to the country.[7]

The Christian message of peace to all men brought in a new social contract that put a high value on human life.

Many Druids became priests and monks in the new faith. Some travelled to Lerins in Gaul to be trained, and returned to establish the first Christian monasteries in Ireland as early as the fourth century.

THE FIRST CHRISTIAN COMMUNITIES
Christian settlements of traders from North Africa had been established in south-west Britain and south-west Ireland in the fourth century.[8] At the same time a group of ascetic monks of the Coptic Christian sect left Egypt to escape persecution. They arrived in the Aran Islands off the west coast of Ireland. The influence of North Africa can be identified even today, in certain forms of Irish music, symbols and art found on the Aran Islands.[9]

The Christianity that was introduced to Ireland combined a penitential spirit with a missionary zeal to 'Go forth and teach all nations'. The monks followed an eremetical tradition, a rule of living at times as hermits, with vows of poverty, penance, learning and writing, working, healing and travelling as missionaries in the service of God. When the Druids became priests they transferred their ancient Druidical knowledge of history, genealogy, law and cosmology to the new faith. Many monasteries had mixed communities of men and women. 'Uniquely in Ireland the new religion was naturalised by a pre-existing clerisy.'[10]

During the early formative years of Celtic Christianity in Scotland, Wales and Ireland, the old religion and the new were combined in a unique way that was easily accepted by the people. There was an amicable blending of the new spirituality with '... the existing primal and tribal religions, adopting their best practice while clearly foregrounding the moral and spiritual superiority of the new faith'.[11]

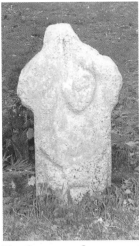

*THE SHEELA AT STEPASIDE, COUNTY DUBLIN. One of three stand-
ing Sheelas, it may have survived because the monolith was
roughly cut at the top in the shape of a cross. Uniquely it is carved
on both sides. One side displays a standing figure with a forbid-
ding frown, hunched shoulders and arms that emphasise the
pudenda. On the other side the head is skeletal – and she stands
above an open grave. The stones indicate the grave.*

Christianity was the fulfilment of the Druidic tradi-
tions. The deep respect for knowledge continued, and

> ... oral traditions were now supplemented with the
> writing skills of the monks. The Celtic sense of form
> and colour found new inspiration and patronage in
> carved crosses, illuminated manuscripts and intricate
> metalwork. Poetry and music, which were the time-
> honoured ways of praising earthly rulers, were now
> employed to praise the High King of Heaven.[12]

A new social order was introduced and many young
men who had been in the militia joined the ranks of the
monks in the monasteries.

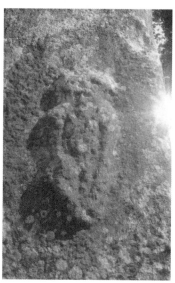

SHEELA AT TARA, COUNTY MEATH. This standing stones, known as St Adamnán's stone or cross, dates to the end of the seventh century if not before. This Sheela is carved in symmetrical fashion and seems to have big ears or some appendage from her ears. Note the hunched shoulders, the crouched position and the arms focused on the genitals.

WHERE WERE THE SHEELAS AT THE FIRST CHRISTIAN MONASTERIES?

Christian monasteries were built on the same sites where the previous faith had been practised. The sacred groves of oak were cut down and small churches, *dairtech*, were constructed of the oak timbers from those trees. This custom served the dual purpose of transmuting earlier forms of ritual, while continuing to use the power spots of the land.

Sheelas would have remained where they had been in Druidic times – standing stones, perhaps beside a holy well, much as the Sheela at Stepaside, Dublin. A church may have been placed beside the carving. Adamnán's Stone at Tara may be such an example. The remains of a small stone church (*damliac*) stand within a few yards of the stone.[13] Many Sheelas have been found at those first monastic establishments.

Early Christian monasteries were built of wood and

wattle. They did not resemble 'the elaborate stone struc-tures which constituted the monastery of the middle ages'.[14] Each monk or nun had his/her own cell – a small, separate sleeping place usually made of wattle and daub, with a thatched roof of reeds. The abbot or abbess had a somewhat larger cell (*cill* in Irish).[15] The whole monastery resembled a village of wooden huts and the founder often had a place to withdraw, a hermitage in which to meditate in silence, perhaps a cave like 'St Kevin's bed' in Glendalough, County Wicklow, or 'St Ninian's cave' in Whithorn, Scotland.[16] There were also communal build-ings: the refectory and the scriptorium where the sacred books such as the *Book of Durrow* and the *Book of Kells*, were copied.[17]

Many Sheelas survive today at these early monastic establishments, though none of the original oak churches have survived in Ireland.[18]

DATING THE CARVINGS

Most Sheelas are found on churches built between the eleventh and thirteenth centuries in Romanesque style. Many of the carvings on those buildings are noticeably more worn than the rest of the stone work, indicating that they were probably transferred from the earlier structures to the later churches. This would be in accord with the veneration in which the people would have held those sacred stones and points once again to the conservatism of the country people of Ireland.

Though it is impossible to date the age of carved stone by the carbon dating system, the stone itself, the style of the carving, and also the weathering give some evidence for dating Sheelas. Every community would have had a shrine, usually beside a well – a custom that continues in country

places in Ireland. The weathering of some of the carvings indicate that they originated at a very early period, perhaps even before the arrival of Christianity. The places themselves, and the historical significance and traditions of the people provide evidence that may be overlooked by a strictly antiquarian analysis of the carvings. A good example is Sierkieran in County Offaly.

The Sheela at Sierkieran, County Offaly

St Kieran of Cork set up one of the earliest monasteries in the country near Birr in County Offaly, around 350 AD. One of the most remarkable Sheelas, now in the National Museum of Ireland, originated at this monastery. Though it had been carved on a stone specifically to fit into a medieval church, this Sheela displays many of the features of a 'pagan idol', including holes at the top of the head that may have held appendages such as antlers or flowers. There

ST KIERAN'S SACRED BUSH AT SIERKIERAN. A monastic site in the midlands that pre-dates St Patrick and was once the hub of Irish monasteries. This May tree, or whitethorn is decorated with rags of petition. The devotion is still so strong that the tree has been preserved in the centre of the road.

are a number of holes around the womb area as well, that may have been filled with semi-precious stones, similar to the decorative work that can be seen on croziers, reliquaries and sacred vessels. This little sculpture has been dated to the fifteenth century by the National Museum of Ireland, where it is on display. Compare the Sierkieran Sheela with the Neolithic carving from Yorkshire displaying cupmarks – source of life-giving moisture.

Although this carving is medieval, the back of it being shaped to fit into the wall of the church, its presence denotes a long tradition of belief dating back to the early Christian community and before. The tradition continues to the present day with ancient rituals still practised at Sierkieran, such as prayers at the holy well and the hanging of rags and mementos on the whitethorn bush growing in the middle of a modern road that has been constructed around it.

Sierkieran was an important and influential monastic centre. It was taken over by the Roman Church, becoming the seat of the bishops of Ossory in the Middle Ages. Raphoe in Donegal and Elphin, County Roscommon are further examples of Druidic centres that were assigned as bishoprics by the Roman church.

The Sheela at Glendalough, Wicklow

Glendalough was established in the sixth century by St Kevin, at a site formerly inhabited by an order of Druidesses, who were driven out by the monks. Glendalough became one of the great centres of learning and spirituality, welcoming pilgrims and students from afar, down to the sixteenth century, when all Catholic monasteries and churches were disbanded by

Henry VIII. It managed to survive the thirteenth-century introduction of Roman Orders from the continent.

A Sheela was recorded at Glendalough on the south jamb of the east window in the Romanesque church of St Saviour in 1986, but unfortunately it has disappeared. Called *La Femme aux Serpents,* it was carved in a small triangle – another symbol of the goddess – with the vulva discreetly indicated by a small gash.[19] Unfortunately there are no photographs or drawings of that carving.

The fact that Sheelas were placed on Romanesque churches in those monasteries during the eleventh and twelfth centuries is a certain indicator that early Irish foundations held onto the belief in the Great Mother at least down to the Roman reforms and the introduction of continental orders in the thirteenth century.

Tomregan, Cavan

Tomregan (Tuaim Drecain) near Ballyconnell, was another famous monastic settlement begun during the earliest period. Like Glendalough, a nunnery was there around the year 500 AD. The dating of all the early monasteries is somewhat suspect, because annalists presumed that there were few Christians in Ireland when Patrick arrived. This is patently untrue.

Tomregan is only four miles from the site of the god Crom Cruaich of Magh Sleacht, where St Patrick destroyed his statue and those of twelve other idols surrounding him.[20] The monastery at Tomregan became a centre of learning and provides a good example of how the old Druidic tradition and the new faith were combined to produce a great university similar to Clonmacnoise, Glendalough, Sierkieran, Clonard, Fore, Iona, and Aran, to mention only a few. Tomregan had schools of Classics,

Law, Medicine, History and Bardic Poetry. It also had a hospital where leprosy patients, amongst others, were treated.[21]

One of its most famous surgeons was also a priest – St Bricín, head of Tomregan University in the year 637 AD. Bricín, like all the abbots of Irish monasteries, was a member of the aristocracy. Among his patients was a young warrior, Cenn Faelad (of royal lineage) whose skull was fractured during a battle near Lisburn, County Down against the Dalriadans of Scotland who were trying to secure the monarchy of Ireland. Bricín performed an operation on the young man, using a circular saw called a 'trepan', relieving the pressure on his brain. While he was recovering, Cenn Faelad attended lectures at the university:

> And there were three houses in the place; a school of Latin learning, a school of Irish law, and a school of Irish poetry. And everything that he would hear of the recitations of the three schools every day, he would have it by heart every night. And he fitted a pattern of poetry to these matters and wrote them on slates and tablets and set them in a vellum book.[22]

The Tomregan Stone: Sheela – or Saint?

The Tomregan stone is an extraordinary carving in the style of the pagan big head. Some say it is a Sheela, but having seen and inspected it on a number of occasions, it appears to be a carving of St Bricín. The head is bald in the tonsured style used by Celtic monks until 664 AD when tonsure was forbidden by the Synod of Whitby. The carving depicts Bricín's beard, and also his testicles. In his left hand he holds a skull and in his right, a trepan saw. There is no stomach area in this carving and the hands do not

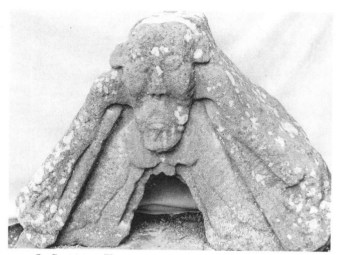

ST BRICÍN OF TOMREGAN, A SIXTH-CENTURY ABBEY NEAR BALLYCONNELL, COUNTY CAVAN.

emphasise the pudenda as in the case of the Sheelas. This carving serves to illustrate that the carvers of the early centuries did not consider the display of sexual features – even those of a saint – as rude.

Tomregan passed out of existence as a university in the eighth or ninth century. The foundations of a church and a round tower were discovered in 1900 on the site of the place where Bricín taught, and also the remains of sweat-houses. Medicinal herbs were discovered around the site of the hospital, and there is a holy well nearby with an ancient stone boundary wall.[23] All in all, excavations might reveal a monastic settlement that continued on for hundreds of years, but one that had been forced to suspend teaching the old knowledge under the strictures of Roman reforms – or possibly due to warfare between the clans.

SAINTS AND SCHOLARS – IRELAND'S GOLDEN AGE

During the first centuries of Christianity, Celtic and Roman forms of the religion existed in harmony, leading to a rich cultural and spiritual life, and political stability that lasted for over 400 years. Though there were disagreements between kings and clergy, conventions and synods were called at which each side presented its case and compromise was found. The country was unified with a common language (Irish), whilst common beliefs and laws maintained social continuity. There were no invasions for over 1,000 years – not until the Vikings arrived in the ninth century.

The Irish from Ulster had helped the Scots (then known as Picts) repel the Roman armies in northern England; therefore, the Romans were never able to penetrate the Highlands, nor did they invade Ireland. After the collapse of the Roman Empire, Europe remained in chaos for centuries during 'the Dark Ages'.

In that period Ireland experienced a golden age, and the learning that was lost in Europe was preserved at the great monasteries of Ireland and Scotland. The traditions of discipline and learning, the development of writing and illustration, music and poetry, work and prayer were integrated into Celtic monasticism. The Brehon laws were recorded and the finest minds in Europe were codifying the laws of nature with Church (Roman) law, integrating them with Brehon law. The kings donated lands to build the abbeys, and the abbots of those monasteries were selected from amongst the kinsmen of the ruling families. There were 45 monasteries in Ireland by the end of the sixth century and a large number of converts, many attached to the monasteries.

Many of the founders of those monasteries were

trained by two men who had been taught in Gaul: Finnian
of Clonard, County Meath, and Enda of Inishmore on the
Aran Islands. Columba [Colum Cille] (who is pivotal in
the history of Sheelas), Brendan the Navigator and Ciaran
of Clonmacnoise were amongst the group of twelve
trained by St Finnian.[24] These famous twelve, and hun-
dreds of other 'Founder Saints' had a powerful influence
on the way Christianity developed in Ireland, Scotland,
England and on the continent. Pilgrims from England and
the continent journeyed across the seas to live and study at
the Irish monastic settlements.

IRELAND AND THE SCOTTISH CONNECTION

From the fourth century the Dal Riada Clan from
Northern Ireland (called Scotti by the Romans, hence the
name 'Scotland') had taken over the western part of what
was then called Pictland.[25] In 506 AD Fergus Mór mac
Eirc, a member of the royal line of Ireland was inaugurat-
ed King of Argyle. According to the annalists, the Stone of
Destiny (originally brought by the Tuatha Dé Danann to
Ireland, and upon which the 'rightful king' was to sit) was
brought from Tara for this inauguration. It was never
returned to Ireland.[26]

St Ninian's, Scotland.
The Sheela found in recent
archaeological excavations.

The Sheela at Whithorn, Scotland

The first Christian settlement in Scotland was at Whithorn, on the south-west coast of Scotland. Whithorn is called 'the cradle of Scottish Christianity'. A thriving community of traders from North Africa set up there after the Roman invasions. St Ninian, trained in Gaul in the same traditions as the Irish, was assigned to Whithorn as bishop by Rome in 400 AD. Whithorn came under the influence of Iona in the sixth century, that is under the influence of the kings of Argyle and St Colum Cille. In the eighth century it came under the influence of Northumbria,[27] and it was always regarded as a centre for pilgrims down to and including medieval times.

A Sheela was recently discovered at Whithorn during an excavation of the medieval section of the monastery.[28] She has an impish look, with a large round face and mischievous eyes. Though she has no arms the pudenda is clearly visible. The decorative motif on one side is similar to the treatment of the Sheela at Liathmore Abbey, County Offaly, which may indicate that the Whithorn carving was also inserted on the eleventh- or twelfth-century Romanesque church on its side in the occulted position.

BRIGID, PATRICK AND COLUM CILLE – THE THREE PATRONS OF IRELAND

These three Irish saints stand for three strands of spiritual tradition in Ireland: Brigid for Christianity that incorporated the nature religion,[29] Patrick for the Roman form of Christianity, while Columba or Colum Cille combined the old Druidic learning with the new Christian message of 'peace' (his spiritual name – *Colum Cille* – means 'the dove of the church').

St Brigid represented the laws of nature and nurture.

She is strongly connected with the goddess Brigid and many of the rituals surrounding her are associated with the old religion. She founded 30 convents and under her patronage, the nuns of Kildare (founded around 480 AD) continued the ancient traditions of healing, midwifery and medicine, herbalism, food production and dairying, arts and crafts such as poetry, music, smithing and the practice of law. Her symbols are the symbols of the goddess: the sacred fire, the sun, moon, and order in the natural world. Tending the eternal fire was the responsibility of Brigid's nuns, a fire that continued to burn in her monastery at Kildare until the twelfth century. In fact, Brigid's Christianity was under threat from the beginning because the vast majority of clergy denied the rights of women.

The name Patrick may well be a generic name for the promoters of Roman Christianity in Ireland, just as Brigid probably is a generic name for the followers of the older order. Tradition tells us he was appointed bishop in 432 AD, but the official records in Rome list no Patrick. The name itself comes from the Latin *Patricius* – meaning 'nobleman'. Could it be that this term was applied to all representatives of the Roman Church? Some scholars hold this opinion. The histories of his life include an impossible amount of travel for one man and a very long life for those times. He is reputed to have died in 463 AD, but connections with saints born later in the century (such as Brigid) give further evidence that Patrick was a title of the Roman representative rather than a personal name.

Power Struggles
The battle between the followers of the new order – under Patrick and the bishops appointed by Rome – and the old

CELTIC CHRISTIANITY: SHEELA'S GOLDEN AGE

order is illustrated by the number of holy places, originally dedicated to the goddess Brigid that were re-dedicated to Patrick.[30]

The followers of Brigid (the old order) and of Patrick (the Roman church) split fairly soon after her death. *Liber Angeli*, a document dating perhaps from the seventh century, closes with the phrase:

> Between St Patrick and Brigit, the pillars of the Irish, such friendship of charity dwelt that they had one heart and one mind. The holy man therefore said to the Christian Virgin: O my Brigit, your Paruchia in your province will be reckoned unto you for your monarchy; but in the eastern and western part it will be in my domination.[31]

Although both saints were long dead, a story such as this, involving the personal relations between them, could not have been factual. In the opinion of Professor Bieler it seems to imply that some kind of an agreement had been made between the two factions, Celtic and Roman.[32] Brigid's paruchia was then the middle of Ireland – the very area where most Sheelas are now found, nearly 1,500 years later. Moreover, this is the same area where most of the early saints established their monasteries.

COLUM CILLE – THE THIRD SAINT OF THE IRISH TRINITY

Columba, or Colum Cille, is a pivotal figure in tracing Sheelas to early Celtic monasteries. His Christianity combined the old Druidical knowledge with the new understanding of peace. He is reputed to have founded 100 monasteries, although they are not named. Durrow, Derry, Kells and Iona are amongst the most famous of his

foundations and carvings of Sheelas have been discovered at many of his foundations in Ireland and in Scotland.[33]

Like most of the founding saints, Columba was a member of a dynastic family. He was a prince of the royal family of Ulster – born in 525AD, a great grandson of Niall of the Nine Hostages, descended from his son Conall Gulban. His mother was a member of the royal house of Leinster. He was a scholar and an ascetic. He was also a skilled warrior with a sharp temper. Moreover, he was a tough, shrewd, practical politician.

Though Columba's aim was to achieve peace in Ireland and Scotland, he caused two civil wars. Power struggles between the kings and the priests did not abate when members of the royal families became clerics. Colum Cille was angry with the monarch, Diarmuid MacFergus Ceirbhuil, because the high king had legislated against him in a dispute between himself and St Finnian (Colum Cille had taken Finnian's book and had a copy made. Finnian claimed the copy as well as his original, but Colum Cille refused to return the copy. This was the first copyright case in law).

Contests between King and Clergy

After further disagreements between the monarch and the clerics, the leading saints of the time united against him. Saints Ciaran of Clonmacnoise, Brendan of Birr, Colum Cille and Ruadhan all rallied at Tara where they fasted against the King.[34] In the end the clerics cursed Tara in 558 AD, and from then on it declined as a political centre of the monarchs of Ireland.[35]

The King and Colum Cille continued to quarrel and their differences culminated in a battle in which Colum Cille and an army of Ulster fought the king and defeated his army of 3,000 men at Ben Bulben in County Sligo.

Colum Cille was ordered by the saints to leave Ireland or be excommunicated. He sailed with twelve companions to the island of Iona off the west coast of Scotland and set up his monastery there in 563 AD.[36]

IONA – A GREAT CENTRE OF CELTIC CHRISTIANITY

Colum Cille chose exile to a friendly land. His clan had ruled western Scotland for nearly 60 years, a kinsman was the first king of Argyle[37] and he met with a ready welcome. Because of the relative political stability and the intellectual calibre of the monks, Iona became an outstanding literary, artistic and spiritual centre of the early Christian church. It became one of the earliest 'universities' with one of the most complete libraries in Europe. Exquisite books, poetry, crafts and metalwork were produced, objects used in Christian rituals. Books like the *Book of Kells* and the *Book of Durrow* (both now in the library of Trinity College Dublin) were probably written in the scriptorium on the island. Languages like Latin, Greek and the romance languages, Pictish, and Irish were studied and used. Cosmology, astronomy and the various systems of law were being analysed and integrated by the great minds of the clerical scholars.[38] Other great leaders of the early Church such as St Isadore of Spain and scholars on the continent were in regular communication with Iona.

Colum Cille's attitude towards women

Colum Cille's memoirs reveal a great respect for women – particularly for married women and for the sacredness of motherhood. He is reputed to have had a child of his own, though he denied it vehemently. Marriage was not forbidden in early Christian times and the marriage of clergy and

even hierarchy was common across the whole of Europe until the twelfth century, and even later in Ireland.[39]

THE SHEELA AT IONA

This carving is badly eroded and would seem to be considerably older than the fifteenth-century nuns' refectory on which it is inserted. The carving gives the impression of the Great Mother in the characteristic position of giving birth. Her legs are held apart, but all detail of her face and hands are worn away with time. The carving is inserted on a lintel made of the same white stone above a window. It is inserted in a similar way to many of the twelfth-century churches – preserved from the earlier buildings.[40] What is most remarkable is that it was not occulted, even though it was placed on a fifteenth-century building, which means that the devotion to the Divine Mother was still carried on at Iona long after it was forbidden in the rest of the Roman-dominated church.

The Iona Sheela and others that were placed in an upright position (not occulted) on medieval churches, demonstrate that the practices and rituals in the Christian church were not universally changed at the same time. In remote places, many of the older traditions continued for hundreds of years longer than at the centres of power. If this Sheela had been associated with the traditions of their founder, Colum Cille, as the Sheela in Tara is associated with one of his successors, seventh-century St Adamnán, how could those who followed the saint think of profaning it?

THE CHRISTIANISING OF SCOTLAND, WALES AND ENGLAND

Wherever Sheelas are found in Wales, Scotland, England

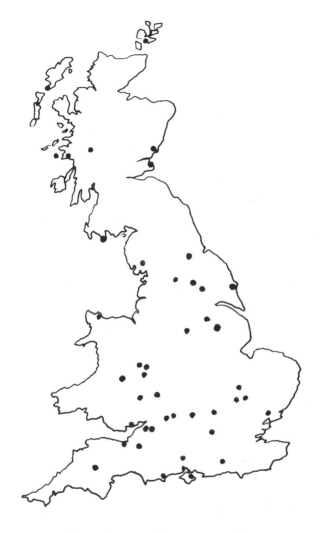

MAP OF ENGLAND, SCOTLAND AND WALES
Though many Sheelas in England are the product of an opening of
awareness as a result of the Crusades, many of the carvings – par-
ticularly in Scotland – attest the presence of the early Celtic
Church and of pagan roots.

75

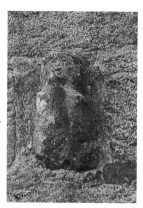

SHEELA AT TAYNUILT, SCOTLAND. Thought to have originally been part of the thirteenth-century church of Killespickerill, this well-worn Sheela may well have originated at an even earlier church. Its antiquity and proximity to Iona indicate that its presence may have been due to to missionaries sent out from Iona to christianise the rest of Scotland during the sixth and seventh centuries.

or on the continent, it is an indication that the first Christians at those places were early Irish missionaries. By the seventh century the influence of Iona was so great that the Christian church in Scotland is still called 'the Columban Church' by the Scottish to distinguish it from the Roman Church. And so we look to the foundations of the missions from Iona for further evidence of Sheelas.

A number of the carvings are found near Iona: on the island of Mull – the nearest to Iona, and at Taynuilt, sixteen miles from Oban, the mainland port of departure for Iona. There are other Sheelas on out-of-the-way islands, places the early saints would have ventured in their search for isolation, austerity and penance. The presence of a Sheela on the church at Kirkwall in the Orkney Islands is surprising, because the Orkneys were Pictish territories. However, the Picts were introduced to Christianity by none other than Colum Cille himself, who made a journey to meet King Brude for that purpose. Long before the Picts arrived in the Orkneys, it was a centre of goddess worship with megalithic cairns similar to those of Malta and various sites in Ireland.[41] The people of the Orkneys must have been comfortable with the Sheela imagery on their church.

St Aidan was one of the first missionaries to branch out from Iona, going to Northumbria where he set up schools and monasteries, notably at Lindisfarne.[42] More Sheelas are found in Northumbria and northern England than anywhere else in England, further supporting the theory that they were a phenomenon of Celtic spirituality and particularly of the Columban Church.

THE YORKSHIRE SHEELAS

York, the centre of Northumbria, became identified with the Celtic church. Even today four Sheelas remain in the West Riding area[43] of that county and one in the East Riding area. As we shall see, the kings of England and the Roman Church began to take alarm at the success of the Celtic Church in England, Wales and Scotland. Hadrian's Roman wall was being breeched not by warriors, but by Scots and Irish missionaries.

SHEELAS ON THE CONTINENT

From the fifth to the tenth centuries Irish monks established literally hundreds of religious houses across Europe. Amongst the first Irish foundations to be established on the continent during the fifth and sixth centuries were Jumiege and Peronne in Normandy. Jumiege may have been a daughter house of Iona because three Sheelas are found in that area. On the other hand, there are none in the Peronne area. Traditionally Peronne was a centre that loved Patrick. Was this a reflection of the conflicting traditions within the Irish Church between the followers of Patrick and of Colum Cille? Altogether Andersen identified only eleven Sheelas on the continent.

CONFLICTING TRADITIONS

It would appear that many of the early Irish saints did not have the same devotion to the Divine Hag that Colum Cille and his followers had. For example, St Columbanus, (not to be confused with Colum Cille) was educated by Comgall at Bangor, County Down. He founded the monastery at Luxeuil, France, in the sixth century, and from there his monks set up nearly 100 other houses on the continent by the time of his death, in 615 AD. Yet not one Sheela is found at any of these monasteries.[44] Columbanus, most probably, was a follower of the Roman traditions.

Jørgen Andersen identified eleven Sheelas on the continent – ten of them are on the western coasts, or near a river. They are found on churches no later than the twelfth or thirteenth centuries, and on the pilgrimage routes to Santiago in Campostella, Spain. Thousands of pilgrims travelled to the holy centres during the Middle Ages. The Sheelas may be all that remain of the enormous cultural and spiritual influence that the early Irish monastic settlements had on Europe during the Dark Ages.

THE IRISH CONTRIBUTION TO EUROPEAN CIVILISATION

History has glossed over the enormous contribution to culture made by the Irish missionaries during the Dark Ages on the continent. They established foundations in Peronne, Jumieges, Laon, Liege, Trier, Auxerre and Luxeuil in France. They travelled to Germany, Czechoslovakia, Switzerland, Italy and Austria, setting up houses in Cologne, Regensburg, Wurzburg, Fulla, Reichenau, St Gall, Lucca and Fiesole. Wherever they went they shared their vast knowledge, built up the foundations of the great continental libraries, continued to

write scholarly texts and brought back to Europe a civilis-
ing influence that had been lost during the violent
upheavals of the warring tribes.[45]

Unfortunately the influence of the Celtic Church,
after 300 years of success, was to be short lived. The
onslaughts of the Vikings and the political manoeuvres of
the Pope and the English monarchy blocked the develop-
ment of Celtic Christianity.

CONFLICT BETWEEN ROMAN
AND CELTIC CHURCHES

With approximately 300 years of successful mission-
ary work behind them, the Celtic Church was pros-
pering intellectually and materially in the seventh century.
Monasteries had become very rich and influential. In gen-
eral, abbots and kings co-operated with each other.
Although they had their differences with the kings, as
described earlier, there was an active partnership between
the dynastic families and the monasteries. Iona was the
premier monastery of Celtic Christianity at that time. The
Picts, and the king of Northumbria had been converted to
Christianity and their people followed. Also the great
monasteries of Iona and Lindisfarne trained others from
England who returned to their homes and set up monas-
teries based on Celtic monasticism.

THE SYNOD OF WHITBY – A MAJOR DEFEAT FOR THE
COLUMBAN CHURCH
The kings in the south of England feared that once the
Celtic missionaries had a hold in Northumbria, perhaps
the Dal Riada and the Irish clans would follow. Therefore,
when the first Christian bishop to England was appointed
by the Pope, in 597 AD,[1] the king and the leaders of the

Roman Church quickly formed an alliance in order to pre-
vent the Celts from moving further south into England.
To this end the Synod at Whitby was called in the year
663 AD.

The Synod was in reality a contest for political control
of northern England and Scotland. It was held at a famous
Celtic Abbey of mixed men and women founded by St
Hilda.[2] At the beginning of the Synod the delegation from
the north (the Columban or Celtic Church) were offend-
ed by some slight by the delegation from the south. They
walked out and the reforms were decided upon in their
absence.[3]

The result of the Synod was that the distinctive form
of Christianity promoted by the Columban Church was
outlawed. Tonsure (the shaving of hair), the dating of
Easter and, as this implies, the whole of Celtic cosmology
was eliminated.[4] There were other aspects of Celtic
Christianity that Rome disapproved of. Amongst these
were mixed communities headed by an autonomous
abbess. Whitby was a prime example.

But the core issue was sovereignty – who had the right
to rule? Who was vested with the power to proclaim the
monarch? The Celts claimed that that right came from a
partnership between king and the goddess of the land. The
Roman papacy claimed it was the right of the successor of
St Peter to appoint the ruler of the state. Consequently,
the concept of the Divine Hag of the Celts was anathema
to this claim.

THE CELTIC CHURCH IS EXPELLED FROM NORTHERN
ENGLAND AND FROM PICTLAND
King Nechtan of Pictland, fearing that his country would
be taken over by the Dal Riada (the Irish who had settled

in western Scotland)[5] granted lands to the Roman Church. The clergy and nobility became the king's local agents. The Pictish church was prevailed upon to change to Roman observance and to build new churches in the Roman (Romanesque) style.[6] 'This type of symbiosis between king and church was a recognised phenomenon throughout north-west Europe in the eighth century … Nechtan's reforms were effective and extended as far as the Northern Isles.'[7] The monks in Northumbria who refused to change to Roman rites were expelled from northern England, and many chose to return to Ireland.

ADAMNÁN – SUCCESSOR OF COLUM CILLE

Adamnán (624-704 AD), born 100 years after Colum Cille, a member of Colum Cille's royal family, was the ninth abbot of Iona. Though Adamnán was known to compromise on serious issues, he did not accept the changes made at Whitby until 24 years later and the monks of Iona did not comply with them for nearly 50 years (712 AD). When it is understood that their whole cosmology was eliminated, not just the dating of Easter, and that the Irish system was older and more accurate, the reluctance of the monks to change seems justified.

Adamnán's greatest gift was his extraordinary legal mind, capable of synthesising three legal systems: Canon (Church) law, Natural law and Brehon (Irish) law. His method and his writings formed the foundations upon which European law was later codified in the twelfth century (although history has never given him credit for this massive feat).[8]

He was a man of colossal legal intelligence, and an arch ascetic.[9] He changed the status of women in Ireland with his Law of the Innocents (*Lex Innocentes*). By this law women,

clerics and children were freed from having to participate in battle and were protected from injury.[10] It became a more serious offence to kill a woman than a man.[11]

This law brought Irish law more in line with Roman law and custom, which deprived women of more rights than Celtic law had done. It brought a major setback to the balance between masculine and feminine in the Celtic way of life, that had allowed some women to achieve a higher status than Roman law did.[12] Cáin Adamnán was drafted ostensibly to protect women, but by the same stroke it prevented women from being elected chieftains since they were not allowed to lead their armies into battle. Was Adamnán a pragmatist who had come to accept the inevitable in order to avoid branding the Celtic Church as heretical?

THE SHEELA ON ADAMNÁN'S STONE AT TARA
Adamnán's cross bears a carving that has been described as the oldest datable Sheela. It has been described as 'a rude Pagan carving' and is found on a monolith, or standing stone, about six feet high. The stone itself is red sandstone (red is the colour of the goddess). It remains where it was placed in the seventh century. That it has survived in situ for over 1,300 years through puritanical times attests to the veneration people had for the early saints of Ireland, such as Adamnán. It certainly attests that Adamnán still believed in the power of the Divine Hag.

This ancient carving is highly stylised and very weathered, but on close inspection, there is no mistaking the hunched shoulders, the bald head, the big ears, the squatting position, and the long arms pointing to the vulva. This Sheela is more a symbol than a human being. Its placement at Tara of the Kings and the association of the

Divine Hag with sovereignty was an appropriate memento of Adamnán's Law, *Lex Innocentes*. It remains a visible reminder that rulers and leaders must care for the land and people in order to be successful. Nearby (as was the custom in many pre-Christian cultures) is a small lingam stone, the masculine counterpart.[14] The pair of stones are known as Bloc and Bluigne.

The imagery of the Divine Hag continued to appear on stone carvings in the eighth century even in Pictland, which had been converted to Roman Christianity over a century before.

THE DROSTEN STONE

The Drosten Stone and a number of other memorial slabs of the first importance are on display at St Vigean's, near Arbroath, Scotland. Vigean (the Latin name for St Fechin, its Irish founder and the founder of Fore Abbey in Westmeath) died in the mid seventh century.[15]

The stone, probably carved in the eighth century, is a Celtic High Cross, over six feet tall. It is inscribed with three names at the bottom, most likely the names of the patrons or the carvers: Drosten, Uoret and Forcus.[16] One side carries thirteen personal and status symbols used by the Picts, including an elephant, a serpent, double disc, crescent, mirror and comb, a bowman and wild boar.[17] All of these symbols are goddess symbols with the exception of the bowman. The other side of the cross is intertwined in the Celtic style. The Picts, like the Celts, obviously transmogrified their goddess symbols into the new religion.

The Sheela on the Drosten Stone

Almost unnoticed on the upper right corner of the cross is a Sheela. The carving at first sight appears to be an angel.

SKETCH OF THE SHEELA ON THE DROSTEN STONE AT ST VIGEAN'S, NEAR ARBROATH, SCOTLAND, is one of the earliest definitely datable Sheelas, because of its Pictish symbols.

The wings are in fact shoulders lifted in the hunched position typical of Sheelas. The head is large, in the pagan style, with prominent cheekbones and a heavy jaw. Instead of the protruding ears, this carving seems to have horns sprouting on top of her head. The legs are turned out and she is crouching in the typical Sheela position with knees drawn up near the navel – all features of early Sheelas.

This stone, carved within a century of Whitby, at what had been a Celtic monastery, indicates the negative transformation of the Great Mother into a type of devil. However, the Sheela is also a symbol of death and transformation, and would have been a suitable image placed above the arm of the cross. Interestingly, it is not on the left side of the cross (the side of negativity) but on the right. What were the carvers trying to convey – both Picts and Celts? Surely they were affirming the existence of the feminine deity and the power of the Divine Hag to regenerate. Fortunately, this stone has been preserved, though the significance of this carving is ignored.

THE ATTITUDE TOWARDS WOMEN IN EARLY IRISH SOCIETY
With few exceptions, women were not appreciated in a

society that valued warfare above all else. Only the woman who was successful on the battlefield was equal to the heroes idolised by old Irish society. Queen Maeve of Connacht (*c.* first century AD) and Grace O'Malley of Mayo (sixteenth century) are examples of esteemed women.

Women were possessions – they were legally dependent upon men. If an offence was committed against any woman her honour price must be paid not to herself but to her male guardian. Women could not inherit land. If there was no male heir in the family, a woman might be permitted to have her father's lands but only for her lifetime. Then it reverted to a male in the family. A woman could not make a valid contract without the permission of her superior:

> ... her father has charge over her when she is a girl, her husband when she is a wife, her sons when she is a (widowed) woman with children, her kindred when she is a 'woman of the kin' (that is, with no other guardian), the Church when she is a woman of the Church (that is, a nun). She is not capable of sale or purchase or contract or transaction without the authorisation of one of her superiors.[18]

Kelly notes the remarkable similarity to the Indian laws of Manu with regard to women in the above respect.

No Illegitimacy in Celtic Society
One reason for considering women in Irish society to be better off than their English and continental neighbours were the marriage laws. There were nine degrees of marriage in Brehon Law: any union which produced a child was considered a marriage, and the father was expected to provide for the child's maintenance – a major change from

the matrifocal society which prevailed in earlier times when a mother's kin were responsible for the child and its upbringing. The mother's male relatives provided the masculine influence on a child in former times.[19]

PATRIARCHAL INFLUENCES
As the Christian Church came more under Roman control, women were further excluded. Nuns were no longer independent, even abbesses were under the authority of the bishop. Women no longer held high office in the church and mixed communities of men and women were prohibited. Noble women could no longer hope to become chieftains. Although celibacy could not be enforced completely until well after the twelfth century on the continent, and even later in Ireland, it was promoted as the superior spiritual way of life.

EMPIRE BUILDING – STATE AND CHURCH
The Dark Ages of Europe gradually came to an end during the eighth century as the threat of invasions by hoards from the east died away. The nobility on the continent began to take control of their territories and society began to settle into an ordered system. Rome had become a strong temporal as well as religious power and the Pope as the temporal ruler of the Roman State, with spiritual authority over the Holy Roman Empire, made alliances with the monarchs of Europe. The leaders of the Celtic Church were forced to compromise – perhaps realising it was useless to resist the power and authority of Rome.

Unquestionably the cult of the Sheela as the symbol of the Great Mother was labelled one of the 'pagan practices' of the Irish church that Rome wanted 'reformed'. No mention of the carvings or of the name 'Sheela' was made

in the *Annals*, though they were placed in all the great centres of Christianity in Ireland.

THE VIKING INVASIONS

As Europe recovered from the Dark Ages, Ireland went into a period of decline, partly due to the corruption of the clergy and the kings, and the Viking invasions added to that instability. Iona, being the nearest to the homeland of the invaders, was attacked three times between 795 and 806 AD. Lindisfarne and other Scottish monasteries were decimated. Murder, looting and destruction caused havoc on the abbeys, and on the people. Vast wealth and treasures in gold, silver and bronze were pillaged and the great libraries of books were burnt.

The Iona monks established a monastery in Kells in County Meath after the third invasion, and though Iona remained a functioning monastery this move marked the end of Columban influence on the Christian Church of Scotland. Kells became a major influence in the affairs of the Irish Church during the following centuries. Although they had been defeated at Whitby, they set up a whole new system for renewal of the Irish Church from within.

REVIVAL OF THE CELTIC MONASTERIES – NINTH AND TENTH CENTURIES

In spite of the Viking invasions, which were sporadic, the monasteries continued to be the centres of life, learning and wealth. A reform movement called the Céili Dé (the servant or client of God)[21] began about 750 AD within the monasteries. Basically they called for a more ascetic life, prayer and fasting, giving up vast wealth and luxurious living, and caring for the spiritual welfare of the people.

A new style of monastic architecture developed replac-

ing wood, wattle and daub structures. Stone was used and corbelled roofs constructed in buildings that were beautiful, enduring and also provided a greater protection from the enemy. Exquisite sculptures in the form of high crosses were carved at this time and many were placed just outside the gates of the abbey. The monasteries became the focal point of the market squares in the towns that later developed around the abbeys.[22]

> There is nothing in Europe of the time to compare with the elaborate schemes of imagery which were finally worked out by the Irish artists on great monuments like Muiredach's cross at Monasterboice or on the Cross of the Scriptures at Clonmac-noise, erected early in the tenth century ...[23]

The Cross of Kells is another outstanding example of a high cross skilfully carved by a master craftsman. It is called 'the Cross of Patrick and Colum Cille', indicating a truce between the two branches of Irish Christianity at that time and that the monks at Kells, though their founder had been Colum Cille himself, had given primacy to the Roman sect by the ninth century.[24] There was a Sheela at the Kells monastery also, but it has disappeared and only a record of it now survives.[25]

The Sheela in a Round Tower

A new feature of Irish monastic architecture introduced at that time was the round tower, constructed with doors about fourteen feet above ground level. Entry was difficult and could be made only by ladders, which would be pulled up after the monks had entered. There are many theories about the purpose of the towers, mainly that they were

built as defences against enemy attacks. In seeking to find a religious purpose for the towers, they may have been a northern variation of the stylites found in the Middle East in the middle of a crowded city, where hermits would retire to spend years in prayer high above the throngs of people.[26] The Irish monasteries had become virtual towns, and there were few places a hermit could escape to pray. The clever abbot of Rattoo, County Kerry, ordered that the Sheela be inserted high in their round tower, where she could be venerated in silence.

The cult of the Sheela seems to have endured in Ireland during the ninth and tenth centuries. Although the Irish Church was willing to compromise, it was not willing to give up its theology entirely. Perhaps there is some truth in the Papacy's complaint that the Irish Church was a law unto itself.

Sheela stood for the eternal truth of death and transformation. Death itself became something to be feared by the Roman Church as it rejected the psychological truth that all life in the end returns to the Great Mother so that regeneration can occur. In the tenth century, Rome forbade the chanting of certain early Irish hymns because they were on the subject of death.[27]

SHEELAS CLASSIFIED AS PAGAN IDOLS ALONG WITH THE VIKING GODS

An attempt was made to dispatch the Sheela symbol along with all the pagan gods of the Vikings, and eliminate them. But old customs and traditions do not die easily – particularly with people as conservative as the Irish. The next stage in the demise of the Great Mother was the process of 'occulting'.

Chapter 6

THE SHEELA IS OCCULTED

Pressed to eliminate the Divine Hag from their theology and ritual, the abbots of Celtic monasteries opted for a gradual process: Sheelas were initially occulted on Romanesque churches during the eleventh and twelfth centuries. Their significance eventually shifted from being a symbol of the deity to one of immorality and a warning against sexual excesses.

EUROPE AND IRELAND DURING THE ELEVENTH CENTURY

As the first millennium came to a close there was widespread expectation that the world would end at the year 1000 AD. Instead, a period of prosperity and advancement developed both in Ireland and on the continent. The eleventh century was the turning point of the 2,000-year cycle of the Piscean Age.

Order was restored in Ireland after the defeat of the Vikings (1014 AD). Monasteries were thriving, and the reforms called for by Rome in the seventh century had been implemented from within the Celtic monastic system during the eighth, ninth and tenth centuries. Because the Papacy was focused on building its power base in central Europe it did not interfere in the affairs of the Celtic Church until the twelfth century. In fact, there was no

communication from the Papacy to the Irish Church for over 200 years.

Left to develop in their own way, monastic schools were secularised and great scholarly works such as traditional sagas, genealogies and Latin epics – all were translated into Irish, and histories and devotional literature abounded. Exquisite metalwork in the Romanesque style was crafted and Romanesque churches were added to the buildings at Irish monasteries.[1] King Cormac's Chapel on the Rock of Cashel is perhaps the most outstanding example, with its uniquely Irish zoomorphic figures, interspersed with exquisite carvings of flora and fauna. There were over 200 native Irish monastic centres, all thriving under the patronage of the local and provincial kings at the time continental orders of priests were sent over to replace native monasteries. The Sheelas remained on the churches and at holy wells.

Irish missionaries were still active on the continent, moving further into central Europe, where they established monasteries in Germany and Czechoslovakia,[2] though the Roman Church did not always welcome them.[3]

PILGRIMAGE

Pilgrimage had always been a part of religious practice, even in pagan times, and it continued to be an important aspect of Christian life. Thousands of people from all walks of life had travelled over the sea to pray and study in Ireland during the Dark Ages, and in the early Middle Ages this practice continued. Pilgrimages provided the opportunity to do penance for sins but they were also social occasions involving travel, adventure and the chance to meet different people from all walks of life. Every year pilgrims visited local Irish centres like St Patrick's

Purgatory in County Donegal,[4] Ballyvourney in west Cork, Clonmacnoise Abbey, Iona and Whithorn in Scotland. Some made the great journeys to Campostella in Spain, to Rome, or on the Crusades to the Holy Land. On the route to Santiago many of the Sheelas are still found on eleventh- and twelfth-century churches where pilgrims stopped to pray.

THE POLITICAL SCENE

Across Europe, strong monarchies with central governments had been established. The Roman Church had become the most powerful influence in the Western world and the Papal State was becoming the most influential and powerful kingdom of Europe. Pope Gregory VII made a further bid for temporal power, humbling the German emperors and imposing Roman laws and taxes on all Christian states.[5]

Unfortunately for Ireland, neither the northern or southern Uí Néill nor any other dynastic line was strong enough to sustain a central monarchy. For the first time in history, the Dal Cais of Munster, under Brian Boru, united the country, but after his death in 1014 AD, none of his descendants was strong enough to attain the monarchy of Ireland uncontested. Tribal warfare between the Irish septs (clans) continued much as it had through the previous centuries.

THE CRUSADES

On the continent, however, the warlike and violent character of the men who were not so successful at claiming control of lands and possessions needed to be channelled outwards, to prevent inter-tribal warfare that would have weakened the central monarchies. The violent element was particularly strong in France – ferocious carnage occurred

when private armies invaded Russia, and when William of Normandy conquered England in 1066. The Crusades were inaugurated at the end of the eleventh century by the Pope and the European monarchs to deal with that threat.

The Crusades combined the idea of pilgrimage to the Holy Land with a series of wars against the Muslim 'infidels' who had taken over Jerusalem. There were seven crusades in all and they became 'a license to kill' in the name of Christianity. Not only did the people in towns and villages on the Crusaders' route suffer, many thousands of Crusaders died of starvation, disease and hardship.

> The Crusader 'movement', as it is sometimes called, stretched over a period of 200 years, unleashing a frenzy of hate and violence unprecedented before the advent of the technological age and the scourge of Hitler. The madness was initiated in the name of religion by a Pope of the Christian Church, Urban II, in 1095, as a measure to redirect the energies of warring European barons from their bloody, local disputes into a 'noble' quest to reclaim the Holy Land from the 'infidel'. Once unleashed, the passion could not be controlled. The violence began with the massacre of Jews, proceeded to the wholesale slaughter of Muslims in their native land, sapped the wealth of Europe, and ended with an almost unimaginable death toll on all sides.[6]

On a positive note, the Crusades had a profound influence on those who travelled and, resulting from their experiences, on the Europe to which they returned. There was a sense of unification of the different countries of Europe as participants from the continent, England, Scotland and Ireland focused on a common cause. The art,

culture and philosophical concepts of Islam were fascinating to Europeans who brought them back to Europe and incorporated them into the great new cathedrals that were built at that time.

These ideas were not so astonishing to the Irish and the Celtic Church.[7] What the Irish Crusaders met in the Middle East was a reminder and a confirmation of their ancient beliefs in God manifest through feminine symbolism.

THE REDISCOVERY OF SYMBOLS FROM ANTIQUITY

Returning Crusaders[8] brought back to Europe the Black Madonna and other symbols from Islam, which began to appear on continental churches, such as Sagrado di San Michelle in France, where the zodiacal constellations are carved. A number of Cathedrals built in northern France depict such imagery most notably at Chartres which was previously a great Druidic oak grove. Ireland also has some exquisite architecture from this period: the Nun's Chapel at Clonmacnoise Abbey is full of symbolic motifs and King Cormac's chapel, at Cashel, Tipperary is an outstanding example of the genre. Some carvings express the idea of the

DETAIL OF ROMANESQUE ARCHWAY AT THE NUN'S CHAPEL, CLONMACNOISE. A Sheela is positioned at the top left.

dark and the light Moon – for example, the tears of Isis and her dark sister Nephtys are portrayed at Chartres Cathedral. All the imagery of the dark moon had been removed from Christian symbolism, with the exception of the Sheela.

One of the most important of those symbols was the *kteis* – a symbol of the female organ. It was an Egyptian hieroglyphic symbolised by two crescents (). The *kteis* or the *Visica Piscis* was a symbol of the vulva of the goddess.[9] It was 'at one and the same time – a mouth and a doorway into the spiritual world, an initiation hall or birth passage between the material and the spiritual'.[10] Irish tradition had retained this imagery in the symbolism of Brigid 'born on the threshold' – in the doorway. The Sheela of Kilpeck is an excellent example of the imagery of the Great Mother – her body both the entrance and the exit from life itself.

THE 'LITTLE MOUTH' OR GOBEEN AT THE AUGUSTINIAN ABBEY, BOYLE, COUNTY ROSCOMMON

In a very discreet carving, at the top of a column in the beautiful thirteenth-century Romanesque Abbey at Boyle is a rendition of the Divine Hag – the hole in her mouth being the most distinctive feature. The carving is executed in a different type of stone to the column on which it has been placed, indicating that, as in so many other instances, it had been preserved from an earlier building. The Augustinian friars had been sent to Ireland along with many other continental orders to eradicate the old Irish monasteries, and they often built on the site of the earlier monasteries. Though they eliminated the earlier architecture, it stands as comment on the beliefs of the Irish people that the newcomers could not entirely eradicate the symbols of the old, strongly held tenets. Nonetheless, it was placed far too high to touch

CARVED HEAD IN THE
TWELFTH-CENTURY
AUGUSTINIAN ABBEY,
IN BOYLE,
COUNTY ROSCOMMON.

it or to take rubbings, or for that matter to notice it. This indicates the process of occulting.

The early medieval church known as Kilgobbin at Sandyford in Dublin, and St Gobnait's at Ballyvourney, Cork may refer to similar aspects of Brigid. The mouth is also a symbol of the Oracle as seen in the beautiful carving from Knowth, County Meath, (*c.* 3500 BC). Stones with round holes are symbols of regeneration and healing and are found in many places in Ireland, Scotland, England and continental Europe on megalithic dolmens, passage graves, and slabs.

THE MOUTH OF THE ORACLE,
KNOWTH, COUNTY MEATH,
is exquisitely carved from flint
and polished. Note the spiral
eyes and snake spirals on the side
of the head.

COURTLY LOVE AND THE CULT OF MARY

The Crusades opened the minds of the nobility, poets and musicians to the feminine. A form of chivalry developed that went beyond the power to destroy: it was a new ethic of love not based on legal marriage. For the first time in history this romantic and idealistic love placed the beloved woman on a pedestal. She was symbolised as good, pure, cultured and full of feminine wisdom. The knight to whom she gave her affection was her champion in the jousting arena, her protector from the slander of others. Through his love for her, he sought to develop the most noble of masculine virtues. This new ethic was lauded in poetry and song by the troubadours of France and practised by King Arthur and the Knights of the Round Table.

The cult of the Virgin Mary was an extension of this idealism of the feminine as 'perfection'. St Bernard of Clairvaux was a key figure in the introduction of this imagery.[11] Mary was lauded as the all-perfect mother, pure, conceived without sin, conceiving without sex, living in a marriage but never consummating it. This was a new form of the goddess, but she was not to be thought god-like, merely a mediator between man and God.

THE IMAGERY OF MARY

Statues of Mary reveal her disempowerment: hands held down at her sides, whereas the goddess held her hands high above her head – an action used by the priest at Mass during the consecration of the bread and the wine, and in the final blessing. Mary's foot is resting on the head of the serpent symbolising the conquest of sexuality – the serpent being equated with the devil in Judaeo-Christian theology. Here is an example of a negative transmogrification of the older religions bringing the imagery into Christianity.

However, most of the symbology of Mary introduced at this time as attributes of Our Lady were positive. Many of these symbols are mentioned in the Litany to Our Lady: Mystical Rose, Star of the Sea, Vessel of Honour, etc.

During this period paintings of Our Lady began to appear surrounded in light in the shape of the *kteis*. The cult of Mary was developed from the symbology of Isis, as both Mary and Isis represent the light side of the moon (there are many medieval pictures of Mary standing on the moon.) The circular rose windows of the medieval cathedrals were symbols of the feminine deity.

The churches built around this time are often dedicated to St Mary at places that had formerly been sanctuaries to Brigid, for example St Mary's at Abbeylara, County Longford and St Mary's at Clanaphilip, Cavan – both which feature carvings of the Divine Hag.

The effects on women of the Virgin imagery

The cult of the Virgin Mary intended to redress an imbalance, but it intensified the growing imbalance between masculine and feminine polarities. All the natural cycles of birth, transformation and death were replaced by a symbol that was impossible for human women to emulate. God was a patriarchal father – men could imitate that image and became patriarchs; yet women could not be virgins and mothers at the same time. In Christian theology, the Virgin Mary was the only perfect woman. The darker side that leads to empowerment and wisdom was rejected, and all women by their very nature were considered by official Christian theology to be unclean, sinful and evil.

Standing triumphantly over the serpent/goddess, the Virgin Mary embodies the double jeopardy into which

Christianity had plunged women. By accepting Mary as model, women would become complicit in their own oppression, helping to eradicate the essential mystery at the heart of life and positing a stark dualistic theological system in which good resided in the realm of the spirit and evil in the realm of their own uncontrolled sexuality ...[12]

Women who refused to conform to the strict standards set by the social and religious mores found themselves categorised as witches, whores, bawds. They became the scapegoats of society and the scene was set for the witch hunts of the following centuries. When the Crusades ended, a new class of scapegoats had to be identified to take the negative projections of a society that would not look at its own darkness. But that was later – for the present the Irish were able to retain their Divine Hag on the new medieval churches.

SHEELAS OVER THE ENTRANCE TO CHURCHES
Building churches in stone rather than wood and wattle had been the practice since the Viking invasions. Many Sheelas were placed above the entrance door. In Christian symbology this placement symbolises the transformation that the faithful would undergo as they went into the womb of 'Mother Church'. The doorway of the church, like the vulva of the Great Mother, was the gateway to rebirth, to spiritual transformation. The faithful were spiritually healed in the darkness, and symbolically reborn as they exited into the light of day.

The Sheela at Killinaboy is placed high over the entrance doorway to the medieval church. What remains of the round tower is nearby. The church itself has been

rebuilt a number of times and the carving may have been removed from a previous structure. Referring to this carving, Mary Condren associates the Sheela imagery with Brigid, the saint and the goddess:

> … her maternal imagery reappears throughout her career as a saint: Brigit is the mother of the particular saints, and in the medieval church at Killinaboy her image, a Sheela-na-gig (a figure holding the entrance to her womb wide open) is carved on the top of the arch to the door, effectively allowing the congregation to enter through her 'womb'.[14]

The placement of the Sheela high over the doorway may have acknowledged this maternal imagery, but it prevented the ordinary people from touching the carving which had been their customary ritual. This was an initial step in the process of occulting.

OCCULTING

The word 'occult' means 'secret' or 'hidden'. Occult knowledge is information that is guarded, kept a secret by a select few. The purpose of occulting powerful symbols is to hide them, so that they are seen, but difficult to identify at first and are generally overlooked. Occulted symbols are often placed upside down, reversed or on their sides. (A well-known example of occulting was the swastika, a symbol of the goddess, which the Nazis turned backwards and used as their official emblem.) Symbols that have been venerated by millions of people over millennia hold enormous power.[15]

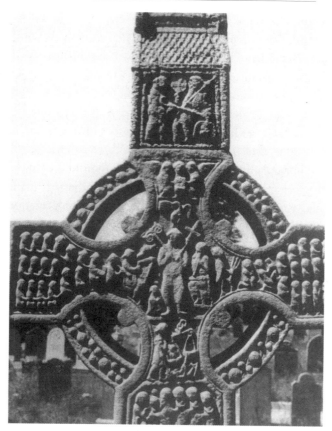

CROSS OF MUIREDACH, MONASTERBOICE, COUNTY LOUTH, showing the last judgement.

THE OCCULTING OF THE SHEELAS

The first step in the process of eliminating the Sheela was to occult the carvings – to make them almost invisible, without exactly hiding them. In seeking out the Sheelas, for example, it is difficult at first to find them because they blend into the walls on which they were inserted. The effect is that it is there – but not there. The process had already begun at the beginning of the tenth century with

Muireach's Cross at Monasterboice. There, a 'pagan' figure of lust (or is it two – or is it a Sheela?) is depicted in the final judgement scene as being cast into hell by Satan, holding a pitch fork. Monasterboice may have conformed to Roman pressure, but that compliance was not universal, either in Ireland or England, in the twelfth century.

Another striking example is on the Drosten Stone in St Vigean's, near Arbroath, Scotland, carved around the end of the eighth century. Here, above the right arm of the cross, is a Sheela, but no mention of this carving is made in all the descriptions of this famous stone. This is a good example of a *skitoma* – preconceived ideas are so powerful that the mind blocks out the incongruity of the Sheela on the cross and our eyes are overridden. Thus the viewer may see an angel instead of the Sheela.

It was more difficult to try to convince the ordinary people that what they had worshipped for hundreds of years was now considered an aspect of the devil. It is not possible to excise the ancient beliefs of a people simply by changing the law.

> In all lands and at all times since the advent of 'civilisation' man's religious beliefs have been classifiable between the 'official' and the 'unofficial'. The 'official' belief is always that of the dominant ruling class, whose acceptance of religious theories may – and almost always is – influenced more by political and economic advantages than by the more abstract benefits of theological conformity ... With the non-ruling, and therefore subordinate, part of the population, where emotion and superstition, rather than sociological reflections, incline the mind towards Higher Things, religious views may well not accord with those

of the 'official' religion.[16]

OCCULTED SHEELAS AT LIATHMORE, OFFALY AND WHITE ISLAND, FERMANAGH

Liathmore was an abbey founded in 560 AD by St Mochomog, on an expansive plane in Tipperary surrounded by mountains. Two churches and the remains of a round tower are all that is left of the once thriving monastic settlement. The last abbot of Liathmore died in the eleventh century[17] and no further abbot was appointed, indicating that this was one of the Celtic monasteries that were forced out of existence by the continental orders introduced as a result

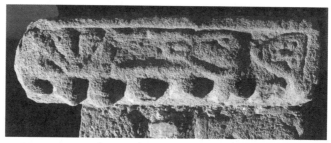

OCCULTED SHEELA AT LIATHMORE, COUNTY TIPPERARY, inserted in the occulted position at the entrance to the church.

of twelfth-century reforms, though the church itself 'continued to be in use down to the sixteenth century'.[18]

The Sheela at Liathmore is carved in red sandstone, red being the colour of the goddess, and it is occulted. It was placed at the entrance – the south doorway to the Romanesque-style church. This Sheela is artistically carved with detailed decoration at the bottom, leaving no doubt of the carver's intention to insert it sideways, in the occulted position. The triangular pagan head and hands emphasis-

ing the pudenda classify this carving as conforming with the early imagery of the Divine Hag, though the occultation demonstrates the changing attitude within the Celtic Church itself towards the Sheela symbol. Nonetheless, this carving was not placed so high that it could not be touched by the person entering the church and thus permitted the continuation of the pre-Christian custom of 'rubbing'.[18]

The church at Liathmore had been rebuilt several times during the Middle Ages, and a number of very old carvings have been inserted in the later structures, which seems to have been the custom of the times. As a result of the weathering, and other carvings in a similar condition, it can be surmised that they came from the first stone church that had been built at the monastery (between the seventh and the tenth century). A smaller and older church with corbelled roof in the style of St Kevin's kitchen at Glendalough establishes Liathmore as contemporaneous with Glendalough.

SHEELA AT WHITE ISLAND, COUNTY FERMANAGH, where the Romanesque church was built in the eleventh century. The figure on the left of the group now embedded in the wall of the church was originally inserted in a wall outside the entrance to the church in an occulted position.

What Liathmore demonstrates is the downgrading of what had been a key concept of Celtic monasticism. It was a subtle transition in the process of eliminating the Sheela symbol from the official Christian tenets during the tenth and eleventh centuries.

The Sheela at White Island, County Fermanagh is another example of occulting. When the church was built around the eleventh century, the carving was inserted beside the entrance in the occulted position. More recently the carvings have been gathered and placed on a wall inside the church.

White Island is a beautiful example of an early Celtic monastery – chosen by its founder for its isolated position on a lake in County Fermanagh. The island is uninhabited and overgrown now, but the sense of peace and of silence is mystical. The only access is by boat, giving the sense of pilgrimage sought by the early Christians.

SHEELAS IN AND OVER WINDOWS
Even more frequently than above and beside the entrance to churches, Sheelas appeared close to or over a window in Irish, English and Scottish examples, and they date from early as well as later medieval times.[19] When they were placed on an outside wall, it was most often on the south side – the side that gets most light in these northern countries. Examples include the church at Kilsarkan, County Kerry, at Ballyvourney, County Cork and that at Taghmon, County Westmeath. When in later medieval times they were incorporated into castles they were often placed in a window like that at Bunratty Castle in County Limerick.

DID SHEELAS SERVE A DIDACTIC PURPOSE?
Some astonishing carvings appeared on Christian churches

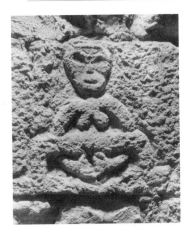

THE BUNRATTY SHEELA,
COUNTY LIMERICK.

in England during the twelfth and thirteenth centuries. Figures of naked men and women in lewd poses decorated continental and English churches. They have been interpreted by some scholars as having a didactic purpose – warning the faithful against the sins of lust and greed.

Lust and greed were the very vices that were secretly obsessing the hierarchy and clergy, who found it difficult to adhere to their vows of poverty and chastity, and projected their vices onto the laity. 'The female exhibitionist is ... the fruit of an unbelievable misogyny.'[20] Christian theologians had claimed that women have no souls, are untrustworthy, dishonest, incapable of giving true witness in court, and that any man who touches them is defiled.

The carvings, like the Cavan Sheela, served to shock people by ridiculing and satirising those who indulged in sexual excesses and avarice. That message, of course, applied to clergy as well as lay people. Geoffrey Chaucer in his *Canterbury Tales* immortalised the bawdy humour of the medieval period.

Some scholars are of the opinion that the carvers did not consider their work obscene – they saw it as a moral

warning – to demonstrate the fruits of sin and to frighten people from it. They were '… serious works that dealt with the sexual mores and salvation of medieval folk, and thus gave support to the Church's moral teachings'.[21]

AN ASSERTION THAT THE OLD RELIGION STILL APPLIES?

An alternative theory is held by some scholars who believe that in England the art of the Christian Church from the eleventh to the fifteenth century was anything but Christian and that grotesques were set up to indicate that the old religion still applied. The carvings were meant to mock in every way the anti-life asceticism of the clergy. Illustrating the point, Harrison refers to the Sheela in the late Saxon or early Norman Church of St Mary (this name always refers to a goddess site) at Whittlesford, Cambridgeshire. Carved on a single piece of asymmetrically shaped stone is a Sheela, on her hunkers with vulva exposed. Beside her the phallic symbol is graphically depicted in the form of a man with the body of an animal – the grossly exaggerated penis is directed at her from the other side of the arch of the window. 'The Great Mother, Sheila-na-Gig surely is … in her crudest, least ambiguous aspect: the Female Generative Principle, completely "despiritualised", and free from all irrelevant "higher" associations.'[22]

PHALLIC SYMBOLS BURIED UNDER HIGH ALTARS

Adding credence to the above theory was the discovery of stone lingams buried in the altars of eleventh- and twelfth-century English churches. The partial destruction of buildings by German bombs during the Second World War led Professor Webb, an expert in medieval church architecture, to an investigation that ascertained 90 per cent of all medieval English churches which he examined had, in the

interior of the altars, a stone lingam '... that master-sym-
bol of the ancient, world-wide Fertility Cult: the universal
Phallus by which all animal life was generated'. These
lingams were found in churches built up to the time of the
Black Death (1348), after which there was no further
building for some time.[23]

CHURCH REFORM IN THE TWELFTH CENTURY

The brief period of openness to new ideas in culture and
religion ended when reactionary countermeasures were
taken by Rome in the twelfth century. The major issue was
the question of married clergy, simony (the taking of
money by the clergy for religious ceremonies they per-
formed) and, in Ireland, the lack of a diocesan system to
minister to the faithful. Rome wanted a diocesan system
whereby the Papacy held the right to appoint all bishops,
who would appoint all clergy. Thus all tithes and taxes
would be paid to Rome's nominees and the lands on which
the churches stood, and the wealth from them, would
accrue to the Papacy. In effect Rome wanted to eliminate
the Celtic monastic system whereby the abbot was
autonomous. Moreover, it wanted to end the influence
and interference of kings and chieftains who were allied to
the great Irish monasteries.

The twelfth-century reforms were designed to wrest
from the great families the vast lands and wealth of the
monasteries. The practice of hereditary entitlement to
church benefices (common custom throughout Europe)
was to end.[24] The Synod of Cashel (1111 AD) marked the
beginning of the process whereby the old Irish monastic
system and the Irish monasteries were doomed. They were
replaced with a diocesan system and continental orders of
monks replaced the Celtic form of Christianity.[25]

THE CELTIC FLAW

Some Irish kings saw the call for reform as an opportunity to defeat their opponents. At the Synod of Cashel, King Muirchertach O'Brien, descendant of Brian Boru, gave the lands of Cashel, the traditional seat of the MacCarthy Kings of Munster to the Roman Church forever. He did this so that the MacCarthys, rivals of the O'Briens for the kingship of Munster, would no longer have a royal residence. O'Brien saw the Synod as an opportunity to consolidate his power base, but this act marked the beginning of the disintegration of the Irish land laws. It initiated the loss of the hereditary rights of the Irish septs to their ancient lands.

Rome gained all monastic and church lands, and autonomy over clergy and the religious by 1152, when the diocesan reform was completed at the Synod of Kells, County Meath. The country was then divided into 36 sees, with four archbishoprics: Armagh, Cashel, Dublin and Tuam.

CONTINENTAL ORDERS BROUGHT TO IRELAND

As part of the reform, many European orders were introduced to Ireland. The Benedictines and Cistercians[26] had arrived in the eleventh century. New orders of friars – the Augustinians, Franciscans and Dominicans – established monasteries around the country, during the twelfth and thirteenth centuries, attracting young Irishmen to join their communities, further weakening the native Irish monasteries, which, if they refused to conform, were left with neither an abbot nor the patronage of the local king.

THE CISTERCIAN ABBEY SHEELA

One of the most fascinating Sheelas, though badly eroded, is the carving at St Mary's Abbey, Abbeylara, County

Longford, as discussed earlier. The holy well at Kilbride is nearby and the Sheela may have come from that earlier church. The insertion of the ancient carving at Abbeylara was clearly a concession to the local people's faith, while at the same time it terminated the practice of their ancient rituals.

Andersen noted a number of Sheelas on Romanesque-style churches in twelfth-century England, citing Kilpeck, Tugford, Holdgate, Austerfield, Benstead, Rath, and some Irish examples. Many of these places are on the early pilgrim routes. That at Whithorn, Scotland has recently been unearthed during the excavations of the Romanesque cathedral. Whithorn originated, as discussed, from the same monastic traditions as the early Irish monasteries and was a great pilgrimage centre, from the time of its foundation in the fourth century down to the late Middle Ages.

Two Sheelas at Clonmacnoise Abbey

Clonmacnoise was one of the largest and most distinguished of the Irish abbeys. Founded by St Ciaran of the Aran Islands in the fifth century, it was the premier monastery of the west, second only to Armagh, and a great centre of learning. There are a number of notable carvings at Clonmacnoise, including high crosses and two Sheelas. The carving on the north pillar of a medieval High Cross shows a pagan type, cross-legged figure. This is not a Sheela, but there is one in the museum at the abbey.

The second Sheela is on the Romanesque arch at the entrance to the Nun's church. It is inserted within the diamond (or lozenge) pattern. The posture of this figure, with legs and feet raised above the head, is more reminiscent of Hindu goddesses than any other Sheela in Ireland. The Sheela at Clonmacnoise may have a nun's cowl on her head, but she has a mischievous grin and is displaying her

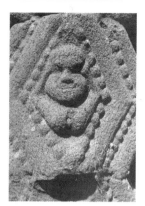

SHEELA ON THE CHANCEL OF THE NUN'S CHAPEL, CLONMACNOISE ABBEY.

genitals and anus, more like a Baubo[27] than a Sheela. The carving is executed with high artistry, but this is more a mockery than the earlier examples of the pregnant mother in the old birthing position. This carving, and the exquisite arch of which it forms a part, appeared about the same time as the grotesques in England and on the continent. The arch is replete with symbols of the goddess; note the triangles, diamond shapes, meanders. The dots or seeds represent the masculine principle.

The Queen who endowed the Nun's Chapel

The Sheela on the Nun's Chapel may have been a form of ridicule of the benefactress who paid for the building of that chapel by pointing the finger at her adultery – a Queen named Devorgilla – or perhaps it was a monument to her courage. The daughter of a king, she was married to Tiernan O'Rourke, King of Breffni. She had been abused by her husband and to spite him arranged to elope with Dermot McMurrough, King of Leinster.[28] To take away a king's wife was the greatest of insults. O'Rourke appealed to the sovereign, Turlough O'Connor, who brought an army into Leinster to defeat MacMurrough. Devorgilla was returned to her husband along with her cattle and pos-

sessions. A compensation of 100 ounces of gold, her 'honour price', had to be paid by MacMurrough to O'Rourke.[29]

Devorgilla did not stay long with her husband, but retired to Mellifont Abbey, a newly-built Cistercian monastery in County Louth. Her great benefactions to Mellifont and Clonmacnoise are recounted in the *Annals of Ireland*, as well as the fact that she did penance for leaving O'Rourke. The Brehon laws did not condone wifely abuse, but the clergy of the time obviously did. Devorgilla was the daughter of a king, wife of a king and mistress of a king, but there was nothing left for her to do with her life after her abduction than to retire to a nunnery! At least she was saved from further abuse and managed to live a long life, dying in 1193 at the age of 85. Women of lesser status would not have fared so well.[30]

THE RAPE OF THE ABBESS OF KILDARE

O'Rourke was a wife abuser, but MacMurrough was even less likeable – even his own people disliked him. MacMurrough's army, under his instructions, attacked and pillaged the abbey of Kildare. The abbess was raped and driven out, and a relative of MacMurrough's replaced her. Mary Condren points to this rape of the successor of St Brigid of Kildare as 'the final symbolic blow to independent female power in the Irish church'. She also refers to the Gregorian reform movement as an onslaught against women in an effort to consolidate power in Western Christendom.[31]

Once revered symbols of creativity, [women] have become signs of danger and pollution; transformed into virgins, they now need to be 'protected'. The

church may well have begun by protecting women from the power of the male warriors, [Adamnán's laws] but who would now protect women from the power of the male church?[32]

The mockery, destruction and eradication of feminine symbols was documented and celebrated by the Christian hierarchy. The loss of those symbols parallelled the slow erosion of essential feminine values, such as responsibility for life and the preservation of it, the care and nurture of the child, the family and the clan. This was a gradual process and hardly recognised at the time.

The image of the Sheela, a symbol of the Divine Hag, had to be excised from the consciousness of the Irish people. Like all the other symbols associated with women and the feminine aspect of God throughout the western world, she was a threat to the authority of the Roman Church and must be eliminated:

> ... any other sources of authority, whether derived from hereditary succession, charismatic leadership, generations of religious tradition, or especially from symbols associated with women, were to be superseded and, if necessary, destroyed.[33]

When the Church reforms of the twelfth century began to have their full effect, certainly during the thirteenth century, Sheelas disappeared from the churches on the continent, England and Scotland, reflecting the demise of Celtic Christianity outside of Ireland, whereas within the country they had been occulted during that period and did not entirely disappear. Political events, however, were to occasion their appearance on medieval castles.

Chapter 7 —————

SYMBOLS OF 'LUCK' ON CASTLES –
A HEX ON ENEMIES

Betrayed by the Papacy, Ireland was invaded by the Normans and submitted to the King of England in 1171 AD. Sheelas, discarded as new churches were built, were retrieved by Gaelic kings and chieftains and inserted on their castles as an assertion of their ancient sovereign right to the land of Ireland. Sheelas became part of the Gaelic Revival that lasted over 200 years. The carvings became 'an architectural convention' as Normans copied the custom. When the Gaelic Revival ended in the sixteenth century as the Tudors, and later Cromwell, conquered the country, the significance of the Sheela was subverted and she came to represent a hex on enemies.

In 1155, only three years after The Synod of Kells, and Roman Church 'reforms' were set in place, Pope Adrian IV (the only English pope) gave Henry II of England permission to invade Ireland '… in order to subject its people to law and root out from them the weeds of vice', '… to enlarge the boundaries of the church' and '… to proclaim the truths of the Christian religion to a rude and ignorant people'.[1] Clearly the papacy and the English sovereign had more than the spiritual welfare of the Irish people in mind, but Irish leaders, both kings and hierar-

chy, were not aware of the impending conquest - they continued to focus on their inter-tribal feuds.

THE NORMANS INVADE IRELAND – INVITED BY THE KING OF LEINSTER

Dermot McMurrough, the same man who abducted Devorgilla and caused the abbess of Kildare to be raped and driven out, found himself isolated without any Irish allies. Banished from Ireland in 1166,[2] he decided to invite King Henry II of England to invade Ireland, promising fealty to the English Crown and his own daughter in marriage to the leader of the invaders.[3]

With the approval of both King and Pope (both English), Dermot approached a group of adventurers, mostly Norman and Flemish stock whose ancestors had invaded England 100 years before with William the Conqueror. Some of the invaders were Welsh and all were skilled with more advanced weapons and fighting techniques than the Irish.

The Normans landed at Wexford in 1170 and they slaughtered and routed the Irish. Their leader, Richard de Clare (Strongbow), was immediately married to McMurrough's daughter Aoife. Strongbow then went on to capture Dublin. Henry II arrived one year later to receive the submission of the kings of north Leinster, Breffni, Airgialla and Ulster.

THE ROLE OF THE CHURCH

The Roman Church and the Papacy continued to support the Normans and the English King.[4] Within a short time the continental orders of preachers were introduced to the country – Dominicans, Franciscans and Augustinians. Over 200 Celtic monasteries were defunct within a short

time, without patronage or postulants and Irish candidates were not welcome in many of the continental monasteries.

Following Strongbow's example, the leaders of the Norman armies married into the families of the Irish nobility. Not numerous enough to overcome, they adopted a policy of 'divide and conquer'. Within two generations, for example, William de Burgh and his son Richard ousted the O'Conor provincial kings and became known as 'the uncrowned kings of Connacht'. The province was granted to Richard de Burgh as fief in 1227 by the English king.[5]

As long as they remained loyal to the Crown, asked for no funds from the Royal Exchequer, and maintained their own armies, the Normans had the royal blessing. But when times were difficult they would ally themselves with one or other Gaelic chieftain and, having defeated one Irish chieftain, they turned against the former ally. They quickly adapted Irish customs and language – their mothers' being Irish – and often became 'more Irish than the Irish themselves', sometimes changing their names, when, for example, the de Burghs became De Búrca, Burke or Bourke.

By 1238 the whole of Connacht was dotted with Norman castles. North Kerry had been ringed with castles by 1232 and the eastern part of Ireland had been encastellated even earlier.

Gaelic Lords Unite

By the middle of the thirteenth century the Gaelic aristocracy had finally come to realise the significance of the Norman/Roman Church presence.[6] All the old Irish culture, history, poetry, laws, and religious customs and rituals were fast being destroyed. By fighting for their own territories they were labelled warlike and ungovernable, their clothes, customs and language disparaged and reviled, and

their religious symbols and practices labelled 'pagan'.

In 1258, the sons of the two provincial kings – O'Conor of Connacht and O'Brien of Munster – marched north to Beleek and acknowledged Brian O'Neill of Cenel Eogain as king of Ireland. They had finally realised that Ireland needed a strong monarch if she was to free herself from the English. Unfortunately, O'Neill was killed in battle only two years later, but the attitude of the Irish chieftains was clear. In the following year O'Conor's daughter was married, not to a Norman, but to a Scottish chieftain who brought a dowry of 100 fighting men (Gallowglasses) to Ireland. The Irish chieftains continued to seek a strong monarch and even approached King Haakon IV of Norway in exchange for his support in expelling the English.

THE GAELIC RENAISSANCE

The unification of spirit amongst the Gaelic chieftains may provide an explanation for the appearance of Sheelas on the Irish castles as part of the Gaelic Revival of the thirteenth and fourteenth centuries. The Normans had neither enough warriors nor funding to conquer Ireland completely and the king of England was more interested in France, being the monarch of a number of provinces there. He did not have the money or interest to pursue the complete conquest of Ireland. The English kings who followed him were preoccupied with wars against France and with civil wars for several hundred years.[7] The lack of interest in a full-scale war to completely subjugate the Irish gave the Irish chieftains the opportunity to promote the Gaelic culture and way of life, and to demonstrate that they were not a rude and pagan people.

Irish nobility recovered much of their territory outside

the Pale (the 30-mile radius surrounding Dublin). The rest of the country enjoyed their own Gaelic laws and customs and the Irish language· remained intact – the poets, musicians, historians and genealogists flourished, working not only for the leading Gaelic families but also for the Normans, (who gradually became known as the Anglo-Irish). Many of the greatest books in the Irish language date from this period. From the thirteenth to the fifteenth centuries Irish life remained much as it had for well over a thousand years.

SOVEREIGNTY CONNECTED WITH SHEELAS

The Irish quickly adapted some of the Norman's skills in warfare and in building. Tower castles provided much safer and more enduring defences against the enemy. They inserted the stone Sheelas on these castles as they were removed from the older churches, where they were being torn down to construct new Gothic and continental style cathedrals and churches. These stones were a symbol of the entitlement of the Gaelic lords to sovereignty over their ancient territories. They were originally only placed on the castles of the Gaelic chieftains. Just one castle in England has a Sheela on it, and no French castle has one of these carvings.

Stones – particularly stones associated with a saint, or with a noble family – were enduring treasures to the Irish. The leading Gaelic families all had their inauguration stones and their 'luck stones'. The Sheela stones, when rejected and removed by the Roman Church, were retrieved and returned to the clan of the chieftain who had provided the land for the church or monastery. Not to be outdone, the Normans imitated the convention on their castles, thus proving their Irishness … or was it to confuse the native Irish into accepting them as the same as themselves?

OCCULTED SHEELA AT THE ROCK OF CASHEL, located in a quoin high on the exterior of the four-teenth-century refectory building.

Many Sheelas are found at the Seats of the Provincial kings. For example, in Munster, an occulted Sheela was carved on a corner stone on the fourteenth-century refectory at Cashel – seat of the archbishop/kings of that province. The town of Killaloe, County Clare, also in Munster, was the seat of the O'Brien kings (and for a short period the Seat of High Kings) – a Sheela (unfortunately decapitated) stands beside a holy well in what was a part of the ancient abbey of Killaloe. Two Sheelas are found near Cruachan in Roscommon – the Seat of the O'Conor kings of the province of Connacht, and in Leinster there is the Sheela on Adamnán's stone at Tara. There is no record of a Sheela at Armagh – but Armagh Cathedral has a number of 'pagan sculptures' in the vestry that were discovered during excavations nearby.

THE CASTLE HAGS
Sheelas have been noted on 33 castles in Ireland. In all probability, there were many more. During their constant battles the Gaels and Normans frequently destroyed each others' castles. As the Anglo-Irish were victors by the six-teenth century, more of their castles survive than those of the Gael and therefore antiquarians identify them with these Norman castles.

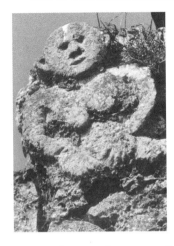

Sheela, high up on the ruined walls of Garry Castle, County Offaly.

Unfortunately, many Sheelas originally recorded on castles are now lost and only records survive. 'The Luck Stone of the O'Neills', sometimes referred to as 'the black head of the O'Neills' was noted at Shane's Castle, Antrim in 1932. Castle Warren in Cork, Shane Castle in Laois, Carrick Castle, Kildare, Lemanaghan and Cloghan Castles in Offaly all once had Sheelas. All of these castles were constructed during the Gaelic Revival (from around 1250 to 1500 AD).

Cloghan Castle, County Offaly

The history of Cloghan Castle at Banagher on the Shannon River is typical of the evolution of Irish castles. Cloghan may have been a pre-Christian sacred site before St Cronan built a monastery there in the sixth century. Like many of the early monastic settlements, it was a seat of learning and the *Book of Dimma* was transcribed there.

Cloghan was on the main pilgrimage route to Clonmacnoise Abbey from the midlands and from Dublin. Because it was situated on a river it gave easy access to Viking invaders, who pillaged it in the ninth cen-

tury. In 1203 the Normans took it over, but in 1336, Eoghan, the O'Madden chieftain, regained his territory, built his castle and placed a Sheela on it. In 1595 Queen Elizabeth's army invaded the castle, and in 1651 the Irish fought the Cromwellians there. In 1689 the Irish Army, fighting for King James, camped at the castle. Unfortunately the Sheela has disappeared from the castle in recent times.[8]

From the late thirteenth to the sixteenth centuries, 'the Castle Hag' became an architectural convention, and Sheelas were often carved expressly to occupy a corner quoin on the castle, presumably because an original was not available.

THE SHEELA AT TRIM, COUNTY MEATH

For a short time during the thirteenth century, Trim was to become the capital of Ireland as Dublin was still in the hands of the Viking kings. King John's castle was built, churches, monasteries and town walls constructed, and King John himself landed in Waterford in 1210 to make Trim the Norman capital of Ireland, but the plans did not materialise.

The ancient, weatherworn Sheela at Trim is on a four-teenth-century castle built by the Dillon family. Though

SHEELA AT DILLON CASTLE,
TRIM, COUNTY MEATH,
which is not yet recorded.

the name Dillon is Norman, it is also a Gaelic name. One is tempted to surmise that this castle was built by a Gaelic family and that the Sheela came from the nearby townland of Kilbride. Certainly the carving is sufficiently weather worn to have been carved 1,400 years ago. The name 'Bride' always indicates a place that was once a sacred site of Brigid.[9] In the next field, adjacent to the castle, are the remains of a medieval church most likely built around the same time as the castle (most castles had their own churches adjoining). The Sheela was not placed on the church – but on the castle.

Are Sheelas connected to the descendants of Niall of the Nine Hostages?

Meath and Westmeath were the territories of the southern Uí Néill – the chieftains descended from Niall of the Nine Hostages and therefore of royal lineage, as were the O'Donnells and St Colum Cille. We may discover with further research that many of the original early Sheelas are found on castles whose owners had a hereditary connection with Niall and the Uí Neill who had provided the vast majority of High Kings of Ireland down to the eleventh century. The Sheela from Carne Castle, County Westmeath, belonged to the O'Melaghlin family (modernised McLaughlin), who were the Kings of Meath and members of the southern Uí Néill.

The Ballaghmore Sheela

Ballaghmore, County Tipperary, has a fine example of a Sheela, probably carved specifically for the castle when it was built in 1480. The owners were the Fitzpatricks (MacGiolla Phádraig in Irish), meaning the son of the servant of Patrick. The Fitzpatricks were of Gaelic stock (the

only 'Fitz' prefix that is not Norman) and were Earls of Ossory. The Sheela is carved on a corner stone, high up on the western side of the castle.

A number of Sheelas on castles were placed on side quoins, high up and in the sideways, occulted position. The Sheela on the castle of Doon in County Offaly is of a later development and, like most of these examples, was specifically carved for the castle. Presumably the convention had been set in place by the time they were built.

A HEX ON THE ENEMY – THE 'EVIL EYE' OF THE WITCH

As the function of Sheelas changed from religious symbols to emblems of status on castles, eventually becoming a superstitious hex on enemies, the carvings reflected the shifting attitudes of the times. Town councils began to place them on walls to frighten away potential invaders. A good example can be seen in Thurles, County Tipperary on a medieval wall, now a tyre yard.

A magnificent example of a 'witch of the wall' is embedded on the town wall at the entrance to Fethard in County Tipperary. This carving is executed with a high degree of artistic skill and symmetry, and the sculptor was knowledgeable about the symbols of the goddess. The face, apparently full of hideous wrinkles, is carved with chevrons. Note too the symmetry of the legs and arms, both hands with clearly defined fingers reaching under the thighs to the vulva. Both eyes stare ahead with the sight that sees all, knows all. Note the enlarged belly and the protruding umbilicus – revealing the potential for rebirth, within the body of an apparently ancient hag. Comparison of this carving with the materials of the town wall lead to the conclusion that it was not designed originally to be placed there, but was brought from elsewhere and inserted

in the wall when it was built. The striping on the face is
evocative of the carving of the face of the Hag at
Clanaphilip in County Cavan.

MISOGYNY

Undoubtedly a group of medieval Sheelas reflect the
misogynistic attitudes of that society and time. They
reflect the increasingly negative attitude towards women,
particularly old women, or those who do not conform to
societal standards and expectations of the time. For exam-
ple, those who were neither wives nor nuns, those who
used herbal medicine, or who had sex and children outside
of marriage. Women became the scapegoats for uncon-
scious projections during the Middles Ages as the
Christian church became more radical with regard to
women's sexuality and power – the very qualities that the
Sheela symbol had formerly represented in the psyche.

Malleus Maleficarum

There is a deep-seated fear in patriarchal authority that
'caused the subordination of women and that needs to
control them all over the world'.[10] All those fears culmi-
nated in the violent witch hunts and burnings of an esti-
mated nine million women over several hundred years.[11]

Church authorities, seeking justification for the perse-
cution of women during the Middle Ages, published a
manual that was used for 300 years – the *Malleus
Malificarum* (1486). It stated that carnal lust is insatiable
in woman '... she is more carnal than a man, as is clear
from her many carnal abominations ... Wherefore for the
sake of fulfilling their trysts they consort with devils.'[12]

Post-menopausal women were required to keep their
eyes lowered and heads bowed in the presence of the clergy

and other male authorities, lest the 'evil eye' be cast upon them. A number of Sheelas display the evil eye, that is, one eye is closed. Church authorities were extreme in the punishment of women who refused to follow the rules, calling them 'living Sheela na gigs or *gieradors* – that is those with loose morals'.[13] They excommunicated them, ostracising these women from all society. 'The female exhibitionist is the fruit of an unbelievable misogyny ... Crude, vulgar, not without satirical or sardonic humour, they were executed in the full knowledge that they might shock or give offence.' Indeed that was most probably the intention.[14]

THE TUDOR CONQUESTS (1534-1603)

When stability returned with the ceasing of the civil wars in England, Henry VIII began to look abroad to expand his Empire. Both he and his daughter, Elizabeth I, realised that England was vulnerable to invasion from 'the back door' – Ireland – and they did not trust the Anglo-Irish who had integrated too well with the natives. New blood was needed, new settlers who could be trusted to remain loyal to the Crown and the Church of England.

THE PROTESTANT REFORMATION

Henry had quarrelled with the Pope over his divorce and had confiscated all church lands and property in England and Ireland, outlawing the Roman Church. The lands of Catholics were sold to provide revenues for the King's expansionist policies in the Americas, as well as in Ireland. Gold and silver were melted down, and sacred books burnt. All monasteries were closed and friars and nuns were ordered to depart. All people, no matter what their religion, had to pay tithes to the established church. Catholics were forbidden to worship or to build churches

and those that were standing were taken over by the Church of England.

What happened to the Sheelas?

Struggling for their lives and livelihood, the refinements of the old Irish culture faded into memory. English laws were enacted that were designed to break the spirit of the Irish people. Both Church and Crown put great pressure on the people to destroy the Sheela carvings and other stones held in reverence by the leading families. The Sheela at Castle Magner, County Cork, was sealed in a room during the sixteenth century and was only discovered recently when that room was opened up. Doubtless many others did not survive the rigorous destruction of all that was Gaelic in their heritage.

The Ardcath Sheela

Illustrative of the secrecy with which the owners of Sheela carvings had to treat them is the Sheela at Ardcath, near Athboy, County Meath.[15] This carving was built into the filling of the gate pillar at a farmhouse, perhaps as late as the seventeenth century, to conceal it from public view. The carving is 54cm high and 28cm wide, carved on a limestone block 24cm thick. Although it is considerably weathered, most of the detail is still discernable.

The figure is standing with legs slightly bent and arms hanging down and pointing to the pudenda. The head is large and pear-shaped, with prominent eyes, nose and mouth. It has been suggested by Jerman that Sheela carvings fall into three classifications revealing regional styles and that type three are found mainly in the midland lowlands.[16] Keeling classifies the Ardcath Sheela as 'a type three' (those who pass both hands in front of the body to

touch or indicate the pudenda).[17]

THE ELIZABETHAN PLANTATIONS

Conditions for the native Irish became worse during the sixteenth century as Elizabeth continued her father's policy of confiscating Irish lands and giving them to loyal settlers. Famines were a recurrent phenomenon of the time. Revolts were methodically and ruthlessly put down. Edmund Spenser, the English poet who held land in County Cork from the Queen, eulogised her in his famous poem *The Faerie Queene* which records the dire situation of the native Irish at that time:

> Out of every corner of the woods and glens they came creeping forth upon their hands, for their legs could not bear them: they looked like anatomies of death, they spake like ghosts crying out of their graves; they did eat the dead carrion, happy when they could find some, yea and one another soon after, insomuch as the very carcasses they spared not to scrape out of their graves; and if they found a plot of water-cresses or shamrocks there they flocked as to a feast for the time, yet not able long to continue therewithal; that in a short space there were none almost left, and a most populous and plentiful country suddenly left devoid of man and beasts.[18]

THE LOSS OF IRISH LEADERS

Seeing the intolerable conditions, and realising that nothing less than genocide of the Irish people was planned, the Northern chieftains – O'Neill, O'Donnell and Maguire – united in a rebellion that lasted from 1595 to 1603. They enlisted the help of the Spanish crown (who were enemies

of the English) but the Armada of ships that Spain sent was diverted by storms and never arrived. The Irish army was defeated at Kinsale, County Cork in 1601, and shortly thereafter the heads of the leading families had to escape for their lives to France and Spain. With 'The Flight of the Earls' in 1607, the Gaelic people were left leaderless and at the mercy of their conquerors.

THE PLANTATION OF ULSTER – SHEELAS REMOVED FROM THE NORTH IN THE SEVENTEENTH CENTURY

The destruction of the O'Neill inaugural stone at Tullahogue, County Tyrone by Lord Mountjoy in 1604 was indicative of the English policy of total annihilation of the Irish nobility. Tullahogue had been the site of the inauguration of the Kings of Ulster since the fifth century. In 1610 the O'Neill territory of Loughansholin, Tyrone and the counties of Derry and Coleraine were planted by English and Scottish Protestants. There were enough settlers to make a complete conquest of these territories. They

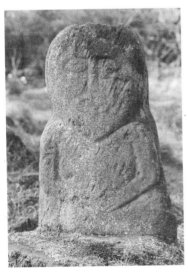

CRANAGH (GRAVEYARD) AT BOA ISLAND, COUNTY FERMANAGH. This Sheela has been cut through the lower portion of the carving and placed on a concrete base at the graveyard of Calderagh Church.

129

levelled the forests, built defensive castles and bawns, towns and villages with markets, constructed stone cottages, new churches and schools. Entirely Protestant communities and towns were developed in the English manner. Everything that was native Irish was demolished and the native Irish were segregated into ghettos.

The carvings of Sheelas were probably destroyed at that time. With only a few exceptions there are none left in Northern Ireland – the territory that provided most of the High Kings of Ireland and the Kings of Scotland. The O'Neill Sheela at Shane's Castle, County Antrim, recorded in 1932, and one at Kirkiston, County Down are lost. There is one from Aghalurcher, County Fermanagh, one from Maghera, County Derry, and one in the Ulster Museum, Belfast – either from Errigal or Keerogue, County Tyrone, or from County Monaghan. There are two standing stone figures on Boa Island in Fermanagh, undoubtedly very ancient, and nearby at the monastery on White Island, carved for the Romanesque church (c. eleventh century). Several Sheelas survived in County Cavan, one of the nine original counties of Ulster, and they are associated with the O'Reilly chieftains.

THE SHEELAS OF THE MIDLANDS

The midlands of Ireland still boast the largest number of recorded Sheelas.[19] Tipperary has twenty, Offaly eleven, Laois seven, Westmeath six, and Meath eight, although a number of these have disappeared since they were recorded.

Perhaps the reason for the greater number of Sheelas in the midlands can be explained by the fact that the plantation of the midlands and west (begun in 1621 and lasting until 1703) was not as thorough as that of Ulster. There may also have been more Sheelas in the midlands of

Ireland originally. It had been the centre for the establishment of dozens of early Celtic monasteries (from 375 to 650 AD). It was the part left by Patrick to Brigid when both the east and the west of the island were apportioned to the Church of Rome. It was the area controlled by the southern Uí Néill, descendants of Niall of the Nine Hostages and High Kings of Ireland. Perhaps all four of these explanations have their parts to play in the retention of these ancient symbols in the midlands.

Though the plantation of the midlands and the west began in 1621 the English monarch had neither time nor money to assist Ireland. King Charles, a Catholic, fought a Civil War against the Protestants in England. When the war ended, in 1649, Charles was executed and General Oliver Cromwell came to Ireland to subdue the Irish.

CROMWELL'S CURSE ON THE IRISH AND THE DESTRUCTION OF SHEELAS IN THE SOUTH EAST

Cromwell's methods were ruthless and thorough. They involved the wholesale massacre of the people, inspiring widespread fear. He ordered that every Irish man, woman and child be butchered in the towns of Drogheda and Wexford. Within one year he had reduced the Irish into a totally subject people. Irish soldiers who survived the conquest were given the choice of execution or emigration. Consequently, 30,000 left the country to join the armies of France, Spain and Austria. Their lands were confiscated as well as that of any Catholics in the east, midlands and south of the country. Cromwell's slogan for Catholic landowners was 'to hell or to Connacht' and his generals and soldiers were paid in the land from which their owners had been dispossessed.

CROMWELL'S VISIT TO FETHARD

Fethard is a small medieval town in County Tipperary that took pride in the fact that it had four Sheelas, until recently. The carving on Kiltinan Church was stolen in 1990. How did so many of these carvings survive? When Cromwell visited the town the Lord Mayor did him some unnamed favours. In return, according to local folklore, he made a promise that Fethard would be spared destruction. No doubt many Sheela carvings were eliminated in other towns by the Cromwellian army.

Cromwell's protectorate had created a new class of landowners in Ireland, ousting both Irish and Anglo Irish. Unlike Ulster, many former owners were allowed to remain on their former lands as tenants and workers for their new masters. These people understandably harboured resentment and caused a great deal of anxiety and insecurity for the planters. Fear of reprisals and insurrection dogged the lives of the new settlers, a number of whom sold out and returned to England.

CATHOLIC REPRISALS AND PROTESTANT FEARS

Though two succeeding kings of England, Charles II and James II were Catholic, with very few exceptions they did not keep the promises made to their Catholic supporters to reinstate them to their former possessions. The English government was committed to the status quo, to the land settlement that had been made to Protestants and the established Church of Ireland.

When James II became King of England, Irish Catholics believed the old order would return and many refused to pay tithes to the Protestant Church. Some of the leading Catholics in the country used their positions to dismiss Protestants and reappoint Catholics in their place.

Both Protestants and Catholics were uneasy – not only in Ireland but also in England in the latter part of the seventeenth century. The English monarchy might revert to Catholicism under a Catholic king. To avoid this possibility, the Protestants of England invited William of Orange, the husband of James' Protestant daughter Mary, to invade England and drive out King James. Irish Catholics backed King James, while the Protestants fought for William in a war fought on Irish soil. The Battle of the Boyne, in 1690, left James defeated and exiled to France, and the victorious Orangemen of Ulster have been marching to celebrate William's victory on the twelfth of July ever since.

Over 14,000 Irish soldiers were forced to leave the country and their properties confiscated, along with the properties of all those killed while fighting for James during the war. By 1703 the Catholic portion of the land of Ireland was reduced to fourteen per cent, from 59 per cent only 60 years previously. The Catholic population of Ireland had been reduced to the lowest level in the social system – that of landless serfs.

The Demise of the Gaelic world
Whereas the conquest of Ireland by the Tudor and Stuart monarchs of England initiated the demise of the Gaelic way of life, the Cromwellian conquest and plantation of the seventeenth century completed it. The Penal laws forbade Catholics from practicing their religion, receiving an education, participating in the professions or owning land.

Without leaders, the Irish social order was destroyed. The poet-historians, who from time immemorial had sung the praises of their chiefs and of their heroic deeds in battle, had no one left to praise. The schools to train poets and the Brehon law schools had been closed down. The

Gaelic institutions, laws, language and traditions that had survived more or less unchanged since the Norman conquest in the twelfth century had been effectively destroyed. English law, English customs and way of life dominated in the towns of Ireland and throughout the Pale.

THE COUNTER REFORMATION

Rome had set up a Counter Reformation to deal with the Protestant attack on its influence across Europe. Amongst its provisions was the establishment of twenty Irish colleges in France, Spain and Italy to educate young men for the priesthood. They were trained to speak Latin and Greek in the scholastic traditions of the European universities, and many became statesmen of the church and advisers to the papacy.[20] Their classical education was achieved at the expense of their Gaelic culture and traditions, and when they returned to Ireland to teach in the hedge schools, the lucky children who received any education at all learned Latin and Greek. But the Irish clergy had lost the connections with their own heritage, which by that time was passed down as folk and fairy tales at the family fireside.

CHURCH ORDERS FOR THE DESTRUCTION OF SHEELAS

The hierarchy of the seventeenth century strongly disapproved of exhibitionist figures, and called for their removal. In 1631 the Provincial Statutes for Tuam, County Galway, ordered parish priests to hide away, and were told to hide the *imagines obesae et aspectui ingratae*, that is, fat figures of unpleasant features. The orders were apparently successfully obeyed. The fact that the order went out at that time indicates that there must have been Sheelas on the churches as late as the seventeenth century.

THE SHEELA IN GALWAY

The only Sheela remaining in Galway is on Ballinderry Castle, built in the sixteenth century. Here, the ghee is clearly carved flowing from her genitals. The designer of this Sheela clearly understood goddess symbolism:

> This is a very important example of a Sheela-na-Gig. The figure is depicted on a background of Celtic style patterns; knotwork based on three threads and three geometric circles, each of which represents and example of the triple symbolism related to the ancient lore of the Sun/Moon/Goddess worship. A triskele motif, a symbol of triple swastika type related to the Isle of Man emblem, a 'marigold motif', which expresses the six-fold division and a 'sun wheel' consisting of the eight annual sun divisions of the ancient calendar.[21]

THE LAST SHEELA

William Palliser, Protestant Archbishop of Cashel, built his palace there around 1720. The building, now the Cashel Palace Hotel, is a fine example of early Georgian architecture. It is constructed of red brick with granite cornerstones. Oddly, considering church attitudes, and particularly English protestant attitudes, a Sheela was incised on a corner stone at the rear and side of the building. It

SKETCH OF THE SHEELA INCISED ON STONE AT THE BISHOP'S PALACE, CASHEL, COUNTY TIPPERARY.

was inserted sideways in the occulted position, about seven feet above ground level. When the hotel was renovated (1995) it was placed on a wall in the basement corridor – in an upright position.

Why did Archbishop Palliser commission a Sheela to be carved on his palace at such a late date? Why did he place it in such a hidden spot – a rear wall, out of view to all except those to whom he chose to show it? Those symbols of 'Irish paganism' had been forbidden by the hierarchy. What was to be gained? Was the Archbishop influenced by the Sheela on the Rock of Cashel nearby and by the other carvings that still remained in the area?

Although the English had decisively conquered the Irish, there was an underlying fear of the natives and apprehension of reprisals from them. Perhaps the archbishop thought it useful to have a Sheela to affirm his right to the tithes that all people, including nonconformists and papists were required to pay. It may have been thought useful to have a Sheela hex tucked away at the back of the Palace to frighten any recalcitrant and superstitious Irish into paying their tithes.

William Palliser was an eminent scholar, born in Yorkshire (where the greatest concentration of Sheelas are found in England). He travelled to Ireland when fourteen to become a student at Trinity College Dublin, and later became a Professor of Divinity at that university. He was described by a colleague as 'a man of great learning and exemplary piety'. He was nominated from Cloynes as Archbishop of Cashel in 1694, and died in office in 1727, leaving a sizeable fortune that he had accumulated during his lifetime, to his son. His extensive library, the Palliser Collection, was bequeathed to Trinity College, Dublin.[22]

The Eighteenth and Nineteenth Centuries

The eighteenth and first half of the nineteenth centuries was an era of great prosperity for the landed estates, the English crown and the Established Church. The power bases of the Protestant ascendancy were by then secure with only five per cent of Irish land remaining in Catholic ownership.

The eighteenth century was marked by the growing prosperity of the landed gentry and nearly universal poverty of the native Irish. The population increased exponentially, encouraged by landowners who required cheap labour to produce grain, which would be sent to France and America during their revolutionary wars.

One of the ships plying the Atlantic during the American Revolution was the *Sheela nagig,* a British naval vessel owned by a Corkman. Did he also have dealings with the East India Company where so many British made their fortunes in the eighteenth century – and/or was it from Cork that he got the name? At any rate, the term Sheela was in common usage by sailors and in the underworld by the nineteenth century.[23]

Ireland had its own parliament from 1775 to 1800 — for the first time in 600 years. Irish parliamentary members created the magnificent Georgian squares of Dublin Unfortunately the affluence of the gentry was not spent on land improvements but squandered in an attempt to imitate the aristocracy of Britain. After only 25 years in existence, Irish MPs voted to return to Westminster, having been bribed to do so with promises of land and English titles.

In ancient times, the Goddess divorced the unjust king and pestilence and famine followed – exactly what happened in nineteenth-century Ireland.

The potato, introduced from America, became the people's sole staple diet. There was no education for

Catholics in the country, and very few could afford to go abroad to be educated. The Irish colleges on the continent trained young men exclusively for the priesthood and though they got a good classical training in Greek, Latin and scholastic subjects, none of that training had to do with their Irish heritage, culture or language. For the native Irish, cultural and intellectual pursuits were limited to the hedge schools, the crossroad dances and the cottage firesides where folk stories kept alive their ancient traditions.

THE GODDESS IN FOLK TRADITION

Deprived of their Gaelic aristocracy since the seventeenth century and without the poetic, historical and legal schools, the traditions of the goddess of the land and of Sovereignty became part of the folklore of the ordinary people of Ireland. Whereas the Chieftain families all had had a specifically named divine hag, such as Aoibheal of the O'Brien dynasty of North Munster and Cliodna of the O'Keeffe dynasty of East and North Cork, Síle of the O'Gara dynasty, Mauveen of the O'Neill Buidhe of Clannaboy at Shane's Castle in Antrim, the majority of those names have been lost or forgotten. To replace them, the anonymous banshee (*bean Sídhe*) or 'woman of the fairies', who cries to foretell the deaths of members of the dynastic families, made her appearance. The banshee carried into modern times the ancient cosmological tradition of the supernatural death messenger, according to Gearóid Ó Crualaich:

> Despite the declaration of the dethronement and even extinction of the goddess and goddess-related elements of native tradition implied in learned literature, it is the case that the ancestral culture of medieval and

early modern Ireland continued to carry forward in lit-
eracy and vernacular cultural tradition both the sover-
eignty queen on the one hand and of the non-sover-
eignty, female landscape figure on the other ... the
world view of later centuries carried the presence and
the significance of the divine female into the early
modern era of the eighteenth century and on into the
beginnings of the modern world of the twentieth cen-
tury.[24]

The royal names of Meadhbh, Macha, Mor Mumhan,
Banba, Ériu, Fotla and so on gave way to proletarian
names such as Noirín Ní Chuileannain, Siobhán Ní
Mheadrha, Meidhbhín Ní Shuilleabháin and Síle Bhan Ní
Shleibhín. In poetry and song the queen of sovereignty
became personified as Dark Rosaleen (*Roisín Dubh*) or
Caitlín Ní Uallacháin (a name first used by Liam Dall Ó
hIfearnain, born in 1720 in Tipperary and a student of
one of the last Bardic schools).

All the supernatural female figures that appear in what
is termed Aisling or Vision poetry of the eighteenth and
nineteenth centuries came from that ancient goddess cos-
mology – the goddess who is autonomous in her sexual
selection of the rightful king. It was scarcely disguised
political poetry that cried out against foreign domination
– both state and religious. W.B. Yeats made the imagery of
the goddess as the Countess Cathleen internationally
famous in his plays and poetry.

RED HANRAHAN'S SONG ABOUT IRELAND

The old brown thorn trees break in two high
over Cumman Strand.

Under a bitter black wind that blows from
　　the left hand:
Our carriage breaks like an old tree in a black
　　wind and dies,
But we have hidden in our hearts the flame
　　out of the eyes
Of Cathleen, the daughter of Houlihan.

The wind has bundled up the clouds high over
　　Knocknarea,
And thrown the thunder on the stones for all
　　that Maeve can say.
Angers that are like noisy clouds have set our
　　hearts abeat;
But we have all bent low and low and kissed
　　the quiet feet
Of Cathleen, the daughter of Houlihan.

The yellow pool has overflowed high up on
　　Clooth-na-Bare,
For the wet winds are blowing out of the
　　clinging air;
Like heavy flooded waters our bodies and our
blood
But purer than a tall candle before the Holy rood
Is Cathleen, the daughter of Houlihan.[25]

FAMINE

By the middle of the nineteenth century, foreign wars were
over and the demand for tillage had fallen greatly, but the
population had doubled to over eight million people. The
stage was set for the Great Famine of 1848, cutting the
population in half as two million died and a further two

million emigrated. There were, in fact, nine different famines in Ireland during the nineteenth century. Poverty and ignorance had successfully removed all cultural and intellectual pursuits as the land and the people were transformed through fear of starvation from the generous, hospitable, big-hearted people they had been.

RECOVERY

Only in the twentieth century, as national independence, universal education and economic opportunity have come to Ireland has the Sheela returned. With freedom came the revival of Gaelic culture – music, visual art, drama, poetry and writing have flourished as never before. The Irish youth are amongst the best educated in Europe. Sexual liberation and a weakening of puritanical morality have created an openness to sexuality in Ireland. The Celtic Tiger also came – and went. At the beginning of the twenty-first century Ireland is once again possibly faced with losing her identity and independence.

The lessons of history remind us that freedom and independence have been hard won by our ancestors, and if they are given away, a very high price will be paid by the generations to come. Perhaps the enigma of the Sheela's reappearance into Irish consciousness is a signal that we in Ireland need to focus on the gifts the goddess has to offer to those who respect her and her children – animal, vegetable, mineral and human. Only by a sacred contract with her can the people of Ireland sustain peace and prosperity.

Chapter 8

SHEELA: SEXUALITY AND SPIRITUALITY

THE SEXUALITY OF EARLY PEOPLES

The indigenous people of Ireland, like most ancient peoples, lived by a philosophy that sought harmony with cosmic energy, of which sexual energy was an integral part. Cosmic energy was the energy of God in manifestation. It was known as *neart* in Irish.

From Palaeolithic times into the Neolithic period (from 10,000 BC) and into the Bronze Age, God was believed to be the Great Mother Earth, Anu or Áine. Creativity in all its forms (animal, vegetable, mineral and human) was the way she manifested herself. Sexuality and giving birth were expressions of her energy and power in the lives of human beings and in all nature.

The goddess survived through the Bronze Age in the form of Brigid in Ireland. She was known as Ananna in southern Sumeria (Ishtar in Semitic northern Sumeria); in Egypt as Isis; and in Anatolia as Cybele.

They reflect the imagery of the Great Mother who presided over the earliest civilisations from Europe to the Indian subcontinent. Inanna relates the Neolithic Great Mother to the Biblical Eve, Sophia and Mary. Her imagery is the foundation of Sophia (the Biblical

Hokhmah, or Wisdom), the Gnostic Great Mother and even the medieval Shekhinah of the Jewish Kabbalah. Sumerian culture ... is the source of many stories and images of the Old Testament ... With Inanna, as with Isis in Egypt, the image of the archetypal feminine is given a definition in mythology that has endured – however obscured, fragmented and distorted it has become – for over 5,000 years.[1]

Ancient peoples thought analogically – they could use the metaphor of the female body as the symbol of divine creativity. Symbols of the goddess abounded from Ireland to India, where icons of the goddess are even today worshipped as sexual fire, creative energy.[2] Small icons of the yoni (the vulva) are displayed as a reminder of that all-embracing creative energy.

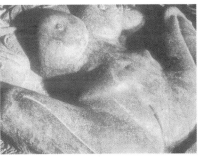

Image of the Goddess as genetrix of all things, displaying her yoni, northern India, c. 600.

The association between the vulva as icon and the anthropomorphic female is stressed by a sculpture which illustrates Indian practice. It represents a puja altar in the form of a female figure with her legs spread apart to display the vulva. This will connect at once in most people's minds with the figures called 'Sheila na gig' from Irish ... churches, which represent the survival of a similar idea much degraded in Western culture.[3]

143

The images of the Sheelas were meant to illustrate the powerful energy of God in anthropomorphic form. By acknowledging the ultimate power of the Divine Hag to give and take back life, the human being was constantly reminded of the temporality of his/her own life, of the power of sexuality to generate, and the ultimate power of the goddess in her Crone aspect to destroy and recreate. For the ancients, death was not the end of life. It was the beginning of transformation into a new round of life.

THE AWARENESS OF THE GREAT GODDESS OF THE SKY

In the fourth millennium BC a tremendous leap in human consciousness occurred in Mesopotamia (modern-day Iraq). Up to that time religious rituals involved celebrations in the yearly cyclic changes. At that time the priests began to observe and calculate the cycles of the stars in the sky. The leap was from the geography of the earth to the awareness of the cosmos. A new symbol of the energy of God was needed to correspond to this leap of consciousness. It was the Great Goddess.

> The priestly watchers of the night skies at the time were the first in the world to recognise that there is a mathematical regularity in the celestial passages of the seven visible spheres – the sun, the moon, Mercury, Venus, Mars, Jupiter, and Saturn – along with the heaven-way of the Zodiac. And with that, the idea dawned of a cosmic order, mathematically discoverable, which it should be the function of a governing priesthood to translate from its heavenly revelation into an order of civilised human life ... A vast concept took the form of the universe as a living being in the likeness of a great mother, within whose womb all the

worlds, both of life and of death, had their existence.[4]

Sacred Sexual Ceremonies

The female's sexual parts are a living symbol of the divine energy, the *neart* of God – just as the male's genitals are a

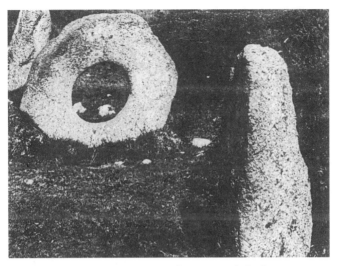

The holed stone represents the yoni and the lingam is represented by the pillar.

symbol of that same divine energy in masculine form. The yoni and the lingam were always paired because both forms were required for creativity. From ancient times on all continents sexual rituals were performed at sacred places – in the temples of Sumeria, Mesopotamia, Egypt, Crete, Malta, India, Greece and Rome. Similar rituals were performed in Ireland, France, Scotland and England – at natural earth temples in the landscape, on sacred mountains and at druidic oak groves.

These ceremonies provided the opportunity for men and women to experience the bliss of participating in the

divine energy of the goddess as they entered with her into the act of procreation, becoming the vehicles of her generative powers. Children born of these unions were considered to be the special gifts of God to the community. They had the title of *páiste gréine* or 'the children of light' in Irish. In Sumeria they were known as 'virgin-born', meaning that they were born of the priestesses of the temple, possibly the high priestess.[5]

This poem from Sumeria from about the third millennium BC describes the feelings of love and delight with the physical world, of passionate eroticism as they experienced the power of goddess Earth and god Heaven in their creative passion for one another:

> The great Earth-crust was resplendent, its surface was jewel-green,
> The wide earth – its surface was covered with precious metals and lapis-lazuli,
> It was adorned with diorite, nir-stone, carnelian, and antimony,
> The Earth was arrayed luxuriantly in plants and herbs, its presence was majestic,
> The holy Earth, the pure Earth, beautified herself for holy Heaven,
> Heaven, the noble god, inserted his sex into the wide earth,
> Let flow the semen of the heroes, Trees and Reed, into her womb.
> The Earthly Orb, the trusty cow, was impregnated with the good semen of Heaven.[6]

BALANCE BETWEEN MASCULINE AND FEMININE ENERGIES
One of the basic laws of nature is that creativity requires a

balance between masculine and feminine energies. Examples of that concept are found at some Hindu temples in India – sculptures of paired male and female in various sexual poses. They are not intended to be realistic portrayals of individual human beings but are symbols of divine energy, the powerful force that sustains the universe. On the same principle, paired stones, circles with holes carved in the middle and lingam stones are occasionally found in old churchyards in country districts of Ireland.[7]

Masculine and feminine (or positive and negative polarities) are also combined in every human being, and a good balance of these energies within the individual generates good health. It connects a person with the earth, giving them vitality, joy at being alive with a sense of connection to the source of all life. This energy is called *kundalini*. The ancient symbol of *kundalini* energy is called the *caduceus*, and it is still used as the emblem of doctors and health organisations. The *caduceus* was one of the primary symbols of the majesty of Inanna as the Great Mother of the Sumerians, and in Crete it symbolised the power to bestow and withdraw life.[8]

KUNDALINI OR SERPENT ENERGY

Kundalini refers to the electrical vibrations that run through living organisms, including the earth itself. In the human body this energy starts at the coccyx and winds up the backbone. Positive and negative polarities intertwine much as the elements in the generation of electricity. In the healthy body these energies flow from the base of the spine to the top of the head and down again, generating the life force. If any part of the body is blocked the *kundalini* energy cannot flow normally and thus chronic ill-

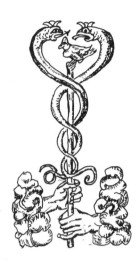

SKETCH OF THE CADUCEUS
FROM THE LATE
SEVENTEENTH CENTURY.

nesses eventually develop around the blocked area(s). The earth too has energy or ley lines, and energy spots where waters gather, such as rivers, underground streams, lakes, wells, springs. Hills, mountains, trees and vegetation also combine with water, creating power spots.

The serpent, as previously mentioned, was a symbol of this universal life energy. With its ability to destroy and to regenerate its own new skin, it was a positive symbol of the power of the goddess. As far back as the fourth millennium BC, the goddess Nammu in Sumeria was said to have been the primeval sea from which all creation emerged. She may have been portrayed in sculptures with a serpent's head, holding her child. The serpent goddess also figures in India, in the image of Ananta, the great serpent of the cosmic abyss where Vishnu 'rested'. The image of the goddess Mucalinda is depicted as a serpent on whose body the Buddha sits enthroned, with her seven hoods providing a canopy behind him as he confronts the negative powers of the universe. In Egypt, the head of the cobra was a part of

the headdress of the Pharaohs. The serpent was carved into the sculptures, painted on murals and engraved on metal work, symbolising the ability of the religious leaders to embody the energy of the goddess and to empower the land and the people.

The Celts of Europe and Ireland used the serpent imagery and *kundalini* energy to empower the land and the people. In fact serpent energy continued to be used by the Druids of Ireland and Scotland down to the sixth century, considerably longer than the countries on the mainland of Europe.

Of all ancient civilisations, only the Jews rejected the serpent, because it was the symbol of the power of the goddess. In order to bring forward the sky god as the sole creator of the universe and everything in it, the goddess had to be disempowered and therefore in the Jewish myth of creation, the serpent was the cause of Adam and Eve having to leave the Garden of Eden. (On the other hand, eating from the tree of knowledge of good and evil implies that an evolutionary leap in the consciousness of humanity was about to be undertaken.)

THE REMOVAL OF *KUNDALINI* ENERGY

The Jews developed the idea of the sky god – Yahweh, the one and only God, and gradually Jewish women became the most restricted and dominated of all the peoples in the near east. Jewish Christians like Peter and Paul (who was also familiar with the partriarchalism of Greece and Rome) developed the attitude that women had no right to participate in religion other than being witnesses.

Tertullian, a father of the Roman Church in the third century called Eve the Serpent of her sex:

149

...Do you not know that you are each an Eve? ...You
are the devil's gateway...the first deserter of the divine
law; you are she who persuaded him whom the devil
was not valiant enough to attack. You destroyed so
easily God's image, man. On account of your desert –
that is, death, even the Son of God had to die.[9]

For Tertullian, as with other Church fathers, evil came
into the world as a result of Eve and every woman is an
Eve. Evil is the offshoot of matter and matter was associat-
ed with nature, sexuality, unconsciousness and the femi-
nine. Thus the natural drive towards sexuality and procre-
ation, far from being a spiritual ritual and experience,
became something shameful – to be avoided. Thus Roman
Christianity developed authoritarian, misogynistic atti-
tudes towards women, though Celtic Christianity at first
did not. This set the stage for conflict between the differ-
ent streams of Christianity that developed in Ireland.

The myth of St Patrick driving the snakes out of
Ireland from the top of the sacred mountain Cruachán
Aigle, (Croagh Patrick) is a metaphor for the conflict with
the Druids. There never were snakes in Ireland, therefore
this is the story that describes the extinction of the use of
sexual energy by the Druids. By cutting off the power of
the Druids, of whom many were women, the active par-
ticipation of women as priestesses was eliminated.
Feminine energy is what is so feared by patriarchy. But ser-
pent power cannot be generated without the combination
of both positive and negative, masculine and feminine
energies. Without the combination there can be no gener-
ation of creativity, there is just disempowerment of the
people for the purpose of control.[10] Furthermore, blocking
kundalini energies blocked the productiveness of the land

as well as the people.

The Christian message was a message of peace – and the Druids welcomed the new religion, trusting it would curb the indiscriminate violence of the warriors. It would, they thought, bring a welcome change to a society that was racked by pillaging, cattle raiding and the undisciplined violence of the warrior element in Irish society during the early centuries of the first millennium AD. But the Christian Church became part of an empire-building process, a continuation of the Roman Empire. It usurped the power of the Druids and people for the use of the authoritarian patriarchal elite. The serpent as a symbol of the goddess had been transmogrified into the devil.

MASCULINE SYMBOLS

From Hellenistic times phallic statues in the form of herms were placed at crossroads in Greece. Herms are four-cornered blocks of stone with the head of Hermes, the Greek god, carved on top, and an erect phallus at the front. On one side are the intertwined serpents in the act of sexual union. They are the famous NAGA serpents of ancient India – perhaps the original source of the name given to Sheela – 'naga' = 'na gig'. The Greeks, however, did not balance male and female symbols. They had also trans-

SKETCH OF A
GREEK HERM.

formed many previously feminine forms of the gods into masculine forms. Hermes is not only a symbol of fertility – he is a guide at the crossroads, and also a trickster, '... and finally the leader of souls to and from the underworld. His phallus therefore penetrates from the known into the unknown world, seeking a spiritual message of deliverance and healing.'[11] The Sheela or the Divine Hag had all these functions: fertility symbol, transformer, and psychopomp to the underworld and regeneration.

Across Europe, phallic figures are commonly found, but the feminine counterpart, the yoni, is absent. The Judaeo/Christian and Muslim religions precluded any images of the female in anthropomorphic form – these were considered 'idols' . Women themselves must be covered up so that they would not be a cause of temptation to men.

Precisely because of this embargo, even a symbol of the yoni or the mouth of the womb is absolutely terrifying. That is why the Sheela has such a powerful effect on many people who are the products of patriarchal civilisation and religion. Not only are these carvings depicting the mouth of the womb in exaggerated symbolic form, but they also reveal the symbol in the context of female anatomy, that is, in anthropomorphic form. That is why so many people, even anthropologists, have considered Sheelas 'pornographic' and 'an insult to women'.[12]

Phallic symbols are, however, so much a part of patriarchal societies that they are not even identified as such. In art, architecture and modes of thinking, the masculine takes preference.[13] Straight lines and geometric forms are preferred to curves and circles in classical Greek and Roman architecture, and in modern architecture also, where structural materials such as steel, concrete and glass

are more easily adapted to straight lines, rectangles and squares. 'Straight thinking', 'straight talk', 'rational, logical thought' has been the preferred, the educated way of functioning in life since the age of rationalism began around 300 years ago.

Thus Sigmund Freud could put forward his theory that women suffer from 'penis envy' in the early part of the twentieth century without being challenged seriously. His group of psychiatrists were all men, of course, and they were communicating to academics and medical people who were also male. The only input from women was as patients. Freud would not accept any criticism, additions or changes to his theories. The preference for the masculine and the privileges of the male have dominated civilisation for so long and in so many areas, and we are so much a part of that civilisation, that we have difficulty sometimes even being aware of the imbalance – though we are aware of the chaos that it has generated.

SEX AND THE VIRGIN

The modern meaning of 'virgin' – one who has never had intercourse, is not at all what was meant in ancient times. A 'Virgin' (written with a capital 'V') was a woman owned by no man. She had sex with whom she chose, but she was not married or given as a concubine or mistress to any man as his personal possession. The Virgin was autonomous over both her body and her position in society.

Virgins were independent but usually lived together in a community where they were privileged members of society, performing religious rituals that ensured the stability and prosperity of the land and the people. Evidence of the ancient tradition comes from as long ago as the Sumerian civilisation (c. the fourth and third millennium BC). The

goddess Inanna of Southern Sumer, known as Ishtar in northern Sumer was a goddess of sexual love and fertility. One of her titles was 'Hierodule of Heaven'. Hierodule comes from the Greek and means 'the servant of the holy' or 'the sacred work'. The word has been corrupted, as so many words referring to the feminine, to mean 'harlot' or 'whore'.

VIRGIN OR WHORE?

The priestesses who served in the temples of Sumeria, in Greece, Rome and in Ireland were in the service of the Great Mother in the act of procreation and 'they were the vehicles for her creative life in their sexual union with the men who came there to perform a sacred ritual'.

> Their virginity did not suggest a physical condition, but rather that the creativity of the goddess was a constant state, brought about by herself in union with herself, and that the fertility of all aspects of creation was her epiphany ... metaphysical ideas were embodied in the sexual intercourse performed ritually in the temple precinct itself, for the fertility of human, animal and plant life depended upon the enactment of this ritual in a sacred place where men and women participated magically in the generation of the life of the goddess.[14]

Sexuality as performed by the Virgins was a sacred act, not only because it brought life into the world, but also because the ecstasy that accompanied it was the nearest thing that could be humanly experienced of the life of the gods. The Virgin and the Druidess on these occasions took the place of the goddess (prostitute means the 'one who stands in for' the goddess).

SEX AND SPIRITUALITY

The hagiographies of St Brigid and the wealth of folklore
and traditions concerning her connect Ireland with the
ancient traditions of the goddess. The Virgins of Ireland,
like the Vestal Virgins of Rome, the Virgins of the goddess
Inanna, and those in tantric service in India, kept the bal-
ance by maintaining the sacred fires and performing ritu-
als at the key spiritual/political centres. Indeed the nuns,
successors of Brigid at Kildare, kept the sacred fires burn-
ing down to the twelfth century when the archbishop of
Dublin ordered that practice to be stopped.

Sexuality must be combined with spirituality – when
they are dissociated, human life becomes neurotic. Carl
Jung observed, for example, that when any of his patients
presented with a sexual problem, the solution invariably
was of a spiritual nature, and when a spiritual problem was
presented the answer was always found in the sexual area
of the patient's life. When one or the other is blocked or
cut off in the life of an individual it creates psychological
and physical imbalance. When it is blocked in a large
number of people, that society becomes imbalanced.
Perhaps that explains why generations of puritanical atti-
tudes and behaviour in Ireland has resulted in a swing that
has turned sexual freedom into licence, as Ireland current-
ly has one of the highest rates of sexually transmitted dis-
ease in Europe.

Balance is the key – and the integration of the sexual
and spiritual life. There is a tradition within mystery reli-
gions that intercourse is good for spiritual development.
Tantric Buddhism subscribes to it, the Gnostics believed
in it, and the Celtic nature religion incorporated it into
ceremonies and festivals.[15] The Celts celebrated Bealtaine
on 1 May each year, when maidens and youths were intro-

duced to sex in sacred ceremonies that encouraged the fertility of the land as well as the people.[16]

Some experts believe that Sheela is perhaps the only survival in Christian symbolism of that ancient sexual magic that was widely practiced in the pagan world, and which is still practiced by the tantrics in the Orient.[17]

The teachings of the mystery schools reveal that sex is the energiser (see chapter two). Both partners should feel the *kundalini* energy rise in the lower chakras – and allow it to move up the body so they experience oneness, not only with each other, but a unity with God and all of creation.

SUBLIMATION OF SEXUALITY

The rationale behind the vow of chastity is that by 'sublimating' sexual desires and redirecting the energy to creative and spiritual objectives, the individual becomes more evolved, more 'godlike'. That the physical body could be godly was denied by the church fathers from as early as the second century AD. The physical body and the natural world were equated with the feminine, and to the patriarchy at least, they were considered a lower order. The higher order – mental and spiritual – was equated with the masculine. As mentioned previously, some Fathers of the Church stated that women did not have souls.[18]

The leaders of patriarchal religions – Christians, Jews, Moslems and Buddhists – changed the laws to gain power and control, exploiting the vow of chastity. When the role of a celibate is adopted, sexual energy which is denied becomes repressed into the unconscious. The energy is felt nonetheless – it takes the form of fear and the need to control that which is feared. Unaware that the energies of desire continue to be generated within (because the role of celibate precludes sex) it is perceived as originating outside – partic-

ularly from the object of the desire – woman. According to this reasoning, women, like Eve, must therefore be the source of these temptations and must be kept under control.

The institutions of marriage, family and convent life in all cases subjected women to male superiors. The Earth also, in partriarchal society, is perceived as a resource to be exploited, conequered (women's bodies are living symbols of the creativity of the Earth Mother). This scapegoating of women reached its zenith during the witch hunts of the Middle Ages.

Just as individuals project what they despise in themselves onto someone else, groups and societies project onto other groups and nations. This is the basic cause of conflict in the world.

As John Moriarty, the Irish philosopher, stated so succinctly, 'a repressed instinct is a poisoned instinct'.[19] When sexual energy is blocked, it takes the form of irrational fear, compulsion, anxiety, phobias and obsessions. Occasionally these lead to the demonic sexual aberrations to which these individuals are driven.

SEX AND VIOLENCE

When an energy force is blocked from its positive direction, nature will ensure that it is released in another way. Mars is the symbol of male sexuality and the energy used, for example, in physical work, sport and warfare. It is also the energy of anger, aggression and violence. When Mars' energy is blocked it does not disappear – it becomes negative, and those who are physically weaker become targets of that aggression – individuals and nations.

Sex is often used to dominate and take power, stealing energy rather than giving and receiving in fair exchange. It was a sin for a woman to refuse to have sex with her hus-

band. Rape within marriage was not only condoned – it was not considered rape, and women were punished for not giving their husbands 'their rights'.

FEAR OF THE FEMININE

The issues of sexuality, birthing and dying – the very issues that were central to the worship of the goddess – are perhaps the three most powerful and transformative experiences of life. Yet they are the very issues that are replete with confusion, uncertainty and secrecy in modern society. Sheela was an archetypal symbol of those experiences as well as the Goddess of Sovereignty, and for those very reasons the Irish held onto her longer than other lands nearer to patriarchal power bases.

Sheelas display all the characteristics of women most feared, reviled and rejected by society because they portray characteristics that make a woman independent, strong and powerful. Physical beauty and sexual allure are insignificant when a woman is giving birth, expressing her wildness, her fearlessness, or dealing with death. She does not think of beauty – the issues are much too profound. The deformed, wrinkled bags of bones of the later medieval period were 'seen in grim and deadly seriousness as personifications of the devil or as the devil's whores, as objects to be exterminated'.[20]

> Whenever there is a deviation from the societal norm there appears to be a mechanism within the detractors' minds which immediately conjures up images of sexual perversion, especially when those movements are particularly favourable to women, and which give women places of authority or equality.[21]

Until all aspects of the feminine side of human nature, both in men and women, are respected, the feminine will continue to be degraded. Instead of recognising Sheelas as images of the impersonal deity, they will continue to be personalised, humanised and classified as pornographic. The non-acceptance and repression of the feminine side will lead men and women to regard the Sheela as a whore, the devouring incorporating mother, the devil, or the avenging old hag.

> When woman's power is taken from her, and when the old sisterhood of the matrilineal order is displaced, the power of women can no longer be direct and open, for direct military power is precisely the force which has displaced the feminine for the masculine order. The feminine compensation for this shift in sexual emphasis from fertility – that is, reproductive power – to erotic power ... 'sexiness', the erotic power of the beautiful woman to lure the powerful man to his own destruction.[22]

Women have learnt from an early age that they are only valued if they are beautiful and sexually desirable. In modern Irish society, where moral values have diminished, the Irish Venus goes to the pub seeking love but only finds a 'one night stand'. Girls have never been taught to value themselves as Temples of the deity.

> [In the modern world] ... sexual repression has given way to sexual liberation, but neither has anything to do with true passion or true self knowledge. Both puritan and hedonist fear the body. The puritan fears gratification while the hedonist fears the absence of

gratification. Both are in conflict with the natural rhythms of the body, and derive their identity through their manipulation of nature's rhythms.[23]

Psychologists Jennifer Barker and Roger Woolger claim that the fear of not being equal to women's mature power lies behind all patriarchal domination and subjection of women, even further back than the time of the Greeks.[24]

> The female, like the Ancient Goddess in whose image she is made, is infinitely generous. Her generosity takes many forms ... sometimes she has a huge vagina which she holds open with her hands. In the eighteenth and nineteenth century most of these figures were removed. For what most terrifies the male is the absolute licentiousness of female generosity. It is a power which is completely free, which cannot be bought or sold, manipulated or exploited and which is continually fuelled by the seasons, nature, by our friendship with each other and our bonds to the earth. No wonder our materialistic world has devised ingenious ways of trying to contain women's wildness.[25]

THE FEAR OF INCORPORATION

Sheelas often elicit a fear of the sexual act – a fear of being taken over, incorporated in the womb. This connects with the unconscious memories of being in the mother's womb, with incestuous longing to return there in some cases, and to the fear of being caught and devoured in others. Examples are found in many myths: the biblical story of Jonah in the whale is perhaps best known. There is a similar Irish myth about Conan Fionn being swallowed by the

monster Coarnach in Lough Derg. Later, St Patrick replaced Conan in the story and he used his crozier to break out of her stomach – indicating his conscious re-birth.

SEX AND POWER

The negative aspect of Sheela threatens to devour – to incorporate, to annihilate. She sometimes takes on the symbolism of Pluto, the devouring mother archetype of death and destruction.[26] Pluto is an outer planet – it is the furthest distance in our solar system from earth – far beyond the limits of human control. Like the atom bomb, discovered at around the same time as astronomers discovered Pluto in 1930, the planet represented destruction and transformation. Plutonic energy destroys and recreates, but it must not be used to gain personal power over others.

Sex is often used as a force to 'possess' another, to enslave him or her, and steal their energy. In his nineteenth-century novel, Bram Stoker depicted Dracula as keeping his women barely alive in coffins. When he needs a charge of energy he sucks the blood from the neck of one of them. Stoker used the metaphor of the blood to describe the transfer of energy from one human to another. When life energy is constantly being sucked from an individual without reciprocity, that individual will sicken and eventually die.

SEX AND DEATH

The ancients called the sexual act 'the little death'. A part of oneself dies to the self in order to be transformed. The experience can bring up the fear of dying. The individuality and separateness of the self must be given up in order to fuse with the other. This death of self was the possibility of creativity.

BLOOD AND POWER

From the earliest times societies associated blood with power. Native American and early biblical Jewish traditions acknowledge the 'moontime' (menstruation) when a woman is most powerful psychically.[27] She was freed from corporal work and withdrew to the women's lodge in order to receive spiritual guidance for the tribe. Neither did she go to the sweat lodge at that time, because her energy was too powerful for the group. She returned to the tribe with what visions or guidance she had received, not only for herself but also for the tribe. In Greece, the place of the Oracle at Delphi is said to have been a menstrual hut called 'the place of the wise wound'.[28]

The female's blood is shed in order to give new life. But the concept of women's sexuality has been so denigrated that menstruation is known as 'the curse'. Many women suffer from pre-menstrual tension and various gynaecological problems, which may emanate from negative psychological attitudes toward their own feminine sexuality. There are no female 'rites of passage' in today's religions. 'Today's world is violent and superficially sexual whereas a return to our true earthy nature would allow an erotic and truly sensual way of living and savouring its gifts.'[29]

THE PHALLIC SYMBOL AT THE CENTRE OF IRELAND

The most significant spiritual and political centre in Ireland was Tara in County Meath. Today though, Tara has returned to nature – with grassy hills overlooking all four provinces of Ireland. Only the phallic stone tells of past glories.[30]

Mistakenly identified as 'the Stone of Destiny', this is the Lia Fian, the stone of the Fianna, the High King's army of warriors, active around the third and fourth cen-

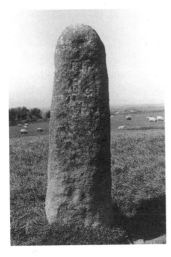

STONE OF THE FIANNA,
the phallic stone on top of
King Cormac's enclosure,
Tara, County Meath.

turies AD.[31] Over six feet tall and made of granite, this is a lingam or phallus. Instead of the Lia Fál (Stone of Destiny) upon which the rightful king sat, the Lia Fian (stone of the warriors) was placed at the residence of the High King. But where is the yoni to balance the lingam at this centre representing the sovereignty of Ireland?[32] The Sheela on Tara is hidden amongst the graves in the churchyard and labelled 'crude', 'rude' and 'pagan'.

Symbols leave a deep impression on collective consciousness. This treatment of symbols of generative energy reflects the lack of understanding of the balance needed to sustain life and prosperity. Sexual and spiritual energy are not exclusive – they are meant to go together.

Two bishops at least retained an awareness of that balance. Their tombs attest their belief in the Great Mother, to whose womb they returned at death. Bishop Walter Wellesley of Kildare (*d.* 1539) and Bishop Henry Wardlaw (*d.* 1440), founder of St Andrew's University in Scotland, both have Sheelas on their tombs, though this is not mentioned in the guide books.

Chapter 9

THE PSYCHOLOGICAL SIGNIFICANCE
OF THE SHEELA

The Sheela as a symbol has enormous relevance in the present day. The reappearance of these carvings may be a signal that the human psyche is responding to an urgent call for balance to the overwhelming imbalance on earth at present – problems so serious that all life on the planet is threatened with extinction. There is a deep need for a return to the feminine – a symbol of the ultimate power of creativity to balance that of destruction – to teach respect to the arrogant and give hope to the downtrodden. Sheela is a symbol of that much-needed feminine deity – the powerful Dark goddess of transformation and renewal.

The Sheela is not just an antiquarian curiosity – a pagan idol that escaped St Patrick's sledgehammer. That she has survived unnoticed on churches and castles for hundreds of years is a skitoma that indicates how deeply she had disappeared into the collective unconscious. But the fact that these carvings are appearing, as if miraculously, at ancient sites and on medieval buildings, and the interest they have aroused – the heated arguments they excite, the strong emotions of amusement or repulsion – points to a shift in the consciousness of a significant number of people. This implies that the psychic need to redress

the lack of a feminine deity is at long last rising to the level of collective consciousness. Anything that is innate to the human being – and the feminine is innate in both male and female – cannot be repressed forever – the psyche will not allow it.

These images of the naked hag are symbols of the Great Goddess who generates and sustains all physical life on the planet. Into her great body all physical life returns at death. But that is not the end. The goddess teaches us that life is renewed and new life emerges from the old in the great round of creation and destruction. All of this has a profound impact on the psyche of human beings, on our understanding of how life functions and of our place and behaviour resulting from that understanding. Seamus Heaney reacted to his encounter with the Sheela at Kilpeck, in Herefordshire, England in the following:

SHEELAGH NA GIG
AT KILPECK

I
We look up at her
hunkered into her angle
under the eaves.

She bears the whole burden
on the small of her back and shoulders
and pinioned elbows.

The astute mouth, the gripping fingers
saying push, push hard,
push harder.

As the hips go high
her big tadpole forehead
is rounded out in sunlight.

And here beside her are two birds,
a rabbit's head, a ram's,
a mouth devouring heads.

II
Her hands holding herself
are like hands in an open barn
holding a bag open.

I was outside looking in
at its lapped and supple mouth
running grain.

I looked up under the thatch
at the dark mouth and eye
of a bird's nest or a rat hole,

smelling the rose on the wall,
mildew, on earthen floor,
the warm depth of the eaves.

And then one night in the yard
I stood still under heavy rain
wearing the bag like a caul.

We look up to her,
her ring-fort eyes,
her little slippy shoulders,

her nose incised and flat,
and feel light-headed looking up.
She is twig-boned, saddle sexed,

grown-up, grown ordinary,
seeming to say,
'Yes, look at me to your heart's content

but look at every other thing.'
And here is a leaper in a kilt,
Two figures kissing,

A mouth with sprigs
A running hart, two fishes,
A damaged beast with an instrument.[1]

The poet observes her whole shape, seeing her 'hunkered' in that typical squat of the Sheela, with shoulders raised as though she is pushing in the act of giving birth to the whole world. He also notices the carvings nearby: the animals, the mouth devouring heads – symbols of life and death. Her hands remind him of his youth on a farm – other hands holding open a grain sack – and he remembers

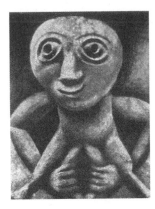

SHEELA AT KILPECK, ENGLAND, carved on a corbel.

167

the traces of animal life in the barn – the hole of a bird's nest, or was it home to a rat? And then he recalls how he found himself inside that sack one rainy night, like a newborn baby in a caul.

Sheela served to connect him with his own history and then led him to see the interconnections between the Great Goddess and the whole panoply of life – vegetable, animal and human, including his own. This poem is a good example of the response of an integrated psyche confronted by the Sheela symbol. All fits into the great pattern of life, including his particular personal experience.

This little carving on a twelfth-century church in England has a numinosity to bring spiritual insight. In the past this would have been the preserve of religion – of the priest/priestess, Druid or shaman. Unfortunately organised religions are concerned with imparting doctrine and rituals that are increasingly more restrictive. There is no room in organised religion for a broadening of perspective to include the feminine at the level of deity. The consciousness of the collective has outdistanced the old patriarchal doctrines but, as yet, we have nothing with which to replace it.

In the modern world it has fallen to psychiatry and psychology to preserve mental health. Psychiatrists deal mainly with psychosis or mental illness, treating it mainly with chemicals and electric therapy. Modern psychologists, on the other hand, work with the mind and behaviour, but restrict their investigations exclusively to what can be scientifically seen and quantified. In many academic institutions psychology is now called 'Behavioural Science'.[2] The word 'psychology' comes from Greek, and means 'the study of the mind or soul', yet this meaning has been lost. There is, however, a branch of psychology called

'humanistic psychology' or 'analytical psychology' that deals with the human being as a whole – body, mind and spirit, or soul, and this is the field where the Sheela symbol can be most useful in the process of facilitating the healing of individuals and groups of people.

MENTAL HEALTH IN ANCIENT TIMES

In the past, the psychological balance of a people was maintained by religion, which was based on the understanding they had of how people understood the workings of the earth and the heavens. To the ancients, the body, mind and soul were an integral whole, and the mind resided in all parts of the body. The truth of that is being proven more and more by modern scientific research.

All religions helped people relate back (*re-ligio* means linking back in Latin) to the universal source of life and assisted them in understanding their place in relation to that source. The constant re-telling of stories, myths, legends and folklore pertaining to the lives of their gods and goddesses maintained the psychic balance of their civilisations.

Myths of the goddess Inanna of Sumeria, Ishtar of Mesopotamia, Isis in Egypt and Brigid in Celtic societies connected people to all life on the planet in the form of the Great Mother, the Great Goddess. They were participating in the process of life and death – co-operating with the goddess and celebrating the seasons, which made their lives meaningful and significant. Later, in Greek and Roman times, they listened to sagas like the *Iliad*, the *Odyssey* and the *Táin Bó Cuailgne* and felt connected to the gods, participating vicariously in their adventures, in the lives and deaths of the great heroes and heroines. The *Rig Veda*, the *Bible*, the *Koran* and the *Bhahavghad Gita* are written examples of the great myths from patriarchal religions.

When theses stories resonated with the individual's inner reality, they sensed the origin and purpose of life and felt joy at being alive. Because the gods lived awe-inspiring, strange and terrifying lives, individuals were spared from having to live those aspects in their personal lives. The archetypes enriched the inner life of the people and maintained the mental balance within that society.

But religions no longer have psychic and moral relevance for the majority. It is not that people do not wish to find a deeper spiritual meaning to their lives – this is a basic human need and one that must be met if the individual and society as a whole are to reach a higher stage on the evolutionary ladder. The present challenge is to recover our lost archetypal heritage and to begin to envisage a new mythology for the future.

ARCHETYPES

Archetypal, larger than life characters, appear in every myth and fairy tale. They appeal to us as they appealed to our ancestors, because they strike a chord deep within. It was Carl Jung who first developed a psychological theory about the archetypes. He saw that they existed within the unconscious of every individual as energy forces, as he called them 'archetypes'[3] of the unconscious. They are experienced as powerful drives that often seem more powerful than the individual's self control and that is why they are depicted as gods and goddesses. Carl Jung names these forces 'archetypes of the unconscious'. Some archetypes are familiar to everyone: for example, Apollo, the sun god, represented youth, vigour and creativity; Mars, the god of war; Mercury, the god of communication; Venus was goddess of love; and the Moon represented all the positive and negative feelings and emotions associated with 'mother'.

Saturn was depicted in myth as the authority figure, the wise old man; Neptune represented the longing for the divine mystical experience; Uranus the desire for freedom, and Pluto is god of the underworld, power and destruction. All of these and many more are dynamic forces that come from within the archetypal memory of the human race. Variations of the archetypes exist within every human being and are experienced at some time during an individual's lifetime.

Sheela represents the powerful transformative process – death of the old into new life, reminding us that death is not the end – new life comes from the buried seed. This archetype has been missing over the past 2,000 years. She represents the divine feminine, that sees beyond illusions, that powerful feminine deity who is the destroyer but also the creator, who gives birth to new life. When this archetype was removed from all major religions, an essential aspect of human nature was also removed from collective consciousness, and all the things that were mediated by the dark goddess went underground with it. The result is a fear of change and transformation, a terror of death, a denigration of the female as a vessel of lust, shame associated with the female body as being inferior, and the scapegoating of the female sex.

REPRESSION OF ARCHETYPES

Whenever a fundamental aspect of human nature is denied, it is repressed into the unconscious of the individual, and of society as a whole. Disowned, the force which it represents is felt to be outside the self, and is experienced as a threat to the individual and to the collective group. That force is projected outwards onto others and it becomes the underlying cause of conflict.

In patriarchal cultures, when the goddess was dethroned, all the archetypal material associated with her was repressed in both men and women, and became something to be feared. Since women were the living image of the goddess, these characteristics became associated with that sex, and so women had to be restrained and restricted as far as possible by religion, by law and by society restrained subjugating them to patriarchal values, ethics and rules. The effects of these repressive attitudes are predominant even today in fundamentalist Muslim cultures and in certain sections of fundamentalist Christian communities. They are also still evident in more liberal societies where equality has been legislated but where custom and culture are slow to implement the law.

THE FUNCTION OF SHEELA
Sheela, symbol of the dark aspect of the goddess, can assist in the restoration of feminine values, lost to humanity by an overlong emphasis on the patriarchal myth. She can help restore the psychic balance of human beings. Moreover, because the feminine is associated with nature and the earth, this planet itself has been abused and exploited, creating irreversible environmental destruction. As a symbol of the ultimate power of Mother Nature, the creatrix and destroyer of life – all life must bow before her ever-changing transformations. The Sheela serves to teach the lessons of humility to the arrogant and gives hope to the disempowered.

PSYCHIC INFLATION
People are not meant to live out their inner archetypal images in the outer world. Deities are meant to inspire, to fill the viewer with awe, and direct the interior life. Those who do

attempt to live like the gods in the real world have allowed their egos to be swamped by the archetype.

For example, the patriarchal archetype has dominated the world for over 3,000 years. At the top of every institution is the authority figure (the king, the pope, the general, the president, the father) whose behaviour and attitude reflect the authoritarian qualities of God the father. When men (or patriarchal women) occupy positions defined by this archetype, they may identify with the role – acting, thinking and believing that they are the archetype. They suffer from psychic inflation.

Whoever identifies with the controlling father archetype will not be able to express other human qualities because in expressing these qualities he or she must give up the role of 'the authority'. 'As long as patriarchy exists, whoever has the most power has the last word. Consequently, the authoritarian father archetype will stay pre-eminent, and power over others will be an obsession.'[4]

THE BATTLE FOR POWER

Both men and women struggle with the Sheela archetype hidden within their own unconscious minds. When the feminine is not expressed overtly, it is expressed covertly: through manipulation, in ways that substitute 'power over the other' for genuine love. Relationships are destroyed in this way, because whenever genuine love is absent the desire to control replaces it.

THE LOSS OF THE FEMININE DEITY

The symbolism of the feminine deity survived at least 1,000 years longer in Ireland than in other European countries. The Divine Hag of the Celts was a symbol the ordinary people clung to despite the injunctions of Rome

and threats to the Celtic Church of excommunication because of heretical practices. But by the end of the twelfth century Ireland had also capitulated to Rome. All the qualities that mediated sexuality, death and regeneration were assumed by Mother Church, who was also styled 'the Bride of Christ'. The hierarchy of the church dressed in gowns of velvet and ermine, in red and purple – the colours of the goddess, trimmed with laces – attempting to fill the role of the feminine deity.

SYMBOL OF THE WHORE

Sheela became the symbol of corruption – the outlaw, the unreformed whore. Women who did not have a male 'protector' or conform to the restrictions of church and society were ostracised and labelled whores, witches and hags. For nearly 400 years, women with knowledge and independence, as well as some brilliantly gifted men who did not conform, were burnt at the stake as witches. Even in the twentieth century many universities would not allow women to study medicine, science, architecture or theology. Women's wisdom was devalued. Psychiatrist Jean Bolen remarked that when patriarchal values are at the forefront

> ... feminine wisdom ... has receded and is deep underground. She is part of the psyche that dreams and knows, tapping into the collective unconscious, where past, present and future are one. The arrogant masculine intellect that assumes dominion over nature discounts the unconscious as irrational and meaningless. Loss of contact with dreams and depth results ... loss with the mother realm that values relationships and nature.[5]

Without the grounding influence of the feminine, people become dissociated from the sense of the geography of place, and from the environment of the natural world. Dissociation is a reaction that splits a portion of the psyche off from consciousness. Because we are no longer aware of it, we are apparently saved from anxiety or guilt and do not have to bear responsibility for our behaviour. For example, in the ethics of patriarchy, king and country take precedence over mother and family. In the *Táin*, the great Irish hero Cúchulainn killed his own son and presented the body to the king of Ulster – Conchobhar – demonstrating that his fealty was first to the king over any ties of blood. 'A child allied with the now excitingly powerful patriarchal fathers finds it seemingly safe to abandon the bountiful mother.'[6]

THE PSYCHOLOGICAL EFFECTS OF REPRESSION
In the lives of modern people, who live almost exclusively in the rational mind, there is no room for either God or the devil. There is no time for ancient myths. Therefore, individuals are being taken over by archetypal energies that they deny exist.[7] The unconscious will break through when we least expect it – in inappropriate speech and behaviour, in dreams and nightmares. The unacknowledged part of the psyche, like a member of the family who is shunned, can become murderous or suicidal.[8]

Why must we continue to believe that man was created first and woman an afterthought? Why should God want to create a woman out of a man? The Judaeo/Christian myth has no ring of truth of nature in it. According to the so-called 'Lost Books of the Bible', Adam's first wife, Lilith, was created equal with him – not from his rib. Her fault was that she was insubordinate to

Adam, wanting 'to be on top' during sexual intercourse. She was sent to Hell (also the name of a German goddess) for her sins. Eve, the second wife, was actually made to be inferior to Adam, and thus were women considered inferior to man. And so it has continued for thousands of years.

There are other cultures, including all the native peoples, who did not subscribe to this thinking. The Maori of New Zealand believe that Father Sky and Mother Earth were equals and they loved each other, but their children came between them and separated them. Perhaps in the new myth of creation their children (humanity) will bring them back together and reunite them. At least it is to be desired that in the future religion/spirituality and the cosmology upon which it is based will be more balanced. In order for this to happen, a sufficient number of people will have to reach higher levels of consciousness.

HOW CAN THE SHEELA ARCHETYPE ASSIST PSYCHOLOGICAL TRANSFORMATION

Human evolution requires the healing of the psychic split that divides masculine from feminine. The human being is meant to become whole according to Carl Jung, and wholeness involves learning to acknowledge, accept and love the contra-sexual side that exists within everyone. (Jung called the feminine side of the male the *anima* and the masculine side of the female *animus*.) This has nothing to do with sexuality. Unfortunately, even language reflects the psychic split within the human being. By living out her masculine side, a woman is meant to think rationally, become educated, be financially independent, set goals for her life – all the things women have been prevented from doing by social and cultural expectations in the past. On the other hand, men need to embrace their feminine side

– they need to be more caring, learn to trust their feeling nature, be more co-operative and able to compromise. These qualities have been thought to be signs of weakness in the past. Wholeness comes from embracing the parts of self that have split off from conscious awareness – that have been disowned and projected onto others. The Sheela archetype is a prime example of an essential aspect of human nature that has split from consciousness. Humanity has dissociated from all that she represents: death, transformation, and rebirth.

THE DEVOURING HAG

The Sheela archetype in most people will be part of what Jungians call the Shadow, that 'devil' within. She may appear a dark, devouring mother, or a wicked witch, repulsive and loathsome, but she has the power to evoke whatever is most repressed in the beholder – a sign that this symbol and the archetype she represents are full of numinosity or spiritual force – what in Irish is called *neart*. By facing the fears she elicits and staying with them – whatever they may be – one begins to discover the comfort and acceptance of the Dark Mother. She becomes the container where one can rest safely, in the enfolding womb of the goddess. One is no longer alienated from her, but comforted and empowered by her. All of this is part of an inner journey and when it is undertaken consciously at an *inner level* the psyche is healed, the personality more balanced.

Consciously working with the inner archetypes through therapy integrates the personality, whereas if the powerful archetypes remain unconscious they sometimes break through into an individual's outer behaviour and can destroy life.

The hag represents the pre- or trans-ego negative (and positive) shadow material that has been kept from consciousness ... the unlived or shunned parts of ourselves and of our society are represented as ... gross and hateful, laden with intolerable affects ... She disrupts our stability as she threatens the boundaries of our sense of identity and its congruence with standards that are ideal and safe.[9]

The hag represents those parts of life experience we split off from because they are so threatening, with defences like denial, dissociation and anaesthesia. We project those qualities outwards on to others because our conscious mind cannot accept that we could be capable of such behaviour. Nonetheless, those parts make up our wholeness and if we are to live consciously we need to own them. Often, when worked with psychologically, they can transform the personality, bringing forth the 'gold' that the alchemists strove to attain in the Middle Ages.

Sylvia Brinton Perera uses mythology to effect psychological healing in her analysands. She points out that the loathsome damsel, the gruesome hag who the prince encounters, is at the same time the embodiment of all that is feared, as well as what is fatally fascinating. 'Only the true king' – or an individual consciousness brave enough to face the ugly, pain-filled reality of the outer world and its own depths – is worthy to receive the beauty that represents sovereignty. First he must disenchant and transform the hag.'[10]

This is one of the major steps in the growth to consciousness. In the past, only the few were able to develop their awareness in this way. The early mystics fasted and disciplined the body, spent days and sometimes a lifetime

in silence in caves, in their 'cells' or in the temples or churches, singing and chanting in their quest. There is no time for this today, but life's crises give every individual the opportunity to make the transformations in his/her life. How they are handled indicates whether, like the brothers of Niall of the Nine Hostages, they will fail the test in dealing with the hag – who is really the goddess of sovereignty over the earth, or like Niall, will choose to embrace what is repellant. If the latter choice is made one begins to gain real sovereignty over the self. This is the beginning of the transformative psychological journey into wholeness.

THE NEW CONSCIOUSNESS

As we strive to attain the shift in consciousness in our-selves, men as well as women are beginning to relate to all three aspects of the divine feminine: Virgin, Mother, Crone. Not only does this create a rich and creative inner life, it is drawing back into awareness those profoundly powerful processes that have been loaded with taboos dur-ing the patriarchal period: sexuality, birthing and death.

When groups of people are exploited by others, the nat-ural response of the exploiters is guilt – followed by fears of retribution and hatred of the exploited. Scapegoats are then found to blame for that hatred. Women and the weaker ele-ments of society, including weaker nations, have had to shoulder those projections for millennia. In the new con-sciousness a democratic people will not allow this to happen.

Women's bodies must no longer be exploited, and brutalised by religious customs that seek to prevent their enjoyment of their sexual nature. Women must learn to respect and love their own bodies so that the alarming inci-dence of self-inflicted abuses, such as anorexia, bulimia,

self-mutilation and suicide will cease. The feminine within both men and women has turned into a devil, full of fear and self-loathing.

Society pays a great price for this rejection. Equality legislation has not had the desired effect in the home, in schools, universities, at the workplace or in the professional, academic or political worlds. Furthermore, as legislation is enforced, masculine fears are creating a backlash against women. 'Today women have demonstrated that they can do everything ... that's not the same as being able to have everything,' said Germaine Greer on a visit to Ireland a few years ago.[11] A woman who wants to succeed in the business world is up against the envy and resentment of her own sex, even more than that of her male counterparts.

Men are also finding the transition difficult as they discover the old stereotypical roles are no longer acceptable. The changes taking place in the world are meant to assist men to discover their inner feminine side (the *anima* or soul in Carl Jung's terminology): that is their ability to nurture, to compromise, to empathise with others.[12] During this time of change, deep insecurity and confusion is created within the individual. The chaotic uncertainty has brought the Sheela symbol back to western consciousness, because she is the goddess of transformation.

SHEELA IS THE GATEWAY THROUGH DEATH TO RENEWAL
The ultimate fear for most human beings is annihilation – to be no more. Panic attacks, anxiety, and phobias are at the deepest level a fear of death and dying. Death is the one thing that has not been conquered by man. Jean Bolen observed, '... awareness of death as an inevitability is denied or repressed as much as possible by power oriented, control-seeking personalities ... Fear of death and of

aging, fear of waning power or loss of attractiveness are frightening to a narcissistic person of either sex ...'[13]

While the Sheela (or the Crone aspect of the goddess) was still a conscious metaphor of the eternal round of life, death and rebirth, people believed in reincarnation. They could see that renewal of life took place every year. Life had a pattern and death was not feared. Therefore, when the viewer contemplates the fearful image of death and does not run away – the fear itself is seen as an illusion. Jonah was swallowed by the whale – but did not die; the Irish Conan Fionn jumped into Loch Derg to fight the monster and was swallowed by her, but was released in the spring; and St Patrick was said to have done the same thing, but fought his way out with his crozier.

The story of Niall of the Nine Hostages and the hag contains the same wisdom – when one embraces what one most fears it becomes an illusion. Fear itself is an illusion – a negative idea of what might happen in the future, not of what is. The hero lay down beside 'death', and she was transformed – he saw her as the potential for renewal.

THE ILLUSION OF DEATH
One of the major findings of modern science is that death, in the way we think of it, is an illusion. Scientists have shown that no energy is ever lost – the soul returns to its original source. Scientific data on near-death phenomena confirm that there is life after death. Many thousands of people have had near-death experiences and have returned to their bodies to describe them.[14] Carl Jung was amongst these.[15]

TRANSFORMATION
There are many ways of letting go of 'life' without losing

the physical body. As people live longer, change careers often, leave what used to be considered lifetime relationships, are sometimes uprooted from one country to another – they are experiencing what might be considered totally new lives, lived out in the same body. They are being led through transformations into renewed life. The Sheela can be the symbolic guide or 'psychopomp' in this process. This Crone can be a useful metaphor to help the individual who is grieving over life's typical losses.

THE ROLE OF PSYCHOLOGY IN TRANSFORMATION OF CONSCIOUSNESS

Normally transformations occur through a crisis – events in the outer or the inner world that make an individual face the facts of loss – through the illness or death of a loved one, the break-up of marriage or a relationship, the bankruptcy of a company, or emotional bankruptcy, the loss of a job, failure to achieve whatever goals have been set. The major 'stressors' bring about neurotic behaviour and sometimes psychological problems such as anxiety, or panic or phobias, sometimes psychosomatic symptoms such as irritable bowel syndrome, psoriasis, and so on.

Over the past 30 years or so scientific discoveries about the human being have been made through co-operative efforts in the fields of medicine, biology, physics, metaphysics and psychology. The new psychology is part of a worldwide trend to understand the human being as an integral whole – body, mind and spirit. It is a vision that sees all of nature as full of energy.

This new awareness of the wholeness of the human being requires that healing, to be fully effective, must take place at all three levels: body, mind and spirit. For example, the work of Alcoholics Anonymous and all the pro-

grammes for addictions founded upon its principles, have healed millions of people and demonstrate conclusively that dysfunctions of the personality cannot be understood or healed without attention being given to the spiritual dimension. When the source of renewal is cut off, the longing for spiritual nourishment is expressed in other vices – all of which are substitutes for genuine love – the love/energy from the universal source.

THE NEED FOR SILENCE TO BECOME WHOLE

In order to get in touch with all the unknown parts of the self, there is an absolute need for quiet in which the mind is rested and at peace. This is not the same as sleep, in which unconscious material is coming up through dreams. The soul, which we are most often unaware of, longs for that silence in order to balance the inner and the outer life.

The majority of modern people are terrified of silence and stillness. In that void, whatever we need to know about ourselves is set before us – desires, fears and cravings. When we stop and face those things squarely we begin to accept and love ourselves. Loving ourselves is the first step towards wholeness. We do this in quiet times, in meditation, in connecting with nature. All of nature is connected to us and we to it by the same energy that gives us all life. We are never abandoned, never alone.

PSYCHIC HEALTH REQUIRES A CONNECTION TO THE ROOTS OF THE RACE

We not only need to connect with the earth, but we also need to be aware of our past as a race – to be rooted to our metaphysical tradition. This is achieved through history, pre-history, myth and rituals to connect us with our source – with deity – and helps us to see our place in the context of

the whole. Thus the folklore and stories of a people motivate the actions of individuals and groups within that society – they become the foundations that make up the history of a people. The stories that are *not retold*, that have been eliminated or forgotten from the cultural heritage of a people live on nonetheless – in the collective unconscious of that people. The whole culture then behaves neurotically.

In the work of transforming the psychic life of an individual or a people, mythology can give a sense of meaning and purpose without which a people can lose their identity. By reading and using those myths, journeying with the gods and goddesses of the past, with their passions, their victories and defeats, we can connect with our own inner life, raising our understanding of the meaning and significance of our life. The balance is re-established as the lost archetypes are reclaimed. The goddess is ever-changing – the Death Goddess promises transformation and renewal. She promises sovereignty to those who have the courage to face her. That takes great humility and letting go of ego:

> Letting go is embracing the black goddess, she who will open our eyes to the illusions, she who will make us see our treasure lies in the repressed energies we once labelled weak, irrational, disorganised, supersensitive … Descending into her territory demands the death of a rigidly controlled life.[16]

The individual must be willing to see without judging, to be open and adaptable to new ways, to end the old criticisms of self and others that block the flow of all creative energy, to be able to contain the opposites.

I was sent forth from (the) power

and I have come to those who reflect upon me.
And I have been found among those who seek after
 me.
Look upon me, you who reflect upon me,
 and you hearers, hear me.
You who are wailing for me, take me to yourselves,
 and do not banish me from your sight.
And do not make your voice hate me, nor your
 hearing.
Do not be ignorant of me anywhere or any time. Be
 on your guard!
For I am the first and the last,
I am the honoured one and the scorned one,
I am the whore and the holy one.
I am the wife and the virgin.
I am the [mother] and the daughter.
I am the barren one
and many are her sons ...
I am the silence that is incomprehensible
and the idea whose remembrance is frequent.
I am the voice whose sound is manifold
and the word whose appearance is multiple.
I am the utterance of my name.[17]

This Gnostic text reflects the imagery of the Virgin
Mother, speaking as Wisdom, as once Inanna spoke in
Sumeria and Isis in Egypt. She is all one – the wholeness
of the all.

SHEELA LEADS THE WAY THROUGH TRANSFORMATION TO
REBIRTH
There is a desperate psychological need in the world for a
symbol that can contain the transformative, life-giving to

death meaning of the feminine aspect of God. It is not a coincidence but a synchronicity that in places where war and hatred are endemic, the Virgin Mary has been seen most frequently. During the great plague of the fourteenth century, when over three-quarters of the population of Europe died, Our Lady appeared at numerous places in Ireland and on the continent. The statue of the Our Lady in Trim, County Meath[18] was seen by the people to be weeping tears during the famine and the plague of the Middle Ages, and again only a few years ago in County Cork. Today millions of people flock to Lourdes, Fatima, Medjugorje and Knock in County Mayo – to New Jersey and anywhere that reports of miraculous happenings are occurring due to the intervention of Our Lady. Her message is always the same: 'Pray for peace'. Peace is what cannot happen in a world that denies the goddess energy – the balance to the warrior ethic of conquest.

The phenomena of the appearances of the Virgin Mother reflect a deep longing within the collective for a feminine mediatrix, an intercessor, who can reinstate peace in the world. This longing is also a yearning to create peace within our splintered psyches and this is what will change society as a whole and move our civilisation into a forward progression of evolution.

COMING TO WHOLENESS
In order to achieve this balance, the Dark Goddess – the Black Madonna, Kali or Sheela – must once again return to our collective consciousness, so that we will no longer have to carry the burden of the missing archetype. Thomas Cahill likens the Sheela to '... Kali of India, death-in-life and life-in-death'. She is a gift from a past civilisation that has been sleeping within the unconscious of the collective

for centuries. Our desperate need has reawakened her into our consciousness.

When the crisis brings forth the Dark Goddess she leads us into an interior quest. This requires time, silence and a connection with nature in all forms. Through her we claim the lost parts of our nature, get in touch with our physical bodies and learn how to heal them. While we are connecting with our physical nature and with the earth itself, we begin to become reconnected with our place on it and our heritage. We begin to be aware of the light and spirit permeating all of nature. We become more comfortable dwelling in nature and in our own bodies, learning to accept them for the wondrous miracles they are.

By meditating on Sheela we begin to value the feminine in nature and in the human being. This powerful, awe-full goddess is the gateway to higher consciousness and to a new stage on the ladder of human evolution.

No doubt this new age we have entered will require new myths, new symbols of the great archetypes to reflect the further expansion of consciousness, to reflect those energy forces that are the expressions of the divine source we call God. But until new symbols appear we have been given an ancient one to contemplate – one without which we cannot make the leap to new awareness – this Kali of the west, this Sheela of the ghee of life, this jigging Baubo who laughs at life and death, the 'witch of the wall', pregnant with new life, this terrifying hag who turns into a beautiful goddess, this goddess of death and the underworld, who generates new life, this whore who is the Virgin.

THE VIRGIN – FREE AND CREATIVE
Some people will see the nakedness of the Sheela and her dancing legs as an image of the freedom of the feminine

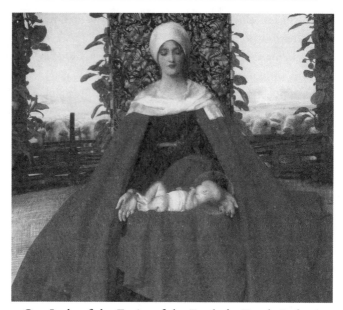

Our Lady of the Fruits of the Earth *by Frank Cadogan Cowper (1877-1958) shows the order and bounty the Earth Mother bestows on those who honour her: animal, vegetable and human. The Divine Child is the gift that integration and wholeness brings to the individual and to the planet.*

spirit, casting off the yoke of repression from all things hitherto thought to be explicitly feminine. They connect with the expression of feelings, of openness, of creativity, being allowed to be what one is instead of hiding what society considers socially unacceptable. Sheela represents the positive shadow for these people. She is the Virgin in the older sense of the word, independent, not possessed by anyone else, but able to relate to others while at the same time living fully and creatively, making her own life choices.

In the modern context, both male and female can live from a Virgin standpoint. A metamorphosis begins to take place in the life of one who decides to live in this way. Like

Baubo of classical mythology, her bawdy gesture and enigmatic smile suggest she knows the mysteries and the origins of life and can lead the way if we are courageous enough to follow.

> ... the Virgin learns to live spontaneously from the emotions and values that are grounded in her musculature. The initiated Virgin is the feminine who is who she is because that's who she is. Like the virgin forest she is full of her own life, full of potential, pregnant. Her characteristics cannot be totally separated from Mother and Crone. One day hopefully Mother, Virgin and Crone will become an integrated whole. The Virgin carries the new consciousness – the consciousness that may radically shift the consciousness of the planet, and in the new physics is shifting it.[19]

SOPHIA, THE GREAT GODDESS OF THE WHOLE

Once we learn to stand alone and to be sufficient unto ourselves, understanding and living life from the standpoint of the independent Virgin, we begin to see ourselves as no longer isolated but part of a great life force. We begin to realise that we have something unique to contribute to it. The sixth sense – intuition and inspiration – begin to function, the third eye of wisdom begins to open and expand our spiritual/human capacities creating what Teilhard de Chardin called 'the noosphere'.[20]

The archetype of the Great Goddess needs to re-enter collective consciousness, to be internalised and loved, so that the many aspects of the feminine will no longer be split within the psyches of men and women, so that all humanity and Mother Earth herself may be healed. What a remarkably wondrous world can be created when there is

peace in the individual, the family, the nation and on earth. When generosity replaces greed, inclusiveness replaces isolation, and the ability to compromise deflects the course of aggression and war. What a wonderful world we will have created when language itself is no longer sexist, nor religions, nor society, when all things are valued equally.

Freedom from fear, ecstasy and at-one-ment with Sophia the goddess of wisdom are the gifts the Sheela archetype brings. The one who has the courage to look beyond the illusions is rewarded with sovereignty over self, genuine love, inner peace and peace on earth.

Appendix 1

THE CHANGING FUNCTIONS OF THE SHEELA OVER TIME

	4000BC-600AD	500 - 800 AD	800 - 1100 AD	1100 - 1200 AD	1200 - 1400 AD	1400 - 1700 AD	1700 - 1985 AD	1985 - present
Where?	Carved on stone or wood. At sacred sites outdoors.	Beside oak churches. Brought to Scotland, England and France by Columban Church.	Over entrances & on windows of churches. On Continental Pilgrimage routes.	Roman reform. Not on English or French churches after 12th century	Removed from churches. Began to appear on castles.	On castles, bridges walls. Hidden or destroyed. On tombs of bishops.	Disappeared from public awareness. Stored away in museums.	Displayed in museums, designs on jewellry, art, & tourist items.
Symbol	Spirals, lozenge, yoni, female figure	Symbol of Great Mother	Symbol of 'Mother Church'	Occulted.	"Luck symbol" of Gaelic **Chieftains**	Grotesque figures: hag, witch, whore	"pagan idols";	Symbol of the Goddess
Function	The Great Mother of All: life, death, and regeneration **Sovereignty Goddess**	**The feminine aspect of God. Goddess of Sovereignty**	Entering 'Mother Church' to be spiritually reborn.	Hidden from view. Or used as warning against sin.	Gaelic Chiefs right to sovereignty over Irish land. Copied on Norman castles..	Apotropaic. "Bad luck" to those who look on her. Occult significance.	"An insult to women". No function.	Transformation.

Endnotes

THE HERO AND THE HAG

1. Rees, Alwyn and Rees, Brinley: *Celtic Heritage: Ancient tradition in Ireland and Wales,* Thames and Hudson, 1989. p73. (First published in 1961.). The text given here is the author's paraphrasing of the Rees and Rees version of the myth.

2. '*Laigfead óat la taeb póici do thabairt*' – the original text which means 'besides giving thee a kiss, I will lie (meaning have intercourse) with thee', as explained in a letter from Seán Ó Duinn to the author, 27 January 2003.

INTRODUCTION

1. Jung, Carl: *Symbols of Transformation,* Part II.

2. Note: on the continent Sheelas are not found at Iron Age Celtic sites, only at those places where Irish missionaries set up their monasteries.

3. Gimbutas, Marija: *The Language of the Goddess,* 1989. p. x. Gimbutas states: 'Sources in archaeology need to be analysed from the point of view of ideology. For this reason it is necessary to widen the scope of descriptive archaeology into interdisciplinary research – comparative mythology, early historical sources, and linguistics as well as to folklore and historical ethnography.'

4. Cahill, Thomas: *How the Irish Saved Civilization. The Untold Story of Ireland's Heroic Role from the Fall of Rome to the Rise of Medieval Europe,* Bantam Doubleday Dell, New York, 1995.

5. Note: The Synod of Whitby, 664 AD. Celtic Church lost its cosmology, tonsure, and other customs and rituals. Roman Church took over Northumbria and Pictland, and Celtic monks were driven out.

6. Note: There were three branches of Christinaity in the early centuries: Brigid's, Colum Cille's and Patrick's (which represented Roman Christianity). Cáin Padraig – the Law of Patrick – declared for the whole country of Ireland in 737AD and reasserted several times during the eighth century, indicates that Roman Christianity was gaining

ground even in Ireland at that time.

7. Reforms of the twelfth-century Synod of Cashel 1111 and of Kells, 1152 dealt with simony, the marriage of priests, the creation of 36 dioceses and four archbishoprics – at Armagh, Cashel, Dublin and Tuam. 200 Irish monasteries were placed under bishops and archbishops responsible to the Pope and eventually most of them became defunct.

8. Campbell, Joseph: 'there is a universally recognised need in our time for a general transformation of consciousness.' P.xiv in Gimbutas, Op Cit, p. xiv.

9. Gimbutas, Marija, *The Language of the Goddess,* op. cit.

10. Campbell, Joseph: op cit, p. xiv.

CHAPTER 1

1. O'Donovan, John: Ordnance Survey Letters, Co. Tipperary (Typed copy) Royal Irish Academy Proceedings Vol. 11, 1840. Quoted in O'Connor James: *Sheela na gig,* Fethard Historical Society, 1991, p.6.

2. Andersen, Jørgen: *The Witch on the Wall,* George Allen and Unwin, London, 1977, p.84.

3. Ibid., p.86.

4. Ibid.

5. Macalister, R.A.S.: *Tara,* London, 1931, p.52.

6. Ibid.

7. Rynne, Etienne, 'A Pagan Celtic Background for Sheela na gigs' in *Figures from the Past.* Glendale Press, 1987.

8. Ross, Anne: *Pagan Celtic Britain,* London, 1967, p. 147-8.

9. Cherry, Stella, *A Guide to Sheela-na-gigs,* National Museum of Ireland, 1992, p.1.

10. O'Connor, James, op. cit. pp. 15, 16.

11. Note: The clan (or sept as it was called in Ireland) was the larger family that included all kindred for five degrees – linearly from grandfather to grandchild, and outwards to cousins, to within five degrees. This was the extended family from which the next chieftain of the clan was elected.

12. O'Connor, James, op. cit. pp.15-17, p.27

13. Ellis, Peter Berresford: letter to the author, 6 May, 1997.

14. Ó Duinn, Sean: private correspondence, 24 January, 2003.

15. Dr Colver Walkins, Harvard University. Dr Walkins states that Old Irish remains the most conservative of all languages of the Indo-European root language that existed prior to 2000 BC. Though the

divergence must have begun around 3000 years ago, the more archaic form, Q-Celtic, is the basis of Old Irish, Manx and Scots Gallic: P-Celtic was spoken by the Picts and in Brittany (Brethonic). Old irish remains the closest to Sanskrit.

16. Dillon, Myles: *Hindus and Celts* and Rees, Cambridge University Press, Alwyn and Rees, Brinley: *Celtic Heritage*, Thames and Hudson, 1961. Cross-cultural connections with the Vedic traditions of ancient India have been noted by a number of scholars and they include similarities between the caste system of India and early Ireland, between the laws of ancient India and Brehon law, cosmology, astronomy, music and symbols.

17. Yule, Henry and Burnell, Arthur C.: *A Glossary of Anglo-Indian Colloquial Words and Phrases and of Kindred Terms,* John Murray Publications, London 1886. Quotation from Shibábuddin Tálish, translated by Professor Blockman, in J. As. Soc. Bengali xli, P. 1, p. 84.

18. Dalrymple, William: *The Age of Kali,* Flamingo/Harper Collins 1999, pp. 177-191.

19. Mary Condren, ed, *The Serpent and the Goddess,* Harper Collins, New York, 1989, p. 26.

20. Gimbutas, op. cit. p. xix.

CHAPTER 2

1. Gimbutas, Marija: *The Civilisation of the Goddess, the World of Old Europe.* Harper, San Francisco, 1991.

2. Gimbutas, Marija: *The Language of the Goddess*, Thames and Hudson, 1989. p.xix.

3. Ibid, p.xv.

4. Ibid. p. xix.

5. Ibid. p.xiii, Foreword by Joseph Campbell.

6. Biaggi, Christina: *Habitations of the Great Goddess,* Knowledge, Ideas and Trends, Manchester CT, 1944.

7. Op cit., Gimbutas, p.xix.

8. On the continent of Europe bodies of water are named after the Goddess: the Rhine after the Celtic sea goddess, Rhianan. The Danube is named for the Great Mother Danu – the same as Anu, Danu, worshipped by the Tuatha Dé Danann – the people of Danu – in Ireland.

9. Dames, Michael: *Mythic Ireland,* Thames and Hudson, London. 1992. p.168.

10. Ibid.

11. There are some 36 places in Ireland named Kilbride (Bride/Breege/Brigia/Brigit/ are variations of Brigid) according to the Ordinance Survey Maps, and many more places that have Brigid's holy wells.

12. Between the Glen of the Downs and Delgany, Wicklow there is a well and a place known as 'Sheela's Well'.

13. Berresford-Ellis, Peter, op cit, 19 , p.37.

14. Ó Duinn, Sean, in correspondence with the author, 27 January, 2003: Loughcrew probably derives from Irish Lock Croch Baoith which means 'the lake of the hill of the (Goddess) Baoith' – the same Goddess as Cill Iníon Baoithe/ Boi, that is, Killinaboy, County Clare where a Sheela is embedded over the entrance to the church, at what was a Celtic monastery.

15. Brigid's day is celebrated on 1 February – Imbolc in Irish tradition. It was one of the four main feast days of the Celtic calendar – the cross-quarter days. Imbolc marks the beginning of spring in Ireland. A baby born on that day was called *páiste greine* meaning 'child of the Sun'; they were treated with great respect by the entire community because many were conceived on another holy day – Bealtaine (1 May). Bealtaine, the summer festival, marked the celebration of sexual rituals to fertilise the earth. Very little information about these rituals has remained, even in folk tradition, because of the disapproval of the Christian church. Even so, May Day celebrations in honour of Our Lady included the May Pole dance of the virgins around the phallic symbol – although the Principals of the convent schools would hardly have known the connection to the pagan past.

16. Note: in this aspect, Brigid is like the Indian goddess of Wisdom: Sarasvati.

17. Note: could this be the origin of the grail legend – the grail in fact being a metaphor for the Goddess?

18. Miriam Robbins Dexter and Starr Goode: 'The Sheela-na-gigs: Sexuality and the Goddess in Ancient Ireland', *Irish Journal of feminist studies*, 4 (2002), p. 70.

19. Ó Duinn, Sean: *Where Three Streams Meet,* Columba Press, Dublin, 2001. P.43-44.

20. Note: See the Dinshenchas, early Irish metrical glossary of place names, Royal Irish Academy.

21. Ó Duinn, Sean: correspondence, 27 January, 2003. *Caille* from Latin – *pallium* meaning veil, or cloak. *Na gCailleach* is the genitive

plural; *Cailli* is singular, meaning the veiled one.

22. Office of Public Works, Dublin: Archaeological excavations at the Ceide Fields, Mayo and at Baltinglass, Wicklow.

23. The Heritage Centre, Carrowmore, Sligo brochure.

24. Leroi-Gourhan, *Treasures of Prehistoric Art,* Harry N. Abrams, p. 174.

25. Note: The cosmology of the Megalithic people emphasised the Solstices rather than the cross-quarter days of the later inhabitants of Ireland.

26. Poynder, Michael: *Pi in the Sky,* The Collins Press, Cork, 1997.

27. Ibid. Gimbutas, who has done perhaps more than any archaeologist in tracing Goddess civilisations, came to this conclusion.

28. Ibid. p.96.

29. Ibid.

30. Andersen, Jørgen, op cit. Anderson describes the Sheela on Iona 'with a swollen belly as in the last stages of pregnancy'.

31. Note: the word in Aramaic is *abwoon,* meaning parent. See Klotz, Neil Douglas: *The Hidden Gospel Guest,* Quest, London 1999. .

32. Cherry, Stella: op. cit. The National Museum classes this carving as 'not a Sheela na Gig'.

33. Note: The Knights Templar had the responsibility of ensuring safe passage to pilgrimage centres around Europe, not only to the Holy Land.

34. Gimbutas, op. cit. p.322

35. Ibid. p.113.

36. Note: the word 'hagiography' is derived from *hagia* the same word as English 'hag'. Hagiography is a biography of the holy one or saint.

37. Ó Hogáin, Daithí: series of talks on Lyric FM, Limerick to celebrate the feast of St Patrick 17 March, 2003 and the following days.

38. Gimbutas, op. cit.

39. Note: at the Battle of Moytura when the Tuatha Dé Danann fought the Fomoire, the Morrígan's function was to create havoc – to insult and demoralise them so that they were defeated by magic. It was a successful tactic on the first occasion, but ultimately the Milesians succeeded in conquering the Tuatha despite their magic.

40. Perera, Sylvia Brinton, 1993: 'War, Madness and the Morrigan, a Celtic goddess of life and death'. In *Mad Parts of Sane People in Analysis.* Stein, ed. Wilmette, Il. Chiron, 1993, p.155-193.

41. Matthews, Caitlin: *The Elements of the Goddess,* Element Books

Ltd., Longmead, Shaftesbury, Dorset. p.24.

42. 'K' is the seed sound of the Goddess in Sanskrit and it is the first sound of the Irish word *cailleach* and English 'crone'.

43. Rawson op. cit. p.130.

44. Keating, Geoffrey: *Foras Feasa Ar Éirinn (The History of Ireland)*, 1640. Vol. 2, p.247. Quoted by Dames, op. cit. p224.

45. Note: the patriarchal world demanded human sacrifice for some considerable period. The Old Testament points to the time it was disestablished: when Jacob was preparing to sacrifice his only son Isaac and God intervened. A lamb was substituted in his place.

CHAPTER 3

1. Note: 'Indo-European', a term applied to all the Kurgans from the lower Volga basin, is a misnomer. These tribes were neither Indian nor European. See Gimbutas: *The Language of the Goddess.*

2. Condren, Mary: *The Serpent and the Goddess.* Harper, Collins, San Francisco, 1989. p. 27.

3. Note: see the magnificent gold jewellery and artefacts in the National Museum of Ireland, Dublin, dating from 2000 BC.

4. Gimbutas, op. cit..

5. Condren, Mary: op. cit. p.28.

6. O'Hart, John: I*rish Pedigrees or The Origin and Stem of the Irish Nation*, M'Glashan & Gill, Dublin, 1876. The Second Series (1878) p.366. The Celts included Iberians, Celtiberians and Cantabrians of Spain, the Milesian Irish, Britons, Picts and Caladonians all a mixture of Celts and Scythians.

7. Rees and Rees, op. cit.

8. Kinsella, Thomas: *The Táin*, translated from the Irish, Dolmen Press, 1969. 1986 edition, p.IX.

9. Condren, op. cit. p.34. See pp34-43 for a detailed discussion of Male Reproductive Consciousness.

10. Byrne, F.J. 'Early Irish Society' in *The Course of Irish History*, eds. T.W. Moody and F.X. Martin, Mercier Press, Cork, 1967. Revised edition, 1984, p43.

11. Kinsella, op. cit. pp.75-6.

12. Ibid. p.156.

13. Ibid. p. ix.

14. Rees and Rees, op. cit. p.166-7.

15. Condren, op. cit. p.30.

16. Cross and Slover: *Ancient Irish Tales*, pp. 208-10.

17. Dames, op. cit. p223. Dames quotes Mac Neill, M. *The Festival of Lugnasa*, Oxford, 1962. p.311-38.

18. *Metrical Dindshenchas*, Vol IV, 149-153.

19. Note: the original text: was quoted by Sean Ó Duinn in personal correspondence, 27th January, 2003.

20. Ó Duinn, Sean: *Where Three Streams Meet,* Columba Press, Dublin. 2001, p.43.

21. Ibid. p.42. (In older versions of this myth the king mated with the goddess every year to ensure the fruitfulness of the earth.)

22. O'Hart, John, op cit. p.53.

CHAPTER 4

1. Note: this form of monasticism is not unlike the Essene tradition of Judaism, practised by Jesus and his people, about which more is now known through the discovery of the Dead Sea Scrolls. See Theiring, Barbara: *Jesus the Man*, Transworld, London, 1993.

2. Quinn, Bob: *The Atlanteans*. Radio Telefís Éireann, Three part documentary, Dublin, 1988.

3. Donald Smith: *Celtic Travellers*. The Stationery Office, Edinburgh, Scotland, 1997, p.6.

4. Note: even if this figure is exaggerated in *The Life of Patrick,* there must have been many Christians all over the country, as the appointment of a bishop to a district implied the presence of a congregation of believers.

5. John O'Hart: *Irish Pedigrees*, Vol 1. Publ. McGlashan & Gill, Dublin 1876, p.53 O'Hart quotes Joyce: *Irish Names of Places, taken from History of the Cemeteries*: see Petries *Round Towers*, p.10 in the Ecclesiastical History of Ireland, Dublin 1845. These scholars claim that as early as 195 AD Airt-Ean-Fhear, monarch of Ireland, believed in Christianity and predicted its spread. Other authors were of the opinion – that two further monarchs, Cormac Mac-Airt (226-266 AD) and Niall of the Nine Hostages (378-405 AD) were also 'enlightened by the Holy Spirit in the truths of Christianity'.

6. Ibid, p.53. Niall of the Nine Hostages, Monarch of Ireland from 378-405 AD (who is a key figure in the unfolding of the mystery of the Sheela) was the son of the High King Eochy Mugmeddon (meaning Lord of the Slaves) and of Cairenn – a Saxon princess taken as a hostage to Ireland. Niall's own epithet indicates that he had defeated nine king-

doms and had brought back nine royal hostages to ensure those territories would remain subject to him. Niall is the ancestor of many High Kings of Ireland, the founder of the dynasty of the Uí Néill (not to be confused with the surname O'Neill). The northern Uí Néill – the Cenél Conaill – later became the O'Donnells (Colum Cille was born into this branch of the clan) and the southern branch became the O'Melaghlins.

7. Minahan, John: *The Christian Druids,* Sanas Press, p.112. High King Loegaire's chief Druid had prophesied that Christians would be 'coming over the seas with their cloaks and bent staffs and their shorn hair and all the people accepting them'.

8. Thomas, A.C., *Christianity in Roman Britain to AD 500,* London, 1981.

9. Quinn, Bob, op. cit.

10. Minahan, op. cit., p. 124.

11. Smith, Donald, op. cit., p.6.

12. Smith, Ibid.

13. Herity, Michael: 'The Layout of Early Irish Monasteries before the year 1000' in Ní Cathaáin and Richter (eds) *Ireland and Europe,* pp. 105-116.

14. Skene, *Celtic Scotland* Vol. ii p. 57

15. Note: The Irish prefix 'kil' is now applied to churches and indicates that the place was the site of an early monastery. The original meaning was 'cell' – the living place or 'bed' of the founder saint.

16. Thomas, A.C., op cit.

17. Herity, Michael, op. cit.

18. Note: the only wooden church surviving today is at Greensted in England. It was built around 650 AD by St Cedd, a Saxon, educated in Lindisfarne – an offshoot of Iona. Bede, in *The Anglo-Saxon Chronicles of 800 AD* described St Finan's church at Lindisfarne in the seventh century as made of 'hewn oak, thatched, with reeds in the Irish fashion.' (Cf. B. Cosgrave: Bede's *Ecclesiastical History of the English People.* Oxford. 1929 pp.214-217).

19. Weir, Anthony, and Jerman, James: *Sexual Carvings on Medieval Churches,* Batsford Academic and Educational Ltd., London, 1986.

20. See. Ó Duinn, Sean: *Where Three Streams Meet* – Celtic Spirituality. Columba Press, Dublin. See pp. 302-326 for a description of the festival of Lugnasa and the Christianisation of the feast.

21. Ballyconnell Heritage Group 2000: *Beneath Slieve Rushen's Slopes,* pp.15-16.

22. Hughes, Kathleen: 'The Golden Age of Early Christian Ireland' (seventh and eight centuries in *The Course of Irish History* , ed. Moody and Martin, p. 77).

23. *Beneath Slieve Rushen's Slopes,* op. cit.

24. Ó Duinn, Sean, op. cit. p. 192.

25. O'Hart, op. cit. p.37. The Picts were from Scythia originally. There were Picts in Ireland also. They were known as Cruithni. Quite a number had settled in Counties Down, Antrim and Derry in Ulster, and in the Loiges of Leinster. The Ciarraigne of Connacht and north Kerry were perhaps the same people according to O'Hart.

26. See *The Annals of Ireland* by the Four Masters – for the year 509 AD.

27. Smith, Donald: op. cit. p. 9.

28. Note: The writer found this carving lying on the floor of the abbey in July, 1999. Asked why it was not in the museum nearby, she was informed that it was only medieval and of no great value compared to the Pictish stones in the museum. One hopes it has been put into safe-keeping in the museum since then.

29. Note: St Brigid, the historical person, was born in 453 AD, ten years before Patrick's death. But the histories of her life and folk stories and traditions reveal a distinct connection to the nature religion of the Goddess. Brigid symbolised the continuation of the old order – a system where women held positions of respect in the community. Abbeys, sometimes of men as well as women, were headed by an abbess who was autonomous in those early days.

30. Note: St Patrick's Cathedral, Dublin. Originally this site was a holy well dedicated to Brigid. The inscription beside the well tells us that Patrick baptised the first Christians in Dublin at this well. But the surrounding streets are called Bride Street, Bride Close and Bride Place – revealing the origins of the place and the strongly conservative nature of the Irish people. Over 1500 years after the deaths of Patrick and Brigid more places in Ireland are named for Brigid than for Patrick or any other saints.

31. Hughes, *The Church in Early Irish Society,* London, 1966, p. 279. For text see Stokes, op. cit. ii p.356.

32. Bieler, Ludwig: 'The Celtic Hagiographer', in *Studia Patristica,* Berlin, 1962. pp. 252-3, and p 247.

33. For a comprehensive history of Colum Cille, see Herbert, Máire: *Iona, Kells and Derry. The History and Hagiography of the Monastic*

Familia of Columba, Four Courts Press, Dublin 1996.

34. Note: this is an ancient custom copied by Irish prisoners of the English in the 1916 struggle for Independence and by prisoners in Northern Ireland during 1970-1980. According to this custom, a petitioner for justice took up a position near the king's house and attempted by fasting to shame him into capitulating. Diarmuid, considering that his cause was a just one, began to fast against the saints and this continued to the end of the year. The clerics had built a house on Tara and they were joined by St Brendan the Navigator. The contest was resolved when King Diarmuid was tricked into ending his fast, having been told the saints had ended theirs first.

35. St Ruadhán rang his bell and prayed to God that no king or queen would ever again dwell in Tara, and that it should be waste for ever without a court or palace. The cursing of Tara took place in 558 AD. And little remains at that place, except a nineteenth-century church that is now the Heritage Centre, a grave yard, and the standing stone with the carving of the Sheela – St Adamnán's stone.

36. *The Annals of the Four Masters.* For the Year 563 AD.

37. *The Annals of the Four Masters*: for the year 506 AD. The Stone of Destiny was transported from Tara for this inauguration. Traditionally all Irish sovereigns were inaugurated with this stone, and no inauguration was legitimate unless the Stone of Destiny was used. The Stone of Destiny was not returned to Ireland, but was kept at Iona by Colum Cille and was later transferred to Scone when the Kings of Argyle became Kings of Scotland. In the fourteenth century it was taken from there and removed to London where it was used in all the coronations of the kings of England and remained under the coronation seat of the kings of England at Westminster Abbey. Recently it was returned to Scotland – to Edinburgh Castle where it is on display.

38. Note: the monks and scholars at Iona were frequent travellers to the continent, making pilgrimages to Rome and Spain, and the Holy Land. They went to Kiev, the Faroes, and Regensburg. The archives Regensburg hold a goldmine of early Irish manuscripts.

When the Bardic colleges were taken over they were replaced by ecclesiastical centres – particularly Durrow and Clonmacnoise – both part of Colum Cille's familia. Astronomy was carefully retained in the abbeys and the Irish predictions were more accurate according to Peter Berresford Ellis (Conference of International Astrologers – Bellinter, County Meath, Jun 1997). 'A wealth of Irish astronomical evidence

from the sixth century AD has been neglected. Links between Celtic and Vedic cosmology imply that the monks were using a more ancient and more accurate form than any other in Europe.'

39. Ó Duinn, Sean: recounted in conversation, 19 September, 2000: A clerical joke is told of Colum Cille, who is supposed to have disliked cows. When asked why, he replied, 'Because where there is a cow there is always a woman to milk her and where there are women there is trouble.'

This is an example of how later clergy, suffering from a heavy dose of misogyny, tried to imply that the early saints of Ireland feared and rejected women. St Kevin of Glendalough is supposed to have pushed a young woman into the lake, drowning her for making advances to him (she did drown – but she slipped and fell into the lake.) These clerical stories are patently untrue – they fly in the face of the message of Christian love and peace that was the message these monks were attempting to share with others.

40. Note: Andersen argues for a dating to the time of the construction of the convent in the fifteenth century, concluding that 'lintel and fragment of window appear to have always belonged together, so that the position of the sheela above a window is likely to be original', op. cit. p.102.

41. Biaggi, Cristina, op. cit..

42. MacAnna, P.: *Encyclopedia of Religion*, 3, pp 148-66.

43. Andersen, Jørgen, op. cit.

44. Note: The biographer of Columbanus, a monk living in Bobbio named Jonas, records that Columbanus was tormented by sexual desire. His surviving colleagues spoke about the temptations he experienced that left him in a conflict about women: 'Let everyone who is dutiful in mind avoid the deadly poison/That the proud tongue of an evil woman has./ Woman[Eve] destroyed life's gathered crown:/ But woman [Mary] gave long-lasting joys of life.' Quoted by Berresford Ellis, Peter: *Celtic Women*, Constable, London, 1995, p.150.

45. Cahill, Thomas: *How the Irish Saved Civilisation – the Untold Story of Ireland's Heroic Role from the Fall of Rome to the Rise of Medieval Europe*, Doubleday, New York, 1995.

CHAPTER 5

1. Note: it is not just coincidence that this was the same year as Colum Cille's death. Southern England had resisted Christianity and remained strongly pagan until the sixth century. Ninian was appointed bishop to

Whithorn, Scotland 200 years before (in 400 AD) and Patrick was made bishop to Ireland in 432 AD.

2. Note: Whitby was famous for its scholars. Caedmon (d. 680 AD) was the earliest known poet in the English language.

3. Note: Had they become too arrogant, too self-righteous?

4. Celtic cosmology derived from the astronomy of ancient India which was based on sidereal time and did not see Earth as the centre of the universe. Rome had adopted an astronomy based on the calculations of Ptolemy – a much later system, and less accurate. The scientific study of astronomy has recently confirmed the earlier system to be more correct.

5. Note: the Dal Riada did rule the whole of Scotland about 150 years later.

6. Foster, Sally M.: *Picts, Gaels and Scots*, B.T. Batsford Ltd., Historic Scotland, London, 1996. p.90.

7. Ibid.

8. Cáin Adamnán Conference, Birr Co. Offaly, July 1997. Celebrating 1300 year anniversary of Adamnán.

9. Note: Adamnán criticised Abbess Aebb's community at Coldingham for feasting, drinking, gossiping 'and weaving elaborate garments with which to adorn themselves as if they were brides, thus imperilling their virginity or else to make friends with strange men'. When a fire destroyed the abbey in 686 AD the clerics who were of a Roman persuasion proclaimed it was a punishment for the debauched lifestyle of the community.

10. Condren, op. cit. Adamnán met with a great deal of resistance to this law from the kings of Ireland. According to them '… an evil time when a man's sleep shall be murdered for women, that women should live, men should be slain. Put the deaf and dumb one (Adamnán) to the sword, who asserts anything but that women shall be in everlasting bondage to the brink of Doom.' According to the annalists the kings assembled to kill Adamnán, but he went about ringing his bell, the 'Bell of Adamnán's Wrath', and threatened to curse them, praying that they have no sons to succeed them or that their present sons might die of plague or accident. The story reflects the tremendous power of the bishops over kings when it came to moral and legal issues. The power of the curse that would continue in the royal family lines and the damage to the reputation of a king was far worse in old Irish society than the loss of his own life.

11. Kelly, Fergus: *Early Irish Law*, Dublin Institute for Advanced Studies, 1988, p.15. Kelly gives a list of the type of women who were above the general laws. In return for this law, women were required to pay compensation to the clergy, contributing to the upkeep of the monasteries. Otherwise they were cursed, 'that the offspring ye bear shall decay, or they shall die full of crimes'.

12. Markale, Jean: 'On the continent, as far back as the sixth century, many women were labelled "witches" and were murdered. Pope Gregory the Great (540-604 AD) came to their rescue at that time by forbidding the execution of these women because, he said, "They have no power in the Kingdom of God." Quoted in *Celtic Women*, by Peter Berresford Ellis, p.67.

13. Hickey, Elizabeth: *The Legend of Tara*, Dundalgan Press Ltd., Dundalk, 1988, p.36.

14. Note: about twelve miles distance from Tara, and three miles from Teltown, another pre-Christian settlement, in the graveyard of the Protestant church of St Patrick, stands another monolith, about seven feet in height, and beside it another lingam stone. There is no evidence about the ritualistic function these stones had for the early Christians, and the pagans before them, but they must have been incorporated into Christian rituals in order to have survived the transformation of religion from paganism to Christianity.

15. Note: St Fechín had founded Fore Abbey in County Westmeath prior to his mission to the Picts.

16. Note: it was the fashion to place the names of the patrons at the base, for example on Muiredach's cross at Monasterboice, Co. Louth, the inscription reads: 'This cross was made by Muiredach, 900 AD'. Muiredach was abbot around that time.

17. Gimbutas, Marija: *The Language of the Goddess*. op. cit. Gimbutas lists a number of these symbols as pertaining to the Goddess.

18. Kelly, Fergus: *Early Irish Law*, Dublin Institute for Advanced Studies, 1988, p. 76. Quoted from the old Irish Dire Text of the Corpus Iurus Hibernici ed. D.A. Binchy, Dublin, 1978.

19. Ibid. p.74: in Brehon law a man could have more than one wife – the first wife was the one who held an equal rank with him, that is, who had as much material wealth as he had. Divorce was also allowed for a number of interesting reasons including homosexual practices of the husband, also for 'spreading scandal about the spouse', impotence, for renunciation, for refusal to have sexual intercourse, or if the husband

becomes so fat as to be incapable of intercourse. A woman may divorce her husband 'if he is in holy orders, because it is not easy for him to reconcile his mutual obligations to wife and to Church'.

Women and children were often taken as plunder of battles and used as slaves (men were usually killed on the spot because it was too difficult to handle large numbers of male prisoners.) The slave woman owned nothing, and was not considered a part of the household. She could not sleep inside the house, but was required to sleep out of doors in a hut, like an animal, so that if an invader approached her screams would sound the alarm as she was slaughtered.

Brehon laws set down the 'honour price' for every class of individual – the honour price of the slave woman was the lowest.

20. Herbert, Máire: *Iona, Kells and Derry. The History and Hagiography of the Monastic Familia of Colum Cille,* Four Courts Press, 1996, pp. 68-78.

21. See Sean Ó Duinn: *Where Three Streams Meet,* Columba Press, Dublin. 2000. pp.190-1; 195-200.

22. de Paor, Liam: 'The Age of the Viking Wars' in *A Course of Irish History,* op. cit. p.101.

23. Ibid.

24. Note: the Cross of Kells was recently removed from the street in the town centre and is now placed outside the Heritage Centre (formerly a Protestant church) in Kells.

25. Cherry, Stella , op. cit. p.9.

26. Dalrymple, William: *From the Holy Mountain,* Harper Collins, London 1998. Dalrymple makes the connection between the monks of the Middle East and the Celtic Church, showing that there must have been regular contact from a very early date.

27. Note: McGlynn, Michael: Notes to an Anuna Concert Peppercannister Church, Dublin, 16 September 1994: 'Media Vita, a ninth-century chant written by Blessed Notker, an Irish monk who was abbot of St Gall, Switzerland. The chant, one of the most beautiful ever written, was suppressed in the Middle Ages by the Catholic church, as it was considered to bring very bad luck when sung, due to its subject matter, namely, death.'

CHAPTER 6

1. The Romanesque church of St Saviour's at Glendalough had a Sheela over the window but it has been stolen sometime since it was recorded

by Weir and Jerman in 1989.

2. Brian Ó Cúiv: 'Ireland in the eleventh and twelfth centuries', in Martin and Moody: *A Course in Irish History,* Mercier Press, Cork, Revised edition 1984, p.117: There were a good number of Irish monasteries in Germany, called Schottenkloster including those at Ratisbon, Wurzburg, and Mainz.

3. Ibid. pp 408-9: Mission to Cologne (970-980), Metz (975), Regensburg (1075). Aaron, an Irish monk was made bishop of Cracow in 1049, Johannes, an Irish missionary bishop was martyred at Mecklenburg in 1066.

4. Note: St Patrick's Purgatory is perhaps the last of the medieval pilgrim penitential places to continue to function. Thousands of pilgrims do this pilgrimage every year between 15 May and 15 August.

5. Note: these taxes were reimposed on the governments of most of the former Roman Imperial lands. Though Ireland and Scotland were never conquered by the Roman armies, they accepted Roman taxation, whereas all the other countries that had never been conquered – the Teutonic-Celtic hinterlands, the Scandinavian territories and both sides of the Baltics – resisted domination and taxation by the Roman Church.

6. Reston, James, Jr.: *Warriors of God,* Faber and Faber, London, 2001, Paperback ed. 2002. p.xiii.

7. Note: Celtic Christianity was based upon Egyptian Christianity, but with the deeper roots of the primal religion connected to the Hindu through Sanskrit.

8. O'Brien, Maureen Concannon, *The Story of the Concannons,* Clan Publications, 1990 and *A History of the Burke/Bourke Clan, 1991*: the coats of arms of many Gaelic and Norman families indicate their participation in the Crusades. For example the coat of the Concannons has two blue crosses indicating participation in two crusades. The coat of the Burkes is a red cross on a yellow background a reminder that their ancestor, Godfrey of Bouillon, who led the first Crusade in 1097, had slain the Moslem chief, dipped his sword in the blood and made a banner to carry into Jerusalem.

9. Note: our Lady of Guadaloupe, Mexico, though painted centuries later, is a perfect example of the Black Madonna surrounded by a 'halo' behind her entire body – in the shape of a Kteis.

10. Ovasen, David and Hedsell, Mark: *The Zelator,* Arrow Publications, London, 1992, p.315.

11. Note: T = the 'Memorare' a prayer to Mary, extolling her virtues and asking for her intercession with God on our behalf was composed by Bernard. He is also credited with the introduction of the rosary – a form of repetitive mantra reminiscent of the meditative chants of the east. The beads have a similar function to the worry beads used by Muslim and Buddhists. Bernard led the call to the Second Crusade but later lamented that he left 'only one man in Europe to comfort every seven widows'. See Reston, op cit. p.xiii.

12. Condren, op. cit. p. 132.

13. Note: The custom of placing the symbol of the womb at the entrance to places used for spiritual transformation is an ancient one found in all parts of the world – here in Ireland at Newgrange, and at the entrance to their ancestral houses of the Maoris in New Zealand. There the symbol of the yoni (the lozenge shape) over the doorway of the ancestral house represents the threshold between two states. When people enter, they cut themselves off from the world outside and are revitalised so that when they exit, they return to the light in the outer world with renewed life.

14. Condren, Mary, op. cit., p.150.

15. Note: A further example is the inverted crucifix used by Satanists as a cult object, and other sacred objects such as rosary beads and consecrated objects from churches used in their 'black masses'. The more an object is filled with spiritual energy (numinosity) the more intense the sexual excitement aroused.

16. Harrison, Michael: *The Roots of Witchcraft*, Tandem Press, London, 1975 p. 204.

17. Official Monuments Commission: notice placed on the church.

18. Note: this church was reconstructed some time in the thirteenth century. Earlier carvings have been inserted into the church walls but they are so ancient and weathered it is difficult to discern what those images represent. The other church on the site dates to the ninth or tenth century and features the corbelled stone roof, similar to St Kevin's Kitchen at Glendalough, Co. Wicklow.

19. Andersen, op. cit. p.100.

20. Weir, Anthony and Jerman, James: *Images of Lust – Sexual Carvings on Medieval Churches*, p.22.

21. Ibid.

22. Harrison, op. cit. p.210.

23. Ibid. p.215-6.

24. Note: for example, the Primate of Ireland, Cellach Ui Sinaig, the seventh in a series from the Ua Sinaig family, was the chief Irish delegate to the Synod of Cashel in 1111AD. Having inherited his position as Archbishop of Armagh, like his predecessors, he had never been ordained. He was not married, though several of his predecessors had been. He capitulated to the demands of Rome and received holy orders before instituting the reforms at Cashel.

25. The *Annals of the Four Masters* for the year 1152 A.D.: Diocesan reform was completed at the Synod of Kells in 1152. The country was divided into 36 sees with four archbishoprics: Armagh, Cashel, Dublin and Tuam.

26. Note: St Malachy, Archbishop of Armagh was a friend of St Bernard of Clairvaux. He invited the Cistercians to set up houses in Ireland. Mellifont Abbey in County Louth, was the first of many Cistercian foundations in Ireland.

27. Note: Baubo is the goddess who figures in the myth of Demeter and Persephone. Demeter is mourning her daughter who is lost and cannot be found (having been abducted and raped by Hades who has her imprisoned in the underworld). Demeter is inconsolable. Baubo arrives and makes jokes, doing a funny little dance and raising her skirts to expose her genitals, causing Demeter to laugh and enabling her to get on with her search for Persephone.

28. The Annals of Clomacnoise: for the year 1152. 'She was procured and induced thereunto by her unadvised brother, Melaughlyn, for some abuses of her husband, Tyernan, done to her before.'

29. The *Annals of the Four Masters* for the year 1153.

30. Ibid. for the year 1193 AD.

31. Condren, Mary, op cit., p. 113

32. Ibid. p.112.

33. Pagels, Elaine: 'What Became of God the Mother? Conflicting images of God in Early Christianity' in *SIGNS 2 #2,* (1976) pp.293-303. p.298.

CHAPTER 7

1. Ó Cúiv, Brian: 'Ireland in the Eleventh and Twelfth Centuries' in *The Course of Irish History,* op. cit. p.108; quote from Curtis, Edward and McDowell, R.B. (eds): *Irish Historical Documents* 1172-1922. p.17.

2. Op. cit. Martin, F.X., 'The Normans: arrival and settlement' in *The Course of Irish History,* op. cit. p.125. William the Conqueror had got

the blessing of the papacy for his invasion of England a century earlier.
3. Note: one of the cardinal tenets of Brehon Law forbade a chieftain from making an alliance with a traditional enemy, because it created chaos in social and political order. By breaking this law over hundreds of years, Irish kings had weakened the structure of society and left themselves open to conquest.
4. *Annals of the Four Masters.* In 1172 Pope Alexander III wrote to the Irish kings to advise them to be faithful to King Henry II.
5. Ibid for the year 1227.
6. Martin, op. cit. p.125: "King Henry was French rather than English. He was born in Normandy, reared in France, and spoke Norman French, not English; most of his life was passed on the continent, and England was only part of his empire, the Angevin empire which embraced England, Normandy, Anjou, Maine, Poitou, and Aquitaine, with sovereign claims over Toulouse, Wales and Scotland.'
7. Note: England was preoccupied with its wars against Scotland, the Hundred Year War (1338 to 1453), and civil Wars of the Roses, in the mid-fifteenth century.
8. Note: brochure advertising Cloghan Castle as a tourist destination gives these historial details.
9. Fay, Frank: in an interview with the owner of the castle, Mr Fay related that the Sheela may have come from the old church that may be buried under the eighteenth-century house at nearby Kilbride, burnt down in the 1950s.
10. Moore, Jakki: *Sheela na Gigs* Esalen, CA. 1995. Private publication.
11. Note: There was only one witch trial in Ireland, however. One explanation of why that should have been so contends that the entire Gaelic population was targeted and ostracised in the Middle Ages and that sufficed.
12. Kramer, Heinrick and Sprenger, Jakob, *Malleus Maleficarum,* edited and translated by Mantague S. Neummer, Ny. Dover Press, 1971, pp.44-47.
13. Church Statutes for Waterford and Wexford for the seventeenth century. Note: I cannot find a definition of *gieradors* in English, Irish, Latin or Spanish. But the reference to *gie* is certainly evocative. The suffix '-ador' in Spanish refers to the profession of a male, such as 'toreador' and 'matador'. Perhaps this is a slang used by the clergy at that time as a slur on those women.
14. Weir, Antony and Jerman, James: *Images of Lust,* 1986. Balsford

Academic & Educational Ltd, London, p.11.

15. Note: both Trim and Athboy Sheelas are in private possession.

16. Jerman, J.A., The Sheela-na-Gig Carving of the British Isles: suggestions for a re-classification, and other notes, *CLAJ.* XX. No 1 (1981) pp.10-14.

17. Keeling, David: 'An Unrecorded Exhibitionist Figure (Sheela-na-Gig) from Ardcath, County Meath', in *Riocht na Midhe*, p.103-4.

18. Spenser, Edmund: *A View on the Present State of Ireland, 1596.* Edited by W.L. Renwick, Oxford, 1934.

19. Note: As mentioned previously, the Midlands of Ireland is the area where the early Christian monasteries were most numerous and where Brigid's form of Christianity was allowed to exist longest.

20. See O'Connell, Patricia: *The Irish Colleges of Spain and Portugal,* four volumes, 1996-2002.

21. Roberts, Jack and McMahon, Joanne: *The Sheela-na-Gigs of Britain and Ireland,* Bandia Publishing, Ireland, 1997.

22. Brady, W. Maziere, D.D., *Clerical and Parochial Records of Cork, Cloyne and Ross,* Dublin, Alexander Thom, Vol III, 1864, pp. 104-106.

23. Partridge, Eric, *A Dictionary of the Underworld,* Routledge Keegan Paul, London 1949, lists Sheela; 'Sheela', 'a girl', 'a sweetheart', perhaps low at first. But in the underworld it had *c.* 1830-1880, the sense of 'mistress'. Even today in County Cork, as in Australia, 'a Sheela' denotes 'a woman of base morals'.

24. Ó Crualaich, Gearóid, *The Book of the Cailleach,* Cork University Press, Cork, 2003, p. 52.

25. Yeats, W.B., *Collected Pomes,* Macmillan, London 1969, reprint, p. 90.

CHAPTER 8

1. Baring, Ann and Cashford, Jules: *The Myth of the Goddess, The Evolution of an Image,* Arkana Penguin Books, 1993, p. 176. (First published 1991 by Viking.)

2. Dalrymple, William: *The Age of Kali.* pp.177-191. Dalrymple describes in detail the ceremonies at the temple of Meenakshi in Madurai where red kum-kum and ghee (butter) are rubbed on the sexual parts of the sculptures of the Yakshi in the temple. Thousands of people attend the festival of Meenakshi every year because she is the goddess of fertility, and her consort, although he is an aspect of the God Shiva, is totally faithful to her, completely devoted to her alone. Many

claim to have had children as a result of their pilgrimage to Madurai and prayers to Meenakshi, just as Irish pilgrims believe that Brigid or Gobnait or Our Lady have granted their request for children.

3. Rawson, Philip: *The Art of Tantra,* p.58.

4. Campbell, Joseph: T*he Inner Reaches of Outer Space, Metaphor as Myth and as Religion,* Alfred van der Mark editions, New York, 1986, p.34. Quoted in Baring and Cashford: op. cit., p. 183.

5. Baring and Cashford, op. cit. p. 697.

6. Kramer, Samuel Noah, F*rom the Poetry of Sumer:Creation, Glorification, Adoration,*University of California Press, Berkeley, 1979, pp29-30. Quoted in Baring and Cashford, op. cit. p.184.

7. Note: At Tara in the churchyard are the pair called 'Bloc and Blinne', also at St Patrick's Church in Teltown, Meath, and at Killadeas Church in County Fermanagh.

8. Patai, Raphael, *The Hebrew Goddess,* 3rd ed. Wayne State University Press, p.224.

9. Phillips, John A.: Eve: *The History of an Idea,* Harper and Row, San Francisco, 1984, p.76

10. Note: Patrick's Roman Christianity had evolved from a form of patriarchalism inherited from imperial Rome and Greece and before that from the Jewish people who had inherited it from Babylonia during their captivity (*c.* 450 BC). This war-like influence had originated with the invasion of the near east and of Europe by horse-riding Kurgan warrior tribes from around the Volga of what is now southern Russia. They came in waves over a period of approximately 2,000 years (from around 4500 BC) destroying civilisations and goddess religions and replacing them with the power of the sword and the imagery of fear of the authority of the mighty warrior. Male gods and eventually the Almighty Father God replaced the Goddess. With this there was a repression of sexuality, resulting in a fear of what is repressed, particularly of female sexuality.

11. Jung, C.G., and Von Franz, M.L.: *Man and his Symbols,* Picador 1978.

12. Note: See Chapter 1 and the antiquarian's description of the Kiltinan Sheela for the Ordinance Survey of Ireland in the nineteenth century. Also the National Museum of Ireland deferred displaying their collection because of the possible reaction of the public to the Sheelas.

13. The monument signifying the goddess of the River Liffey (irreverently known as the 'floozie in the jacuzzi' was removed from Dublin's O'Connell Street to make room to construct the memorial to the new

millennium – the phallic 'Spike'.

14. Baring and Cashford: op. cit. p.197.

15. Llywelyn, Morgan: *Druids*, William Heinemann Ltd., London. 1991. A description of sex magic is given in this historical novel used as a vehicle by the Druids to win a battle against the Romans.

16. Note: On May Day in Waterford and Kilkenny, country people still practise an old folk tradition that involves decorating a dead branch of the white hawthorne (May tree) that had been cut and stuck in the ground. First of all the farmer comes with dung on a shovel and spread it all around the base, and then it is decorated with multi-coloured ribbons and the young girls dance around it. The dung represented the fertilising element that is required for growth. (I am indebted to Olga Irish for this reference in private conversation.)

17. Ovason, David and Hedsell, Marc: *Zelator*, p.315.

18. Note: Augustine was the first of these men.

19. Moriarty, John: Series of lectures given in Dublin, 1990.

20. Lubell, Winifred, op. cit. p. 144.

21. Rudolph, Kurt: Gnosis. 1985. Harper and Row.

22. Thompson, William Irwin: *The Time Falling Bodies Take to Light. Mythology. Sexuality and the Origins of Culture.* St. Martin's Press, New York, 1981, p.165.

23. Needleham, Jacob: *A Sense of the Cosmos.* Publ. E.P. Dalton, New York, 1965, p.47.

24. Woolger, Roger J. and Barker, Jennifer: *The Goddess Within.* p. 223.

25. Kenton, Leslie: *Passage to Power,* p.8.

26. Note: Both Greek and Roman mythology changed the sex of Pluto from feminine to masculine, as they did a number of goddesses adapted from Sumerian and Babylonian civilisations.

27. Diamant, Anita, *The Red Tent,* Macmillan, London 2001. An historical novel about Jewish women's lives in the time of Jacob and his sons.

28. Note: There is an island off the coast of Australia known as 'the island of the menstruating men'. When boys come to puberty an initiation ritual is enacted whereby the shaft of the penis is slit and the blood that exudes is considered extremely powerful.

29. Fox, Matthew: *Original Blessing,* p.62.

30. Note: An interpretive centre is housed in the nineteenth century former Protestant Church in the graveyard.

31. O'Hart, John: *Irish Pedigrees or the Origin and Stem of the Irish*

Nation. M'Glashan & Gill, Dublin, 1876. Book I, p.337. O'Hart states that many learned Irish antiquarians including Keating, O'Flaherty, Ware, Dr O'Connor, Charles O'Conor and accounts from Scottish historians say that it is not.

The Stone of Destiny now resides at Edinburgh Castle, having been returned to Scotland from England where it had been placed under the thrown and used at inaugurations of the English monarchs.
32. This stone, the Lia Fian, was originally placed beside the Mound of the Hostages during the early centuries of the first millennium, at the time the Fianna – the elite warriors of the King of Tara – were active. Though it was not placed at the monarch's palace until after 1798, even when originally placed at the Mound of the Hostages it unblanced the energy of Tara towards war rather than peace.

CHAPTER 9

1. Heaney, Seamus: *Station Island,* First Published by Faber and Faber, London, 1984. Farrar, Straus, Giroux, New York, p. 50.
2. Note: In the academic world until 50 years ago, in Ireland at least, psychology was one of the courses attended by seminarians, men who were being prepared for the priesthood. It was called Scholastic Psychology. Other subjects on their course were Logic, Metaphysics, Philosophy and Theology. Psychology, as we know it today, was not considered a suitable subject of sufficient academic merit to include in the university syllabi.
3. Note: For further information about Jungian archetypes see Storr, Anthony: *Jung,* Fontana Paperback, UK, 1983, pp. 65-125 and C.G. Jung: *Psychological Reflections,* ed. Jolanda Jacobi, Ark paperback, London, 1986.
4. Bolen, Jean: *Ring of Power,* p. 210.
5. Ibid.
6. Perera, Sylvia Brinton: *Queen Maeve and Her Lovers, A Celtic Archetype of Ecstasy, Addiction and Healing,* Carrowmore Books, 1999, p.149-151.
Note: Perera points out that the great Irish hero Cúchulainn killed his own son and presented the body to the King of Ulster – Conchobhar, demonstrating that his fealty was first to the King, over any ties of blood.
7. Miller, Arthur: *The Crucible.* A play written in the 1950s. Miller was drawing a parallel between the witch hunt in Salem, Massachusetts in

the seventeenth century and US Senator Joe McCarthy's hunt for communists in America.

8. Note: Suicide in Ireland is now the highest in the European Union, with most incidences being young men. Priests investigating the phenomenon are inclined to attribute the cause to women and the pressure that is being brought to bear on boys by having to compete with girls. Or to the fact that their mothers are out working! Psychologists have noted also the alarming incidence of battering of women by their sons.

9. Perera, op. cit. p.293.

10. Ibid. p.292.

11. Greer, Germaine: Lecture given at University College, Dublin. Report in *The Irish Times*, May, 1998.

12. Note: The education of boys has not changed to reflect their present needs or the needs of society.

13. Bolen, op. cit. p.210.

14. Note: See the work of Elizabeth Kubler-Ross: *On Death and Dying*; also the works of Raymond Moody and Richard Kearney.

15. See Jung, Carl: *Memories, Dreams and Reflections*.

16. Woodman and Dickson, op. cit. p.181.

17. Robinson, James M. (ed.): *The Nag Hammadi Library in English*, 2nd ed. Translated by Members of the Coptic Gnostic Library Project of the Institute for Antiquity and Christianity. Leiden, E.J. Brill, 1984. The italics are added by the author.

18. *The Annals of the Four Masters*.

19. Woodman and Dickson, op. cit.

20. De Chardin, Teilhard: *The Phenomenon of Man*.

Bibliography

The Annals of the Kingdom of Ireland by the Four Masters ed. J. O'Donovan. 7 vols. (Dublin 1848-51)
The Annals of Ulster,, ed. W.M. Hennessy and B. McCarthy (4 vols, Dublin 1887-1901)
The Annals of Clonmacnoise, being annals of Ireland from the earliest period to AD 1408, translated into English, AD 1627 by Conell Maeoghan, ed. D. Murphy (Dublin 1896).

Andersen, Jørgen: *The Witch on the Wall – Medieval Erotic Sculpture in the British Isles,* Rosenkilde and Bagger (Copenhagen, Denmark, 1977).
Anderson, A.O., and M.O. (eds), *Adomnán's Life of Columba* (London, 1961)
Baring, Ann and Cashford, Jules: *The Myth of the Goddess,* Arkana Penguin Books (London 1993)
Biaggi, Christina: *Habitations of the Goddess,* Knowledge, Ideas and Trends (Manchester CT. 1994)
Blair, Nancy: *Amulets of the Goddess,* Wingbow Press (Oakland CA 1993)
Brady, W. Maziere, D.D.: *Clerical and Parochial Records of Cork, Cloyne and Ross,* Vol III, Alexander Thom, (Dublin 1964)
Cahill, Thomas: *How the Irish Saved Civilization – the Untold Story of Ireland's Heroic Role from the Fall of Rome to the Rise of Medieval Europe,* Doubleday (New York, 1995)
Campbell, Joseph: *The Hero with a Thousand Faces* Princeton University Press, Bollingen Series (New Jersey, 3rd printing 1973. 1st edition 1949).
Cherry, Stella: *A Guide to Sheela-na-gigs,* National Museum of Ireland (Dublin, 1992)
Condren, Mary: *The Serpent and the Goddess,* Harper Collins (San Francisco, 1989)
Cosgrave, B.: *Bede's Ecclesiastical History of the English People* (Oxford,

1929)

Cross, Tom Peete and Slover, Clark Harris: *Ancient Irish Tales,* Figgis (Dublin 1969) First printed 1936 Henry Holt and Company, USA

Dalrymple, William: *The Age of Kali* Flamingo, Harper Collins (London 1999)

Dames, Michael: *Mythic Ireland* Thames and Hudson (London 1992)

Dillon, Myles: *Early Irish Literature* (Chicago, 1948).

Dillon, : *Hindus and Celts*

Ellis, Peter Berresford: *Celtic Women,* Constable (London 1995)

Foster, Sally: *Picts, Celts and Scots,* Historic Scotland, B.T. Batsford Ltd. (London 1996)

Fox, Matthew: *Original Blessing* Bear and Company, (San Francisco 1983)

Gimbutas, Marija: *The Civilization of the Goddess, the world of Old Europe* Harper (San Francisco, 1991)

Gimbutas, Marija: *The Language of the Goddess,* Thames and Hudson *(London, 1989)*

Jung, Carl: *Symbols of Transformation,* Princeton University Press, New Jersey

Jung, Carl: *Man and His Symbols* Princeton University Press, New Jersey

Jung, C.G. and Kerenyi C.: *Science of Mythology,* Ark Paperbacks, (London 1985; First published 1949

Herbert, Máire: *Iona, Kells and Derry,* Four Courts Press, (Dublin 1996)

Hughes, Kathleen: *The Church in Early Irish Society* (London, 1966)

Kelly, Eamonn: *Sheela-na-Gigs – Origins and Functions,* Country House for the National Museum of Ireland (Dublin 1996)

Kelly, Fergus: *Early Irish Law Institute for Advanced Studies* (Dublin 1988)

Kinsella, Thomas: *The Táin,* Dolmen Press (Dublin, 1969).

Kramer, Heinrich and Sprenger Jakob: *Malleus Maleficarum,* Dover Press (1971)

Leroi-Gorhan P: *Treasures of Prehistoric Art,* Henry Abrams.

Macalister, R.A.S.: *Ancient Ireland,* Methuen (London 1935)

Macalister, R.A.S.: *Tara – a Pagan Sanctuary of Ancient Ireland* (London 1931)

MacAnna, P: *Encyclopedia of Religion* 3

MacAnna, P.: *Celtic Mythology* (London, 1970)

Matthews, Caitlín: *The Elements of the Goddess* Element Books (Shaftesbury, Dorset 19

Maxwell, Constancia: *Irish History from Contemporary Sources 1509-1610* George Allen and Unwin (London 1923)

McMahon, Joann and Roberts, Jack: *The Sheela--na-Gigs of Britain and Ireland – the Divine Hag of the Christian Celts,* Mercier Press (Cork and Dublin, 2001)

Minahan, John: *The Christian Druids,* Sanas Press (Dublin 19)

Moody T.W. and Martin, FX (Eds.): *A Course in Irish History* Revised Edition Mercier Press (Cork 1984)

O'Connell, Patricia: *The Irish Colleges of Spain and Portugal* (four volumes) Four Courts Press (Dublin 1997 - 2001)

O'Connor, James: *Sheela na gig* Fethard Historical Society (Tipperary, 1991)

O Crualaoich, Gearoid: *The Book of the Cailleach,* Cork University Press (Cork 2003)

O'Hart, John: *Irish Pedigrees,* vol.1. Mc'Glashan and Gill (Dublin, 1876)

Ó Duinn, Seán: *Where Three Streams Meet* Columba Press, (Dublin 2001)

O Hogain, Daithi: *The Celts,* The Collins Press (Cork, 2002)

Perera, Sylvia Brinton: *Queen Maeve and Her Lovers,* Carrowmore Books; Irvington Publ. (New York 1999)

Perera, Sylvia Brinton: *The Irish Bull God – Image of Multiform and Integral Masculinity;* Inner City Books (Toronto Canada 2004)

Rawson, Philip: *The Art of Tantra,* Thames and Hudson, (London 1973)

Rees, Alwyn and Rees, Brinley: *Celtic Heritage* Thames and Hudson (London 1961 Reprinted 1989)

Reston, James Jr.: *Warriors of God,* Faber and Faber, (London 2001)

Richardson, Hilary and Scarry, John: *An Introduction to Irish High Crosses,* Mercier Press (Dublin 1990)

Roberts, Jack, McMahon, Joann: *The Sheela-na-gigs of Britain and Ireland* Key Books, (Skibbereen, west Cork, 1996)

Ross, Anne: *Pagan Celtic Britain,* Routledge and Kegan Paul (London 1967)

Skene, Donald: *Celtic Scotland* B.T. Batsford (London, 1996)

Smith, Donald: *Celtic Travellers,* The Stationery Office (Edinburgh 1997)

Spenser, Edmund: *A View on the Present State of Ireland, 1596,* Ed. W.L. Renwick (Oxford 1934)

Stephen, Sir Leslie, and Lee, Sir Sidney: *The Dictionary of National Biography,* Vol. XV, Oxford University Press, (London, 1917)

Thiering, Barbara: *Jesus the Man,* Transworld (London 1993)

Thomas, A.C.: *Christianity in Roman Britain to AD 500* (London, 1981).

Watt, John: *The Church in Medieval Ireland,* 2nd edition University College Dublin Press (Dublin 1998). First Edition Gill & Macmillan (Dublin 1972)

Weir, Anthony and Jerman James: *Images of Lust,* Batsford Academic and Educational Ltd (London 1986)

Woulfe, Patrick: *Irish Names and Surnames,* Gill and Son, (Dublin 1923)

Woodman, Marion and Dickson, Elinor: *Dancing in the Flames,* Shambala Publications, (Boston MA. 1995)

Yeats, William Butler: *Selected Poems,* Bell & Random House (New York)

ARTICLES

Bailey, Richard N., 'Apotropaic Figures in Milan and North-West England' in Folklore Vol. 94: ii 198. Univeristy of Newcastle Upon Tyne.

Byrne, F.J.: 'Early Irish Society', in *The Course of Irish History* Eds. Moody and Martin, Mercier Press (Cork 1984)

Beiler, Ludwig: 'The Celtic Hagiographer' in *Studia Patristica,* (Berlin 1962)

Dunne, James H: 'Sile-na-nCioch' in *A Journal of Irish Studies.* Published fy the Irish American Cultural Institute, Number XII. 1997.

Fraser, Douglas: 'The Heraldic Woman: a Study in Diffusion' in *The any Faces of Primitive Art: a Critical Anthology* Prentice-Hall, Englewood Clifs, (New Jersey 1966)

Frothingham. A.L. 'Medusa, Apollo and the Great Mother' *American Journal of Archaeology,* 15. (1911).

Guest, Edith M.: 'Irish Sheela-na-gigs in 1935' *JRSAI,* 66 (1936)

_____: 'Some Notes on the Dating of Sheela-na-gigs' *JRSAI,* 67 (1937)

Hickey, Elizabeth: 'The Legend of Tara', pamphlet, Dundalgan Press,

(Dundalk 1988)

Henry, Francoise: 'Around an Inscription: The Cross of the Scriptures at Clonmacnoise' in *Journal of the Royal Society of Antiquaries of Ireland* pp 293-303 (Dublin 1980)

Herity, Michael, 'The Layout of Irish Early Christian Monasteries' in Ní Chatháin and Richter (ed), *Ireland and Europe,* pp. 105-116.

Jerman, J.A., 'The Sheela-na-Gig carvings of the British Isles: suggestions for a re-classification, and other notes.' *C.L.A.J.* xx No.1. (1981)

Keeling, David: 'An unrecorded exhibitionist Figure (Sheela-na-gig) from Ardcath, Meath', in *Ríocht na Midhe* 1992.

O Cuiv, Brian: 'Ireland in the eleventh and twelfth centuries' in *The Course of Irish History* Eds. Moody and Martin, Mercier Press (Cork 1984)

O'Donovan, John: Ordinance Survey Letters from Tipperary. Royal Irish Academy vol II (Dublin 1840).

Pagels, Elaine: 'What became of God the Mother? Conflicting Images of God in Early Christianity' *Signs 2,* number 2, 1976.

Patel, Kartikeya C.: 'Women, Earth and the Goddess – a Shakti Hindu Interpretation of Embodied Religion' in *Hypatia,* Fall 1994. pp.78.

Roberts, Jack, McMahon, Joann: *The Sheela-na-Gigs of Britain and Ireland. An Illustrated Map/Guide* Banda Publishing (Sligo 1997)

Rynne, Etienne: 'A Pagan Celtic Background for Sheela na Gigs' *Figures from the Past* Glendale Press, (California 1987)

Index

Megalithic architecture and
symbols 19-21, 23
Mellifont Abbey, County Louth
113
menhirs 11-12
menstruation 162
mental health in ancient times
169-70
Mesopotamia 25, 45, 144
Metrical Dindshenchas 53
Midir of the Tuatha Dé Danann
50
Milesians 46, 51
misogyny 125-6, 149-50
missionaries 2, 92
Mochomog, St 104
monasteries 11, 67-8, 80, 88, 91,
131
and monastic schools 92
see also Iona, Scotland
Moriarty, John 157
Morrígan, 38-9
Morrigna, triple goddesses 38-9
Mountjoy, Lord 129
Moycarky Castle, Thurles,
County Tipperary 13
Moytura, battle of 39
Mucalinda, Buddhist goddess 148
Mull, Scotland 76
Munster 118, 120
Muslims, slaughter of 94-5

Naga, Assam clan 16
Naoise 52
National Museum of Ireland 10-
11, 62-3
nature religion, integration with
warrior ethic 52-4
Nazis 101
Nechtan, King of Pictland 81-2
Neolithic period 19-20
carving from Yorkshire 63

temples to the Goddess 30-1
Nephtys 96
Nes, goddess 49
New Zealand 176
Newgrange, Meath 21, 30, 31-3
Niall of the Nine Hostages xii, 54-
5, 72, 123, 131, 179, 181
Ninian, St 69
Normandy, Irish monks in 77
Normans 4, 11, 12, 28, 115-17,
120, 122
Northern chieftains 128-9
Northumbria 3, 77, 80, 82

Oban, Scotland 76
O'Brien, King Muirchertach 110
O'Brien kings of Munster 118,
120
occulting of Sheela na gig 91-114,
120, 124, 136, 163
O'Connor, James 12, 13
O'Connor, Turlough 112-13
O'Conor provincial kings of
Connacht 117-18
O Crualaich, Gearoid 138-9
O'Donovan, John 7, 12, 13
O Duínn, Sean 14
O'Dwyer, Gillian 12-13
Offaly 9, 62-3, 64, 104, 106, 121-
2, 124, 130
O hIfearnain, Liam Dall 139
O'Madden, Eoghan, chieftain 122
O'Malley, Grace 86
O'Melaghlin family, Kings of
Meath 123
O'Neill, Brian of Cenel Eogain
118
O'Neills 129-30
Oracle 97, 162
O'Reilly chieftains 130
Orkneys 20-1, 28
O'Rourke, Tiernan, King of

Ayub Ogaba
Kothbiro